For Barbara,
From the *hand* of the
Cosmos. All the best,

[signature]

The Linda Schele Series in Maya and Pre-Columbian Studies
This series was made possible through the generosity of
William C. Nowlin, Jr., and Bettye H. Nowlin,
the National Endowment for the Humanities, and the following donors:

Elliot M. Abrams and AnnCorinne Freter
Anthony Alofsin
Joseph W. Ball and Jennifer T. Taschek
William A. Bartlett
Elizabeth P. Benson
Boeing Gift Matching Program
William W. Bottorff
Victoria Bricker
Robert S. Carlsen
Frank N. Carroll
Roger J. Cooper
Susan Glenn
John F. Harris
Peter D. Harrison
Joan A. Holladay
Marianne J. Huber
Jānis Indrikis
The Institute for Mesoamerican Studies
Anna Lee Kahn
Rex and Daniela Koontz
Christopher and Sally Lutz
Judith M. Maxwell
Joseph Orr
The Patterson Foundation
John M. D. Pohl
Mary Anna Prentice
Philip Ray
Louise L. Saxon
David M. and Linda R. Schele
Richard Shiff
Ralph E. Smith
Barbara L. Stark
Penny J. Steinbach
Carolyn Tate
Barbara and Dennis Tedlock
Nancy Troike
Donald W. Tuff
Javier Urcid
Barbara Voorhies
E. Michael Whittington
Sally F. Wiseley, M.D.
Judson Wood, Jr.

Art and Society in a Highland Maya Community

THE ALTARPIECE OF SANTIAGO ATITLÁN

by Allen J. Christenson

University of Texas Press, Austin

Requests for permission to reproduce
material from this work should be sent to
Permissions
University of Texas Press
P.O. Box 7819
Austin, TX 78713-7819.

⊗ The paper used in this book meets the minimum
requirements of ANSI/NISO Z39.48-1992 (R1997)
(Permanence of Paper).

LIBRARY OF CONGRESS CATALOGING-IN-PUBLICATION DATA

Christenson, Allen J., 1957–
 Art and society in a Highland Maya community : the altarpiece of Santiago Atitlán
 p. cm.
 Includes bibliographical references and index.
 ISBN 0-292-71237-5 (cloth : alk. paper)—ISBN 0-292-71242-1 (pbk : alk. paper)
 1. Tzutuhil Indians—Religion. 2. Altarpieces—Guatemala—Santiago Atitlán. 3. Tzutuhil
sculpture—Guatemala—Santiago Atitlán. 4. Santiago Atitlán (Guatemala)—Religious life
and customs.

F1465.2.T9 C47 2001
726.5′296—dc21

 2001023702

Book design by Allen Griffith/EYE4DESIGN

Che Linda Schele,
nim a k'u'x chqaxol chbe q'ij saq

CONTENTS

FIGURES

(All drawings and photographs by author except as noted in captions)

PREFACE

This study concerns the extent to which the sacred architecture and monumental sculpture of Santiago Atitlán, a Tz'utujil–Maya-speaking community in Western Guatemala, reflects the worldview of traditionalist members of its society. The central altarpiece of the town's sixteenth-century Roman Catholic church is my primary focus. Originally constructed at an unknown date during the early colonial era (1524–1700), the altarpiece underwent extensive reconstruction after it collapsed during a series of severe earthquakes in the twentieth century. The reconstruction effort took place from 1976 to 1981 under the direction of the town's parish priest, Stanley Francisco Rother. To support craftsmanship within the community, Father Rother commissioned a local Tz'utujil sculptor, Diego Chávez Petzey, and his younger brother, Nicolás Chávez Sojuel, to reerect the monument and to carve replacement panels for those sections that were too damaged for reuse. Rather than strictly following the original arrangement of the altarpiece, the Chávez brothers replaced many damaged panels with entirely new compositions based on traditional Maya religious beliefs and rituals familiar to their contemporary experience.

The relationship between the artists and Father Rother is best characterized as collaborative, a bilateral interaction in which both Catholic priest and Maya sculptors were active participants. Diego Chávez carried out the project with the intention of asserting the legitimacy of traditional Tz'utujil-Maya faith as an independent complement to Roman Catholicism. The result is a work in which Roman Catholic forms and images are reshaped to reveal uniquely Maya

meaning, and Maya motifs and rituals are brought into harmony with Catholic orthodoxy. Consequently, the altarpiece presents an invaluable visual display of important Tz'utujil rituals and beliefs that are otherwise difficult to access by Western researchers.

I first saw the altarpiece in 1977, at the very time the Chávez brothers were reconstructing it and carving new panels along its base. Even in its unfinished state, the monument struck me with its masterful blending of Roman Catholic and traditional Maya motifs. I was intrigued by it, and still am. To see indigenous beliefs and rituals expressed sculpturally by living Maya artists is extremely rare. Never before or since, to my knowledge, has such a sculptural project been undertaken on so grand a scale.

The world of Santiago Atitlán has changed dramatically in the years since the Chávez brothers worked on the reconstruction of the altarpiece. Robert Carlsen (1996, 1997) and Nathaniel Tarn (Tarn and Prechtel 1997) have documented sweeping shifts in nearly all aspects of the society. Santiago Atitlán has little room to grow, being wedged into a small area bounded by Lake Atitlán and one of its bays on the north and west and by mountains to the east and south. Lacking sufficient arable land to support their growing population, the people of Santiago Atitlán, often called Atitecos, have tended to move from an agriculturally based economy toward mercantilism. Improved roads and increased boat traffic on the lake have brought an influx of tourists and non-Maya businesses into the community. This contact with outside influences has had a tremendous impact on the traditional life of the community. In the 1970s, approximately 75 percent of the men wore traditional native Maya costume (Tarn and Prechtel 1997, 309). Today men rarely wear the traditional red shirt, favoring instead inexpensive American seconds, an indication that maintaining a distinctive Maya identity based on the past has declined somewhat in importance. In addition, the introduction of Protestantism and orthodox Roman Catholicism have steadily eroded older Atiteco religious practices to the point that traditionalists now constitute a minority of the overall population. The relatively peaceful town I first encountered in 1977 has given way to a bustling commercial center under nearly constant siege by the din of rumbling trucks and buses, blaring Protestant loudspeakers, and the American ditties that ice cream vendors play at ear-splitting volume.

The devastating civil war in Guatemala, particularly the period in the 1980s known simply as *la violencia* ("the violence") has had

the greatest impact on the social fabric of Santiago Atitlán. Atitecos suffered disproportionately among neighboring highland Maya communities during these years. The Committee of Campesino Unity (CUC) estimates that as many as 1,700 Atitecos were killed between 1980 and 1990, out of a population of approximately 20,000 (Carlsen 1997, 18). Those perceived as promulgating traditional Maya culture and religion were targeted specifically as dangerous threats to social stability by some factions of the military.

The violence culminated in the massacre of December 2, 1990. The day before, the garrison commander and a group of his soldiers had terrorized the community, raping the daughter of a local store owner and committing numerous thefts and acts of vandalism. When several thousand unarmed Atiteco men and women, with their children, gathered the next day to complain about recent abuses, soldiers from the nearby garrison opened fire. Thirteen died instantly and scores of others lay wounded. The incident drew immediate international condemnation, forcing the Guatemalan government to take the unprecedented step of withdrawing its military presence from the community.

Despite the treaty of peace that officially ended the civil war in early 1997, politically motivated violence and repression continues to plague Santiago Atitlán. That same year a dispute between political factions resulted in the destruction of the mayor's offices, which included the town's library and archives. Continued political rancor has created an atmosphere of profound mistrust and even hopelessness among many Atitecos.

The Tz'utujil-Maya are not relics of a long-dead past. They are a modern people, well aware of the broader world around them. Yet, despite strong social and political pressure to abandon their "old ways," a significant number of traditionalists maintain what they can of the ritual cycles observed by their ancestors (Carlsen 1997, 50). The religion of these traditionalists is a dynamic blend of Christian and ancient Maya beliefs—one which is constantly changing from year to year as new theological, political, and economic circumstances force them to adapt. Accordingly, the altarpiece represents not a static vision of an ancient and unchanging Maya belief system, but rather a snapshot of what a pair of Maya artists at a specific moment in time considered to be the most important aspects of their world. Although only a few decades have passed since the Chávez brothers gave the altarpiece its present form, their world has become a very different place from the one they knew prior to the violence of the war years. I

have consciously avoided those recent social and political changes at Santiago Atitlán for the purposes of this book since my intention here is to convey as much as possible the attitudes and worldview held by the Chávez brothers at the time they worked on the altarpiece reconstruction.

This book does not present a unified view of traditional Tz'utujil–Maya theology, for such a thing does not exist. Researchers who have worked in Santiago Atitlán in the past have noted that religious beliefs and practices among the Maya vary from individual to individual. This is because there is no unity of opinion in matters of Tz'utujil faith. Certain core myths are widely known among nearly all segments of the community, but the particulars of these stories are learned primarily through oral tradition and thus are not codified in any single source.

Because I draw heavily on extensive conversations I had with the Maya artists who carved the altarpiece, the organization of this book reflects my focus on their unique understanding of contemporary Atiteco beliefs and rituals. I have included a great deal of information concerning Tz'utujil ceremonialism and myth, but only those elements of traditional life in Santiago Atitlán that refer directly to specific elements of the altarpiece as interpreted by the Chávez brothers. With regard to sources outside the Chávez family, I have made every attempt to identify where I obtained specific information.

I believe the real importance of this study lies not in my interpretations, but rather in the extraordinary degree to which the Maya artists involved were willing to discuss their work and their deeply felt convictions openly with an outsider. The moment was right for the kind of interaction we enjoyed. In this book I have tried not to stray too far from their voices.

ACKNOWLEDGMENTS

A work of this nature would be impossible without the participation of the Maya with whom I collaborated. It has been my great fortune to work closely with the artists who reconstructed the altarpiece, Diego Chávez Petzey and Nicolás Chávez Sojuel, both of whom were extraordinarily generous with their time and knowledge. I am proud to acknowledge them as my patient teachers and friends. To the degree that this study reveals a measure of the beauty and wisdom of Tz'utujil culture, it is to them that much of the credit belongs.

I extend my appreciation to the parish priest in Santiago Atitlán at the time I was gathering material for this book, Father Miguel. He opened many doors that otherwise would have remained forever closed to me. To the people of Santiago Atitlán I owe an immense debt of gratitude. I would like to recognize the assistance of the *cabecera*, the head of the confraternity system at Santiago Atitlán, for his willingness to share his knowledge and experience. My particular thanks go to the *nab'eysil* of the Confraternity of San Juan for his kindness in taking me under his wing through countless hours of late-night ceremonies that opened new worlds to me. I would also like to recognize the generosity of the elders of the confraternities of San Juan, San Francisco/Animas, Santa Cruz, San Nicolás, San Gregorio, Francisco Sojuel, and San Martín Cerro de Oro, who welcomed me into their homes and confraternity houses with extraordinary patience and kindness. I look forward to the day when circumstances in Guatemala will allow their names to be safely acknowledged in print.

My deepest gratitude is owed to my mentor, the late Linda Schele. It was her scholarship that first brought me to the University of Texas as a wide-eyed graduate student. It was her love and respect for the Maya people, and her boundless curiosity, that sustained me through the following years. I had hoped to present this book to her as yet another of her intellectual "grandchildren." Linda, to the degree that I was able, you are on every page.

I convey my special thanks to the following individuals, who were kind enough to read the manuscript and offer invaluable suggestions and insights: Karen Bassie-Sweet, Garrett Cook, Sam Edgerton, Gary H. Gossen, Terence Grieder, John Monaghan, Dorie Reents-Budet, F. Kent Reilly III, and Jeffrey Chipps Smith. I would also like to acknowledge my appreciation to Jaime Awe, James Brady, Eduardo Douglas, David Freidel, Julia Guernsey-Kappelman, Annabeth Headrick, Andy McDonald, Elizabeth Pope, Kathryn Reese-Taylor, Kristen Tripplett, Mark Van Stone, and Khristaan Villela for their kind suggestions on various aspects of this project.

Finally, I wish to thank my wife, Janet, and my children Elise, Sharon, and David. Without their love, support, and patience I would never have had the strength to begin.

Art and Society in a Highland Maya Community

CHAPTER ONE
Introduction

T he Maya are among the oldest of the world's people, their first ancestors having appeared in Central America at least three thousand years ago. One of the hallmarks of ancient Maya culture is the importance it placed on leaving a record of its society through art and written records. The sophisticated Maya hieroglyphic script is predominantly phonetic, making it capable of recording any idea that could be thought or spoken.

Scribes were among the most honored members of ancient Maya society. Many were important representatives of the ruling families. Among their titles were *itz'at* ("sage" or "wise one") and *ah k'ul hun* ("keepers of the holy books"). In Burial 116 at Tikal, the tomb of a seventh-century ruler named Hasaw Chan K'awil, archaeologists uncovered a collection of finely incised bones. One of these depicts a human hand delicately holding a paintbrush emerging from the gullet of an open-mouthed serpent (Fig. 1.1). In the art of the Classic Maya, the serpent's maw represented a portal that led from this world to the world of the gods. For the ancient Maya, the work of scribes came closest to that of the gods themselves, who painted the realities of this world as divine artists.

In modern Western society, we revere the works of great artists and writers of the past but do not look at their surviving work as potentially living entities. For many Maya, even today, old books and artifacts bear the spirits of the men or women who created them. My first experience with the highland Maya of Guatemala was in the late 1970s when I worked as an ethnographer and linguist in the K'iche'-Maya language. At that time I worked with a number of Maya

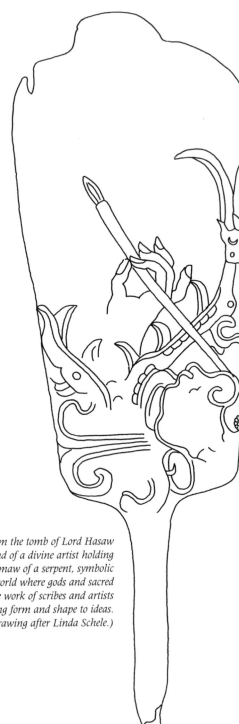

Fig. 1.1. This beautifully incised bone from the tomb of Lord Hasaw
Chan K'awil of Tikal depicts the hand of a divine artist holding
a paintbrush emerging from the open maw of a serpent, symbolic
of a portal giving access to the underworld where gods and sacred
ancestors live. The Classic Maya saw the work of scribes and artists
as somewhat like that of a deity, giving form and shape to ideas.
(Drawing after Linda Schele.)

Art and Society in a Highland Maya Community

shaman-priests, called *ajq'ijab'* ("daykeepers," who work with the indigenous Maya calendar), in preparing translations of old Maya texts compiled soon after the Spanish Conquest in the sixteenth century. Among the highland Maya, such ancient books represent sacred communication from the world of their ancestors, similar to the scribe's hand reaching out from the otherworld as depicted on the incised bone from Hasaw Chan K'awil's grave at Tikal.

Many highland Maya communities possess wooden chests or shrines containing books, clothing, and even pre-Columbian artifacts owned by their ancestors, which they revere as sacred relics (La Farge and Byers 1931, 14, 144; La Farge 1947, 59; Oakes 1951, 64–69; Carmack and Mondloch 1983; Tarn and Prechtel 1997, 39–40). On special occasions, they carefully remove these objects to ceremonially "feed" them with offerings of incense and prayers (Fig. 1.2). Those charged with handling the books and other items do so with a cloth draped across their arms and chests so as not to touch them directly. On such occasions the Maya rarely open the books to read them. The ceremony is intended only to give the objects in the chest an opportunity to "breathe" and be purified with incense smoke. This is partly because the books are often fragile and would be damaged by overuse, and partly out of reverence for the words themselves. When the words of the ancients are read, or spoken aloud, it is as if they had come back from death to speak again. Reading ancient texts is therefore a very delicate matter, filled with peril if the words are not treated with sufficient respect.

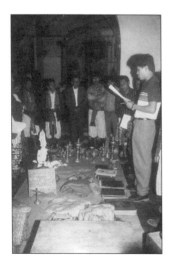

Fig. 1.2. Many highland Maya communities preserve important documents and objects in special chests. At Santiago Atitlán, these are removed during Easter observances to allow them to "breathe" and to be resanctified with incense smoke and prayers.

(All photographs are by the author unless otherwise noted.)

When I worked with the Maya in preparing translations of old documents, the *ajq'ijab'* would first wave incense smoke over my photocopied version of the text and ask forgiveness of the ancestors who had written the originals for disturbing them. When I asked one of my friends why he did this, he replied that "to read the words of one who is dead is to make that person's spirit present in the room and give him a living voice." Such power must be approached with great seriousness. They were very cautious when transcribing or translating ancient texts to ensure that the results would be as faithful as possible to the meaning and intent of the original authors. To do otherwise would be to *b'an tzij* ("make lying words") that would anger the ancients and possibly incite them to seek vengeance by causing illness or some other misfortune. At the end of our work sessions, the Maya politely dismissed the gods and ancestors involved in that day's reading, asking their forgiveness for any offenses that we might have committed.

THE CENTRAL ALTARPIECE OF THE CHURCH AT SANTIAGO ATITLÁN

The massive altarpiece of the sixteenth-century church at Santiago Atitlán, a Tz'utujil-Maya community in the western highlands of Guatemala, occupies the entire apse wall it stands against. In the eyes of traditionalist members of the community, the altarpiece represents far more than a decorative framework for the saints that reside in its niches (Figs. 1.3–1.5). Like ancient Maya texts and artifacts, it is a living thing endowed with a *k'u'x* ("heart"), placed there by the ancestors of the community. But this heart is not indestructible. It must be periodically renewed through prayer and ritual activity.

Weakened by centuries of exposure to humidity, seismic activity, and insects, the altarpiece finally collapsed during an earthquake in 1960. Among traditionalist Maya, the collapse of the altarpiece was a shocking disaster. Because they believed that its shattered wood was still animated with the power of the ancient inhabitants of their community, the disarticulated pieces were put in storage for safekeeping. Wood fragments from the monument, even bits that are little more than splinters, are still carefully guarded by the town's elders as sacred relics.

In 1976 another severe earthquake struck the community and caused additional damage to the monument. That same year the

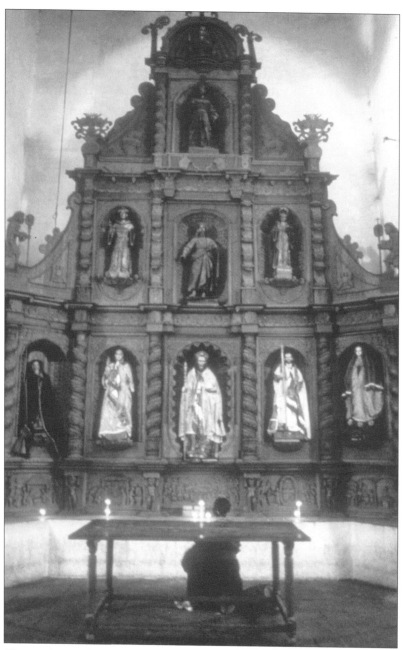

Fig. 1.3. The central altarpiece in the sixteenth-century church of Santiago Atitlán. For traditionalist Atitecos, this monument represents a sacred mountain from which divine beings emerge. Santiago, the patron saint of the community, is the central image in the lowest tier of the monument.

parish priest, Father Francisco Rother, commissioned a local Maya sculptor, Diego Chávez Petzey (later joined by his younger brother, Nicolás Chávez Sojuel), to initiate repairs. The two brothers carried out the renovation of the altarpiece over a five-year period, prematurely abandoning work with the death of Father Rother at the hands of political assassins in 1981.

Diego Chávez approached reconstruction of the altarpiece as a means of honoring the traditional faith of his community. Before initiating the work, he spent several months talking with Maya elders and people who still remembered and practiced what he called the "old ways." He recorded these stories in a loose-leaf binder and used them while selecting motifs for the altarpiece decoration. By so doing, he hoped to make a permanent record of the beliefs and history of his people so that they would not be lost to future generations. While reviewing drawings I had made of the altarpiece, Diego recalled that his original intent was not a simple repair of the sculpted monument but an assertion of the living presence of ancestral faith in the life of his community:

> I wanted to show the continued power of the past. You cannot destroy the past, only add new things to it. I took what is good of Christianity and the Maya religion. My ancestors in ancient times knew the truth of all things, but much has been lost since their day. But still my people, the Maya, remember the old customs and ceremonies and the great things that our ancestors have left to us. I tried to create something that would show what I could of the beliefs of my people and show that they are just as alive as those of the Christians.

Diego lamented the fact that in ancient times the Maya of his community had written down all that they knew, but that this knowledge had been destroyed when the Spaniards came and burned their books. He said that now when people die they are buried forever along with their words. He wanted his collection of stories to be a first step in preserving not only ideas but, in a very real sense, the lives of those who told them, many of whom have since died.

With great sadness, he described how this priceless collection of traditional myths was lost. During the violence of the Guatemalan civil war following Father Rother's assassination, both Diego and Nicolás were interrogated and beaten mercilessly for their long-standing relationship with the murdered priest, and for the perception that they

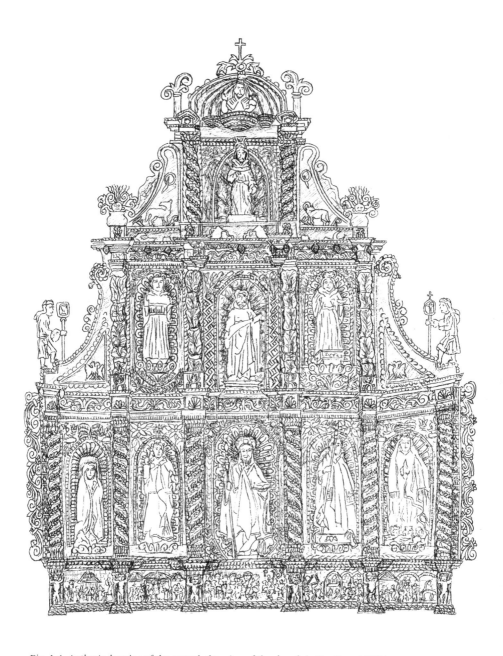

Fig. 1.4. Author's drawing of the central altarpiece of the church in Santiago Atitlán.

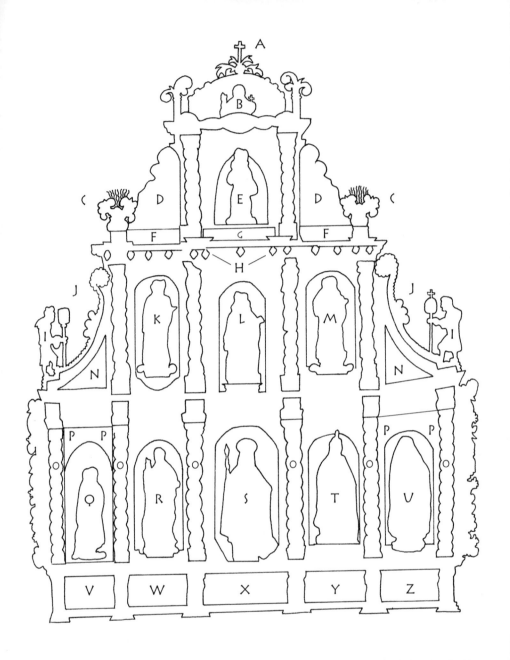

Fig. 1.5. Schematic drawing of the central altarpiece. Drawings of altarpiece details appear in Figs. 2.3a, 4.14b, 5.1, 5.3, 5.4., 5.14, 5.18, and 5.21. For drawings of the narrative panels, see Figs. 6.1, 6.7, 6.26, 6.32, and 6.36.

Art and Society in a Highland Maya Community

Key to Figure 1.5

A World Tree/maize plant/cross
B Dios Padre (God the Father)
C sun vessel motif
D sacrificial animals; initials PFR (Padre Francisco Rother)
E San Francisco (St. Francis of Assisi)
F cup and antler motif
G flowing vases motif
H jaguar teeth/pinecones
I confraternity elders climbing the mountain
J necklace of Tepepul motif
K San Pablo (St. Paul)
L Simón Mam (Simon the Ancient)
M San Marcos (St. Mark)
N bicephalic bird motif
O "serpent" columns
P maize god motifs
Q María Andolor (Mary of Suffering)
R San Juan "Carajo" (St. John "The Prick")
S Santiago Mayor (St. James the Great)
T Santiago Menor (St. James the Lesser)
U María Dragón (Dragon Mary)
V Basal panel 1 (Shamanic Divination/Divine Word)
W Basal panel 2 (Deer Dance/Rilaj Mam)
X Basal panel 3 (Atiteco Last Supper)
Y Basal panel 4 (Observances of Holy Thursday)
Z Basal panel 5 (Burial/Day of the Dead)

promoted indigenous Maya culture. Diego was left for dead in the forested mountains above town after one such beating. Although Diego survived, his collection of stories was confiscated and presumably destroyed. In describing this loss, Diego mourned that now many of the old ones are gone and their words are dead with them. They can never speak again. He hoped his work on the altarpiece would serve as a visual reminder of their spirit and preserve something of the ancient traditions.

Nicolás Chávez recalled that when the two brothers joined the new panels of cedarwood that they had carved to the older ones, they heard creaking and popping sounds as the heavy framework of the altarpiece settled. Nicolás interpreted this as the voice of the ancients welcoming the new panels. When the sounds eventually stopped, he took it as a sign that the "heart" of the new wood was acceptable. This came as a great relief to Nicolás since he had feared that its ancient creators might consider adding new imagery to the altarpiece presumptuous. Both artists considered the altarpiece to be a living thing that demanded respect. They also approached the project as a religious obligation and, for the most part, worked without compensation other than for their meals and the materials they used.

The altarpiece as it now stands is a new creation, combining Roman Catholic symbols with motifs that reflect traditional Maya practices familiar to the residents of the community. Yet these images are not presented in opposition to one another but as complementary elements which are integral to the overall design. The result is neither purely Maya nor wholly Christian; rather it is a harmony of both religious systems. The altarpiece is to a certain extent a synthesis in monumental form of the kind of cultural interaction that has evolved over the centuries since the Spanish Conquest of the Tz'utujils in 1524 and the subsequent evangelization of the region by Roman Catholic missionaries. Today, the traditional religion and art of Santiago Atitlán make no clear distinction between Christian and Maya elements.

Cecelia Klein characterizes the use of Christian imagery to convey native American concepts as "visual bilingualism" (1990, 108–109). It is a means of bridging the world of the European Catholic and that of the Maya. The linguistic analogy is a good one in that as we learn a second language, we tend to interpret unfamiliar phrases in terms of the construction and vocabulary of our mother tongue. The Santiago Atitlán altarpiece subtly blends Catholicism with indigenous Atiteco theology, presenting layers of meaning that complement each other and reinforce certain underlying core concepts. Yet the unifying ideas are founded in a uniquely Maya view of the world.

Traditional Atiteco religion is centered in the confraternity system, a network of voluntary associations dedicated to the veneration of individual saints and associated deiforms. Although the confraternities are ostensibly Roman Catholic organizations, the administration of the ten in Santiago Atitlán is wholly indigenous and independent of the official Church's control. Indeed, the ceremonies conducted in the

confraternity houses retain significant elements of ancient Maya cosmology that run counter to European notions of Catholic orthodoxy. Periodic attempts on the part of reformist priests in this century to purge the confraternities of their perceived "paganism" has created a climate of mutual distrust and sporadic episodes of violence (Lothrop 1929, 23; Mendelson 1957, 332–352, 1965, 66–70; Carlsen 1997, 124–125). The altarpiece represents an attempt on the part of the Chávez brothers to assert the legitimacy of traditional Atiteco Maya faith as an independent complement to Roman Catholicism. As such, it presents an invaluable visual display of important Tz'utujil rituals and beliefs that are otherwise poorly accessible to Western researchers.

DETERMINING MYTHIC AND RITUAL ASSOCIATIONS

This study focuses on the symbolism of the central altarpiece of the Santiago Atitlán church as understood by the Chávez brothers themselves, who base their work on traditional Tz'utujil beliefs in contrast to those that have come with the more recent introduction of orthodox Catholicism and Protestantism. In order to understand the symbolism, I compare the Chávez brothers' observations with related customs and rituals current in Santiago Atitlán, as well as possible cultural antecedents evident in the art and literature of the Maya during the pre-Columbian and colonial phases of their history.

It is not my intention to argue an essentialist view of the Tz'utujil Maya, in which contemporary Santiago Atitlán represents in some way a survival of ancient Maya culture unaffected by the non-Maya world. Nevertheless, as Wilson points out in his discussion of shared historical experience among the Q'eqchi' Maya, "it is misguided to overlook the way in which indigenous identities are chained to images of tradition" (1993, 135). While recognizing profound cultural changes in the past few decades, he asserts that the indigenous people themselves are the primary agents in this reconstruction, drawing upon a cultural legacy that is firmly rooted in the past. In the same vein, Fischer suggests that a shared "cultural logic" exists within individual Maya communities based not only on overt markers such as language and dress, but also on a common history and lived experience (1999, 477). The traditional theological concepts evident in the work of the Chávez brothers are culturally resilient because they are woven into the mythic and ritual practices of the people of Santiago Atitlán.

Until recently, such shared cultural heritage has been overwhelmingly community-based in highland Guatemala. The theology of Santiago Atitlán as expressed in the altarpiece reflects ancient Maya concepts only to the degree that local Atiteco society incorporates into its traditional life indigenous beliefs handed down by its own ancestors. The worldview of the Chávez brothers in the late 1970s differs markedly in content and emphasis from that of other Maya communities. R. G. Fox suggests that "contemporary individuals and groups take pieces, not the pattern, of the past and form them into new social arrangements" (1985, 197). Fischer acknowledges that these patterns are constantly changing, yet at the same time contends that underlying cultural logic ensures that such changes are reconciled with preexisting cognitive schemas in a way that preserves cultural continuity in the face of external pressures (1999, 479). Friedman describes similar processes of cultural articulation in Central Africa and Papua New Guinea in which Western forms are reorganized into "local strategies and logics of social reproduction" (1994, 490). This is distinct from imposed syncretism, as the term is generally used, because the articulation is dominated by indigenous choices based on local experience and strategy. Thus Gossen asserts that the Tzotzil Maya have never been passive recipients of outside forces, even when these wielded superior power to effect economic, political, and symbolic pressures. He suggests instead that they have "brought their own cultural constructs to bear on the course that social change would take" (1999, xxii).

I was fortunate in having the opportunity to discuss the altarpiece at length with both Diego and Nicolás Chávez. Nicolás was motivated to help me in part because of a dream he received soon after we met. In this dream one of the major local deities, Martín, demanded that he share with me all that he knew concerning Atiteco gods and saints so that the *k'u'x* ("heart" or "spirit essence") of the altarpiece would be honored. Nicolás referred to this dream several times during the course of our collaboration. I mention it here because his belief in the dream had a significant effect on our relationship and his willingness to speak about religious topics that he otherwise would have been reluctant to discuss.

Although the elder brother, Diego, was similarly gracious in sharing his thoughts concerning the altarpiece, he was also wary about certain subjects which he considered too delicate to speak about openly. In our discussions he frequently mentioned persons who had offended the

gods by their careless words or actions and were subsequently punished with death, illness, madness, or some other calamity. (Prechtel and Carlsen have noted that it is "customary for the Tz'utujils to refuse to divulge even the most basic of their sacred beliefs, making them not mysterious but misunderstood" [1988, 123]). On a number of occasions, Diego would pause in the middle of a discussion concerning an element of the altarpiece that referred to a powerful divinity and say, "There are many sacred things that this panel refers to." This was his way of indicating that he did not want to say anything more on the subject.

Diego Chávez may also have been reluctant to speak openly for political reasons. Both he and Nicolás had been persecuted for their perceived promotion of traditional Maya culture during the Guatemalan Civil War. Fortunately both survived; others were "disappeared" or murdered. Once while discussing the altarpiece Diego said, "You know, I have had friends who were killed for doing this kind of thing. I want you to write down the stories of my people and I want others to know about my work, but I may be risking my life." In this study I have recorded the names of members of the Chávez family who worked with the altarpiece at their request and with their express consent. These are the only personal names that I cite, a practice which is adopted by many researchers who work in Santiago Atitlán because of the danger that future political instability in the area might threaten those perceived to foster Maya cultural identity (Mendelson 1956, 1957; Carlsen 1997).

The technique Nicolás Chávez and I jointly developed to talk about the altarpiece became the model that I employed in all my subsequent discussions with members of the Santiago Atitlán community. This procedure involved using visual cues to initiate conversations, such as a drawing, photograph, videotape, or direct observation of an art object or ritual. From my prior experience in anthropological research among the K'iche's, a neighboring highland Maya group closely related to the Tz'utujils both linguistically and culturally, I knew that it is nearly impossible to elicit useful responses from verbal questioning.

The Maya are unaccustomed to rhetorical methods of expressing cultural information. As Evon Vogt noted in his work with the Tzotzils of Zinacantan, the Maya are not articulate in describing, only in doing. Nevertheless, he relied on direct questioning as a means of "prying out highly pertinent native exegesis—an exegesis which often proves available to the investigator when the right questions can be asked" (1976, 2). Gossen, however, recently challenged the notion that "any

cognitive domain could be elicited from our native consultants and laid out with its internal patterns of native 'rationality' if we used the right 'question frames'" (1999, xviii). I found that not asking questions at all elicited the best responses, because even the simplest questions reveal the biases and preconceptions of the inquirer. Questions may also be framed in a way that restricts the scope of the response.

The following experience demonstrates the problems inherent in even the most innocent of rhetorical techniques. Early in our collaboration, I asked Nicolás what the altarpiece's pendant decorations just above the second tier of saints represented, objects which were part of the original altarpiece and thus not the invention of the Chávez brothers (see Figs. 1.4 and 1.5 *H*). This question unwittingly implied that the decorations were identifiable as a single entity discrete from the rest of the altarpiece. He had never thought of them as such and studied them carefully before responding that they were pinecones, a common enough motif on colonial-era altarpieces in Guatemala. I asked what the pinecones symbolized for the people in his community. This question forced Nicolás to think of the objects only in terms of pinecones, a concept that he had never considered previously. He therefore struggled to come up with an answer that would satisfy me. The eventual response was that pinecones carry the seeds of new life and thus represent rebirth. For this reason they are sometimes placed under the nests of hens to ensure that their eggs will hatch. This told me something, perhaps, about the Tz'utujil-Maya view of pinecones, but it had little to do with the altarpiece.

A month later Nicolás related a myth about a sacred cave in the mountains south of town called Paq'alib'al, where the gods, saints, and the most powerful ancestors live. In the course of a long story about the cave, he described it as a small opening in the ground guarded by a huge jaguar. As an aside, he asked to see my drawing of the altarpiece (Fig. 1.4). "Look—here you can see the saints inside the sacred mountain in their caves. These [indicating the 'pinecones'] are the teeth of the jaguar who guards the way into their home." I reminded Nicolás of what he had told me about the decorations before. He shrugged his shoulders and said that at the time I had only asked about pinecones and he told me everything he knew about them. On a separate occasion the elder brother, Diego, pointed to the pinecones on the altarpiece and said that these were the *rey b'ajlam* ("jaguar teeth"), independently confirming the identification.

The most typical response to questions concerning why rituals are carried out the way they are is a vague statement that it is *costumbre* ("custom"). This is not an evasive answer but a clue to what is most important in Maya thought. Rituals and works of art are not significant as abstractions that can be explained but because they express sacred precedent that is best understood through its associated mythic history. The goal therefore becomes uncovering the underlying myth connected with the object or action. While preparing a translation of the *Popol Vuh,* a sixteenth-century transcription of an ancient K'iche'-Maya document, Dennis Tedlock worked with contemporary K'iche' *ajq'ijab'* ("daykeepers") who proved invaluable in clarifying the underlying ritual and cultural allusions present in the text. He found that, for the most part, his collaborators were less interested in the technical aspect of translating individual words or phrases than in clarifying meaning through associated myths: "He was never content with merely settling on a Quiché reading of a particular passage and then offering a simple Spanish translation; instead, he was given to frequent interpretive asides, some of which took the form of entire stories" (1985, 15–16).

In working with the Tz'utujil, Mendelson found that spontaneous information was "much more alive and consistent than elicited information" (1957, 5). This is because spontaneous discussion allows a response to be framed in the source's own terms, thus emphasizing those things which are important to the Maya, not the Western researcher. In discussing the altarpiece, or objects and rituals pertinent to it, I preferred to have my collaborators look directly at the subject at hand. Without the artificial construct inherent in a question, the collaborator is free to pick out what is interesting or significant. More often than not, the collaborator's visual observation elicits an account of a personal experience, story, or myth. I have found that a cycle of mythic tales concerning revered ancestors and divinities is widely known in Santiago Atitlán and repeated often, although not codified in any known written text. Such tales are never told the same way twice, even by the same person; however, the basic core concepts embedded in each vary little.

Nicolás proved to be a master at relating Atiteco cultural information. In most of our conversations, we would look at an object or observe a ceremony pertinent to the design of the altarpiece. When this was not possible, we would begin our discussion with one of my

drawings or a videotaped ritual event. When these visual cues remind-ed him of mythic tales or traditions upon which they were based, he would tell the stories in great detail, including variations that he had heard. He sometimes invited elderly individuals who "knew the old stories well" to our sessions. On other occasions he would jot down points about the altarpiece that he knew had been inspired by an important myth, the details of which he could not remember clearly. He would then consult his father or persons who were more "knowl-edgeable on this story" and come prepared to our next discussion with what they had said.

Nicolás' father, Diego Chávez Ajtujal, was a rather frequent source of information in this regard. Now in his eighties, he is a well-respected sculptor in his own right and one of the first Atitecos to carve pieces based on traditional Tz'utujil culture. The elder Diego was somewhat hesitant to speak with me directly about traditional Tz'utujil religion. Nicolás said he feared retribution by the ancestors if he said the wrong things, but the reason for the father's reticence may also have been because he is now active in orthodox Catholic church services and didn't want the priest to know about his once-strong ties to the traditionalists. Nevertheless, he had no problem with conveying stories to me through Nicolás because his son had been charged with helping me by the god Martín and was therefore protected.

In most cases, the Chávez brothers' interpretations of the altar-piece are very similar, although they have not worked together in many years and perceive themselves somewhat as rivals. I take this as an indication that, at least from the artists' standpoint, there is coher-ence in the monument's symbolic message. In addition to my discus-sions with the artists, I was able to observe all of the ceremonies depicted on the altarpiece and speak at length with the principal participants. Most descriptions contained in this book are based on my own observations made from 1977 to 1999 during extended peri-ods of residence in Santiago Atitlán and numerous brief visits. Some of the important ceremonies depicted on the altarpiece are major pub-lic events, such as the Day of the Dead, Easter Week (or Holy Week), and the day of the town's patron saint, Santiago. Others are more intimate ritual dances or prayer ceremonies held in small confrater-nity houses. Although the latter are generally held late at night with few in attendance, Atitecos consider them no less important than the great festivals.

Prior to the sixteenth century, the Maya of the Guatemalan highlands were a literate people, preserving their history and culture utilizing a sophisticated hieroglyphic script in folded-screen codices made of deerskin or bark paper. Fray Bartolomé de las Casas saw several such books about 1540. He wrote that they contained the histories of the people's origins and religious beliefs, written with "figures and characters by which they could signify everything they desired; and . . . these great books are of such astuteness and subtle technique that we could say our writing does not offer much of an advantage" (Las Casas 1958 [ca. 1550], I:346). The Spanish Conquest of the highland region in 1524 under Pedro de Alvarado resulted in the abrupt destruction of political power structures, the more public religious institutions, and most examples of indigenous art and architecture (Orellana 1984, 206). Early Catholic missionaries in the first decades of the colonial period vigorously sought to eradicate the most obvious expressions of native Maya theology and literature. In their zeal to convert the Maya to Christianity, they systematically demolished ancient temples and the carved and painted images they contained (Las Casas 1967 [ca. 1550], II.clxxx.157–158; Avendaño y Loyola 1987 [1688], 6; Mendieta [d. 1604] 1993, 227). Missionaries singled out painted codex books as dangerous hindrances to the conversion of the people and burned those which could be found. Las Casas himself witnessed the destruction of a number of Maya books while serving in the Guatemalan highlands: "These books were seen by our clergy, and even I saw part of those which were burned by the monks, apparently because they thought [they] might harm the Indians in matters concerning religion, since at that time they were at the beginning of their conversion" (1958, I:346).

Of the numerous highland Maya hieroglyphic books that once existed, not a single one is known to have survived. René Acuña argued that the violence of the Spanish Conquest, and the subsequent imposition of Roman Catholic doctrine on the Maya populace of Guatemala, effectively subsumed indigenous culture and theology. He contended that those remnants of Maya culture that survive today are primarily those chosen by the Spaniards themselves, who adapted them to help in their conversion efforts. As a result, he suggested,

highland Maya religion is more a kind of "Folk Catholicism" with little if any authentically Maya components (1975, 1983).

It is the more common assertion among scholars today that important elements of Maya belief and their public expressions in the form of ritual dances, prayers, and ceremonialism were never completely suppressed (B. Tedlock 1982, 1986; Farriss 1984; Freidel et al. 1993; Carlsen 1997). Soon after the conquest, literate members of the K'iche'-Maya nobility, a group closely related by language and culture to the Tz'utujils, made a number of lengthy copies of pre-Columbian books utilizing the Latin script in an effort to preserve what they could of their cultural heritage. A notable example of such an extant transcription is the *Popol Vuh*, the most complete account of pre-Columbian history and myth known from the Maya world (D. Tedlock 1996; Christenson 2000). Its native Maya authors compiled the book in the mid-sixteenth century in an effort to record the acts of ancient gods who carried out their purpose "in clarity and in truth" long before the arrival of the Christian God (Christenson 2000, 38). Thus the book contrasts its "ancient word," which contains light and life, with that of the more recent voice of Christianity as introduced by Spanish missionaries.

The highland Maya were particularly successful in preserving their cultural identity despite the imposition of Roman Catholicism during the colonial period. Two hundred years after the conquest, Fray Francisco Ximénez wrote that many ancient books, including the transcribed text of the *Popol Vuh*, were kept in secret by the indigenous elders of Chichicastenango so that local Catholic authorities would not learn of them. He found that, far from being forgotten tales, these texts were the "doctrine which they first imbibed with their mother's milk, and that all of them knew it almost by heart" (Ximénez 1929–1932 [1722], I:5). As recently as 1973, Robert Carmack located the presumably lost sixteenth-century transcription of the *Título Totonicapán* with a number of other documents that the Maya mayor of the village of Yax kept in an old chest (Carmack and Mondloch 1983).

Although no such sixteenth-century indigenous texts are known from Santiago Atitlán, many of the concepts contained in written sources such as the *Popol Vuh* survive in the ritual life and oral tradition of the Tz'utujils. Carlsen suggests that the pre-Columbian past can be recorded in the cultural lives of the people of Santiago Atitlán in ways other than conventional written sources (Carlsen 1997, 4). Previous

researchers also have noted the prevalence in Santiago Atitlán of objects and practices which preserve significant elements of ancient Maya theology. Mendelson described Atiteco bundle worship as one of many examples of fundamentally Maya practices which have no counterpart in orthodox Roman Catholic worship (1958a, 121).

A certain degree of disjunction in meaning should be considered, and indeed expected, in religious practices such as the bundle cults of Santiago Atitlán. Nevertheless, it is apparent that modern Tz'utujil-Maya continue to practice rituals and relate mythic stories which bear a remarkable resemblance to similar cultural entities from their pre-Columbian past. It is also likely that modern Tz'utujils are influenced to some degree by the original meaning of these practices. Recent advances in the decipherment of ancient Maya iconography and hieroglyphic inscriptions (Taube 1992, 1994; Freidel et al. 1993; Stone 1995; Schele and Mathews 1998) provide a unique opportunity to understand pre-Columbian cosmology in a way which was once impossible. How recognition of these ancient concepts and motifs in the art of the Tz'utujils informs the cultural heritage of the highland Maya people has only begun to be addressed by art historians and anthropologists.

Brief references to the Tz'utujils appear in the writings of most of the important early Roman Catholic missionaries in Guatemala, particularly Fray Bartolomé de las Casas and Fray Luís Cancer (the latter's writings are preserved in extensive quotations and paraphrases in later books such as the histories of Fray Francisco Ximénez). While valuable, many of these references describe the highland Maya in general terms without distinguishing one group from another. There are no extensive colonial-period descriptions of the Tz'utujils that can compare with the wealth of ethnographic material on Yucatec Maya culture compiled by Fray Diego de Landa or on the Mexica in the extensive writings of Fray Bernardino de Sahagún and Fray Diego Durán.

The most informative extant colonial document concerning the Tz'utujils is the "Relación de Santiago Atitlán" written by a Spanish official, Alonzo Paez Betancor, and the resident priest, Fray Pedro de Arboleda (Betancor and Arboleda 1964 [1585]). This document is a response to a series of questions from the Spanish Crown concerning the geography, resources, and lifeways of the native inhabitants in Santiago Atitlán. In addition to the formal responses, Betancor and Arboleda included a map of the town, centered on the recently completed community church and its plaza (*atrio*). Further significant

references to Tz'utujil history and society may be found in the writings of later colonial Spanish writers, particularly Francisco de Fuentes y Guzmán [d. 1699] (1932–1933), Fray Francisco Ximénez (1985 [ca. 1701]; 1929–1931 [1722]; 1967 [1722]), Fray Francisco Vásquez (1937 [1714]); Pedro Cortés y Larraz (1958 [1770]), and Francisco de Paula García Peláez (1943 [1851]).

In contrast to the scarcity of material from the colonial period, in the twentieth century there is a wealth of information concerning the modern Tz'utujil-Maya thanks to the efforts of anthropologists and ethnographers. The first published documentation of Santiago Atitlán's ceremonial life was made by Samuel Lothrop following a two-month stay in various highland Guatemalan villages in the winter of 1927–1928 (Lothrop 1928, 1929). Lothrop's description of public rituals formed only a minor part of this report and was admittedly "superficial in nature" because the Maya people tended to be "suspicious and uncommunicative" around strangers (1929, 1). Lothrop urged that further work be carried out by observers who could remain longer in residence so as to win the confidence of the local population. He also published a brief report on his excavations in the region of Lake Atitlán, including Chiya', the pre-Columbian capital of the Tz'utujils (Lothrop 1933). The introduction to this report contains an excellent survey of indigenous texts which include references to Tz'utujil history prior to the Spanish Conquest.

Various travelers and ethnologists since the time of Lothrop have observed public ceremonies at Santiago Atitlán (Fergusson 1936; McDougall 1955; Termer 1957; Mendelson 1956, 1957, 1958a, 1958b, 1959, 1965, 1967; Douglas 1969; O'Brien 1975; Orellana 1975a, 1975b, 1984; Tarn and Prechtel 1986, 1990, 1997; Prechtel and Carlsen 1988; Canby 1992; Carlsen and Prechtel 1991, 1994; Carlsen 1996, 1997), making it one of the most intensively studied communities in Guatemala. E. Michael Mendelson was the first to spend a significant amount of time in Santiago Atitlán, residing there a full year, from 1951 to 1952, conducting fieldwork for his doctorate under the direction of Robert Redfield. His dissertation (1956) and voluminous field notes available on microfilm (1957) contain much information concerning all phases of Atiteco culture, society, religious organizations, and worldview. Although Mendelson's work focused on contemporary Atiteco society, he suggested that many Tz'utujil religious practices may have had pre-Columbian antecedents (1958a, 124–125). Mendelson

was also the first researcher to mention the church altarpiece. He wrote that his informants referred to it as "the *mero, mero* ('real thing'), it is the place where there is our mother corn, our mother bean, our money" (1957, 444).

Sandra Orellana attempted to reconstruct ancient Tz'utujil culture from the pre-Hispanic era through the early colonial period based on archaeological and documentary sources, as well as her own anthropological fieldwork in Santiago Atitlán (1975, 1984). Her work suggested that despite enforced accommodation to European culture, the Tz'utujil preserved significant elements of their native culture, particularly in the ritual cycles of the local confraternities.

More recently, the anthropologist Robert Carlsen has spent much of the last decade investigating the social organization and political history of Santiago Atitlán, including the development of confraternities and their system of worship (1996, 1997). He is the first anthropologist to work in the area who is conversant in the Tz'utujil language, by far the predominant language spoken in the community. Carlsen's predecessors relied on Spanish, which is well understood by most male Atitecos when they are dealing with commercial matters, but not when it is used in speaking about religious or cultural topics. Tz'utujil women for the most part speak comparatively little Spanish. Carlsen's extensive experience with the religious life of the community included a year's service as the *rukaj* ("fourth member") of the Confraternity of San Juan, one of the most important in town. Carlsen finds that a defining characteristic of Atiteco society is a "distinct and identifiable continuity with the pre-Columbian past" and asserts that many continue to "resist their spiritual conquest" (1997, 5).

CHAPTER TWO

The Altarpiece in the
Context of Tz'utujil History

To understand the underlying meaning of the altarpiece's complex imagery, it is essential to understand the history and culture of the people of Santiago Atitlán. Speaking of the symbolism that highland Maya women incorporate into their woven textiles, Elena Ixk'ot remarked that "understanding and appreciation must take place within the context of community or all meaning is lost" (Otzoy 1996, 150). The imagery displayed on the altarpiece also is closely tied to the society in which it was created. When explaining the imagery in their work, the Chávez brothers often referred to myths and rituals unique to Santiago Atitlán and its people. These myths stress events set in the far-distant past when the gods and traditions of the community were first born.

Although the Santiago Atitlán myths are couched in language which seems to imply that they are based on historical fact (Atitecos accept them as real events rather than allegories), they are never tied to a fixed period of time. I spoke at length with Nicolás Chávez about the deer dance carved on the second of the lower narrative panels on the altarpiece. After he described the dance and its first appearance in the time of the ancient ancestors, I asked Nicolás how long ago these things took place. Without hesitation he said that the dance is as old as the world itself. Yet one of the ancestors he had named as a founder of the dance was Francisco Sojuel, a legendary Tz'utujil priest-shaman who in one way or another appears in myths about the origin of nearly all important aspects of Atiteco ceremonialism.[1] Nicolás had

[1] In this study I follow Barbara Tedlock's definition of "priest-shaman" as an individual involved in rituals that are community-wide in scope rather than those of primarily individual concern, such as healings (B. Tedlock 1982, 52–53).

mentioned that his father had been born only a few years after Sojuel's death and had known the great man's successor Marco Rohuch, a powerful priest in his own right. I asked if the world had begun so short a time ago. Puzzled over my concern for historical dates, he explained that the world has gone through many births as well as deaths. Each time the deer dance is performed, the world is created anew. (Carlsen and Prechtel also noted the Atiteco belief that the world was "born" not created [1994, 92]). For the Tz'utujils, the cosmos is conceived in living terms, undergoing birth and eventual death in endless cycles.

Atitecos are not really interested in when things happened in the past, but in how they relate to the present. The actions of divine beings and revered ancestors are recapitulated through ritual as a means of sacralizing the present and asserting the symmetry inherent in the passage of time. As Vansina suggests, absolute measurements of time do not exist in any of the world's oral traditions, unless based on recent memory: "Time was measured by the return of natural phenomena, by the occurrence of extraordinary events, by reference to human life span and reproduction, and by reference to the return of recurrent social events" (1985, 174). Yet, for the Tz'utujils, the lack of attention to historical dates also relates to their perception of time itself. Bricker notes that Maya ritual maintains a central focus on well-structured mythic events and these are not haphazard constructs of arbitrarily chosen historical precedents: the prophetic tradition of the Maya tends to blur the distinction between myth and history. In serving as a precedent, as a guide for human action, myth becomes just another event in history. But since the events in the corresponding parts of two cycles are never identical, the myth may acquire some new elements before it is eventually reintegrated into oral tradition (1981, 180–181). Bricker suggests that such temporal distortions are related to the nature of the highland Maya calendar, which stresses repetitive cycles rather than linear time. In this view, time for the Maya operates as an endless repetition of paradigmatic events connected with specific days during the year.

In Momostenango, Maya "daykeepers" continue to utilize the ancient ritual calendar of 260 days to time their rituals and offerings, as well as to interpret the significance of recent events (Schultze Jena 1954; B. Tedlock 1982). In Santiago Atitlán, the 260-day count has largely been replaced by the European variant of the solar calendar. But even though the Tz'utujils adopted a foreign calendar to

determine the timing of important ceremonies during the year, the structure of these ritual events remains to a great extent Maya in origin and structure.

The altarpiece at Santiago Atitlán provides a summary of the mythic deeds of gods and ancestors from long ago as they are revealed in the contemporary experience of the Tz'utujils. In this way all history is seen as a procession of repetitive events with different characters and circumstances, but always the same message. The world of the present is perceived as a shadow of things sacred and familiar. Mendelson wrote that the people of Santiago Atitlán explain new crises in terms of old ones. Events associated with the creation of the world are repeated again and again in times of conflict through living priest-shamans who carry out ancient rituals established by the first ancestors (1965, 93–94). When a Maya priest-shaman performs a ritual at the proper time and in the proper manner, he is able to re-create the world just as it was at the first dawn of time. As a result, Mendelson suggests, it is "difficult to expect history, only myths of first beginnings and the present. Between is just the passage of time" (1957, 416).

In Santiago Atitlán, as I will describe in greater detail later in this book, the world is given life and structure when the *nab'eysil* of the Confraternity of San Juan, a powerful priest-shaman, symbolically dies and resurrects in token of Martín, the patron deity of maize, deer, and the fertility of the earth. As part of the ceremony, the *nab'eysil* extracts the garments of the deity from a sacred bundle and wears them as he dances to the four cardinal directions to re-create the limits of the cosmos (Fig. 2.1). Following the performance of this dance, the *nab'eysil* sought me out to ask if I had seen "the ancient ancestors giving birth to the world." He explained that they had filled his soul with their presence as he danced, guiding him in his steps, and now everything was new again. In the eyes of the *nab'eysil* the dance was not a symbol of the rebirth of the cosmos but a genuine creative act in which time folded inward upon itself to reveal the actions of deity in the primordial world.

Barbara Tedlock prefers to characterize the Maya view of history as a dialectic of both cyclical and linear aspects in which the uniqueness of specific events is recognized but patterned to fit important precedents from similar events in the past (1982, 176–177). In this view, the Maya do not reject innovations and foreign influences outright but structure them in such a way that they resonate with older

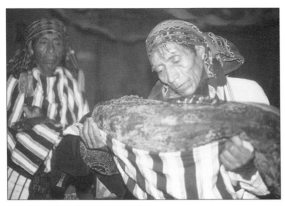

Fig. 2.1. The nab'eysil, *one of only two priest-shamans in Santiago Atitlán who are responsible for world-renewing rituals, dances with the sacred bundle of Martín. The head of the confraternity where the bundle is kept may be seen dancing behind him on the left. The bundle is believed to embody the power of deity to bring rain and provide abundant harvests.*

indigenous patterns. The process of Atiteco mythmaking is therefore one of accumulation, adding newer elements to older traditions rather than replacing them by substitution. Andrés Xiloj Peruch, a K'iche'-Maya daykeeper who collaborated with Dennis Tedlock in his translation of the *Popol Vuh,* suggested that "you cannot erase time" (D. Tedlock 1985, 13). Thus Francisco Sojuel, as the greatest of remembered culture heroes in Santiago Atitlán, is associated in tradition with otherwise anachronistic historic events. In popular myths, he may appear as a creator god at the beginning of the world, be killed and rise from the dead as a Christ figure to inaugurate aspects of Atiteco Easter observances, contend with the Spaniard king in Antigua soon after the conquest, or live a relatively mundane life as a farmer and community priest-shaman around the turn of the last century.

THE STYLE OF THE ALTARPIECE:
MAYA IDEOLOGY AND COLONIAL SPANISH FORM

There is little question that although significant elements of highland Maya culture survived the Spanish Conquest, virtually none of its sculptural or architectural heritage is evident beyond the first few decades of the sixteenth century. The introduction of Spanish rule and Christianity resulted in the abrupt suppression of indigenous art styles and many of its more public religious institutions. In a

paper pointedly titled "On the Colonial Extinction of the Motifs of Precolumbian Art," Kubler asserted that indigenous buildings, statues, paintings, and tools were so inextricably linked to the cultures that produced them that they became primary targets for destruction and replacement with more acceptable forms:

> In the sixteenth century the rush to European conventions of represen-
> tation and building, by colonists and Indians alike, precluded any real
> continuation of native traditions in art and architecture. In the seven-
> teenth century, so much had been forgotten, and the extirpation of
> native observances by the religious authorities was so vigorous, that the
> last gasps of the bearers of Indian rituals and manners expired
> unheard. (1961, 14)

Nonetheless, Kubler also recognized that a work of colonial art may be "European in form, yet Indian in meaning" (Reese 1985, 78). The juxtaposition of Maya and European imagery on the altarpiece at Santiago Atitlán involves for the most part the realm of ideas, rather than artistic style. Although these ideas are predominantly Maya in inspiration, pre-Columbian motifs are rare.

Archaeologists, looters, and centuries of neglect have taken their toll on the remnants of what was once the ancient Tz'utujil capital of Chiya', located across a narrow bay to the west of Santiago Atitlán (see Fig. 2.6). As a result, little of pre-Columbian Tz'utujil art and architecture survives beyond a few unexcavated mounds, small ceram-ic fragments, and roughly carved bas-relief designs on boulders scat-tered about the surrounding mountains (Fig. 2.2). These remnants are decidedly crude by Mesoamerican standards. Although the Chávez brothers are familiar with such artifacts (I visited a number of boulder sculptures in the region with Nicolás), neither claimed to have been influenced by them in their work.

The only element on the altarpiece that is directly borrowed from a pre-Columbian motif is the Maya maize god, paired images of which appear above each of the two sculpted Virgin Marys at either end of the lower tier of saints (Figs. 1.5 P, 2.3a, and 5.7). Diego Chávez recalled that the use of this motif was originally the idea of Father Rother, who wanted to use an ancient Maya symbol to represent the divine nature of God as the "bread of life." Yet this version of the deity is not carved in a local Tz'utujil style. The specific reference is from page 12a of the Yucatec-Maya Dresden Codex (Fig. 2.3b), although the

Fig. 2.2. One of several stones bearing petroglyphs near the ancient site of Chiya', the former capital of the Tz'utujils.

features are distorted and simplified. Diego said that he copied the motif from an old magazine article that he had long since thrown away. In any case, the Dresden Codex version of the maize god is common enough in Guatemala, appearing on tourist brochures, advertisements, and even money. A pair of similar maize gods flank the number "1" on the obverse of the one-quetzal note, the Guatemalan standard of currency (Fig. 2.3c). The motif is therefore a generic reference to the ancient maize deity that is immediately recognizable by Maya and non-Maya alike.

Kubler labeled the use of pre-Columbian motifs in postconquest art *indigenismo* and likened it to ninth-century Carolingian neoclassicism, in which long-forgotten Greek and Roman forms were revived in contemporary contexts. Kubler believed that inherent in this type of revival is a conceptual disjunction whereby "continuous form does not predicate continuous meaning" (Reese 1985, 353). To an extent this is certainly true of the Santiago Atitlán altarpiece's maize god design. After all, it was originally suggested by Father Rother as a Maya expression for a Christian idea. In general, however, the Chávez brothers avoided the use of pre-Columbian Maya motifs on the altarpiece precisely because they are not relevant to the specific history and culture of contemporary Tz'utujil society. Diego Chávez told me that he disliked the way weavers in town sometimes mimic a pseudo-ancient style to depict Maya warriors and gods rather than use traditional Atiteco designs that emphasize birds (Fig. 2.4): "What we weave for ourselves should come from our own people, not someone else's." The artists did not derive their ideas directly from ancient Maya sculpture or texts; instead they took their inspiration from living Atiteco society, which preserves ancestral practices.

Fig. 2.3. Maize god motif. The maize god was one of the most important deities among the ancient Maya. He oversaw the creation of the world, and his life paralleled the cycle of death and rebirth that characterizes all existence. (a) Maize god motif from the central altarpiece. (b) Maize god from Dresden Codex 12a. (Redrawn after Villacorta and Villacorta 1930.) (c) Maize god from the one-quetzal note, the standard of currency in modern Guatemala.

The themes the artists chose for the altarpiece reflect traditional Atiteco beliefs. They made little attempt to resurrect notions that were no longer current in their community. Because the ancient Tz'utujil form of expressing these ideas is extinct, the artists took as their stylistic models the art of the colonial era. This style of art was available and already familiar to them from examples in the local church as well as from old ritual paraphernalia kept in the confraternity houses. Where colonial precedents did not exist for ideas that they wished to present, the Chávez brothers developed their own innovative designs so as to avoid imitating styles foreign to the experience of their society. The absence of pre-Columbian motifs in their work does not, therefore, preclude the existence of an authentically Maya worldview or mode of expression. In contrast to Kubler's definition of *indigenismo*, the altarpiece at Santiago Atitlán does not represent a revival of anything, since this terminology implies the death of the referent civilization. The altarpiece is rather a reassertion of the living culture of the Tz'utujil people which continues to retain significant elements of their traditional Maya heritage.

In her discussion of the changes in the world of the Yucatec Maya following the Spanish Conquest, Farriss stressed that the adoption of foreign ideas does not preclude the survival of Maya culture:

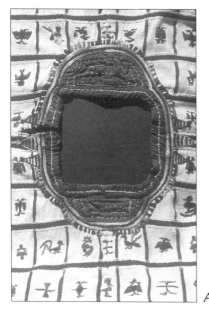

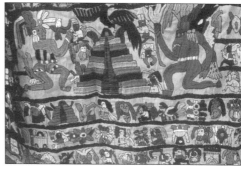

B

A

Fig. 2.4. Embroidered textiles from Santiago Atitlán.
Diego Chávez believes that Atiteco weavers should use
(a) traditional bird designs in their work, as on this
huipil (woman's blouse), rather than (b) the pseudo-
ancient designs now becoming popular among tourists
in the local markets.

*In Mesoamerica the immediate break with the past was only partial,
occurring primarily at the level of the larger state systems that were of
far less significance in the lives of most people than local cults and
local power structures. For the Maya we may speak of a degree of
cultural survival but survival of a particular sort. It is not the preser-
vation of an unmodified cultural system under a veneer of Spanish
customs, but the preservation of a central core of concepts and princi-
ples—a framework on which modifications were made. Cultural
configuration was transformed under Spanish influence but along
Maya lines and in accordance with Maya principles. Such durability
is possible only through creative adaptation—the capacity to forge
something new out of existing elements in response to changing
circumstance (1984, 8–9).*

The Chávez brothers utilized colonial Spanish forms and ideas in
their work because these are at least as much a part of their people's
heritage as those derived from their pre-Columbian ancestors. I do not
believe that the more anomalous a motif or religious practice is in
terms of orthodox Catholicism the more authentic it is as a survival
from the pre-Columbian world. There are no pristine remnants of

ancient Maya culture extant in modern Tz'utujil society. Over the centuries, Atitecos have incorporated selected elements of Catholic theology and artistic motifs into their culture, yet they do so without altering their fundamentally Maya view of the world. Mendelson noted that in his experience at Santiago Atitlán, "Indians hardly ever separate the Indian and non-Indian elements in their religion" (1957, 497).

In none of my discussions with Nicolás or Diego did either artist show any interest in distinguishing purely Maya ideas or motifs from the traditional Tz'utujil version of Catholicism. To them, their art simply reflects the way things have "always been done" in their community. This way of thinking is distinct from that of indigenous activists who recently have favored adopting names, artistic motifs, and other ancient cultural elements in order to construct an "authentic" pan-Maya identity (Fischer and Brown 1996; Fischer 1999). Such an approach is utilized today in Guatemala for the practical purpose of creating Maya political solidarity in the face of oppression by the ladino culture. The work of the Chávez brothers is of an entirely different sort. In reconstructing the altarpiece, Diego Chávez had no intention of modeling a new ethnic identity based on forms belonging to an ancient era untouched by European influence. With few exceptions, the motifs he chose for the altarpiece are based directly on cultural elements derived from traditional religious and social practices that are part of his own experience. These practices freely combine elements of Roman Catholicism and ancient Maya forms of worship.

PRE-COLUMBIAN TZ'UTUJIL HERITAGE

The pre-Columbian history of the Tz'utujils, for the most part heavily mythologized, is a popular topic of conversation in Santiago Atitlán. Nearly everyone I worked with had visited the ruins of pre-Hispanic settlements in the area at some time in their lives. The ancient capital of the Tz'utujil-Maya, Chiya', lies just northwest of the present-day town of Santiago Atitlán on the other side of a narrow inlet that extends south from the main basin of Lake Atitlán (Figs. 2.5 and 2.6). The easiest way to reach the site is by canoe or commercial launch, followed by a very steep climb up the side of a small hill which juts out into the water. The hill on which Chiya' stands is the remnant

of a secondary volcanic core at the base of the San Pedro volcano. The bulk of the visible ruins occupy a small area at the crest, known today as Chutinamit ("Atop the Citadel").

Samuel K. Lothrop partially excavated Chiya' beginning in 1928 and published the first archaeological report in 1933. Work was abruptly cut short, however, due to hostility from the local populace. John Fox made a survey of the site in 1972, dating its first major occupation to the Early Postclassic period (A.D. 1000–1200), when the acropolis structures were constructed (1978, 115–120). A central pyramid with stairways on all four sides dominated a large plaza at the site. (Cached bodies at the northwest corner of the structure suggest the practice of human sacrifice [Lothrop 1933, 75]). Smaller square and rectangular buildings lined the periphery of this plaza, setting it off from the slopes of the hillside below. The Late Postclassic phase of the site (A.D. 1200–1524) shows continuity with the ceramics of the earlier period, characterized by a carved ware with red-to-orange slip and a panel around the vessel containing heavy-line incised or carved decoration, often painted white (Lothrop 1933, 81–83; J. G. Fox 1978, 117). Yet this later occupation also evidences a new wave of lowland Maya influence, likely from the Tabasco-Veracruz area, corresponding to the influx of migrant warrior groups ancestral to the Tz'utujil hierarchy (J. G. Fox 1978; Carmack 1981; Orellana 1984).

According to native highland Maya texts such as the *Popol Vuh* and the *Annals of the Kaqchikels,* the Tz'utujils ruled one of three great kingdoms that dominated the Guatemalan highlands at the time of the Spanish Conquest, the other two belonging to the K'iche's and the Kaqchikels. Highland Maya tradition asserts that the legendary founders of these kingdoms left their original homelands and traveled eastward to the city of Tulan-Suiwa, where they received divine sanction for their right to conquer from a great lord named Nacxit (D. Tedlock 1996, 151–152; Recinos 1953, 58). As each lineage group arrived at the city of Tulan, it received a patron god who would accompany the group in its subsequent migrations. The god of the K'iche's was Tohil, associated with rain and thunder, who provided fire in exchange for human sacrifices. The god of the Tz'utujils was Saqibuk ("White or Pure Incense Smoke"). In addition, Nacxit gave to the dominant K'iche' lineage a sacred bundle called Pizom Q'aq'al ("Bundle of Flames"), containing tokens of power and authority (D. Tedlock 1996, 174–175, 193, 338; Chonay and Goetz 1953, 170).

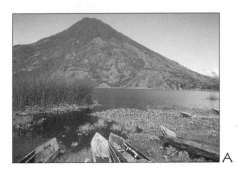

A
B

Fig. 2.5. (a) View of Chiya', the pre-Columbian capital of the Tz'utujils, as seen from across the bay. Many traditionalists believe that ancient kings continue to watch over their community and report seeing strange lights above the ruins late at night during times of crisis. (b) One of the unexcavated mounds at Chiya'.

Having received their individual investitures from Nacxit, the people gathered together and began their migration westward toward the Guatemalan highlands, likely following a route along the Usumacinta River (Carmack 1981, 45; Orellana 1984, 38; Hill 1992, 18). The leaders of the major lineages that left Tulan were both rulers and priests, able to perform great miracles. The authors of the *Popol Vuh* called them *ah k'ixib'* ("they of the spines"), suggesting that they bled themselves in honor of their gods, as well as *ah kahab'* ("they who dismember or tear"), meaning sacrificers (Christenson 2000, 134; D. Tedlock 1996, 149).

At length the lineages united near a mountain called Chi Pixab ("Place of Counsel"). This must have been some years after the progenitors left Tulan because the chronicles mention that the people had increased greatly in number and that there were many grandchildren (Recinos 1957, 37). It was here that the tribes received the names by which they were to be known upon arrival in the highlands of Guatemala, and "renewed their traditions and laws, naming and establishing captaincies" (Fuentes y Guzmán [d. 1699] 1932–1933, II.388, 392). Because the K'iche's and Tz'utujils had arrived at Tulan first, they dominated the confederacy and took the choicest lands (Recinos 1953, 49; Carmack 1981, 65–68; Orellana 1984, 39). The K'iche's took the area to the north, eventually building their capital at Q'umarkaj near present-day Santa Cruz el Quiché. The Tz'utujils took the southern territory bordering Lake Atitlán and extending to the rich cacao-growing lands of the Pacific Coast (Fig. 2.6). This settlement

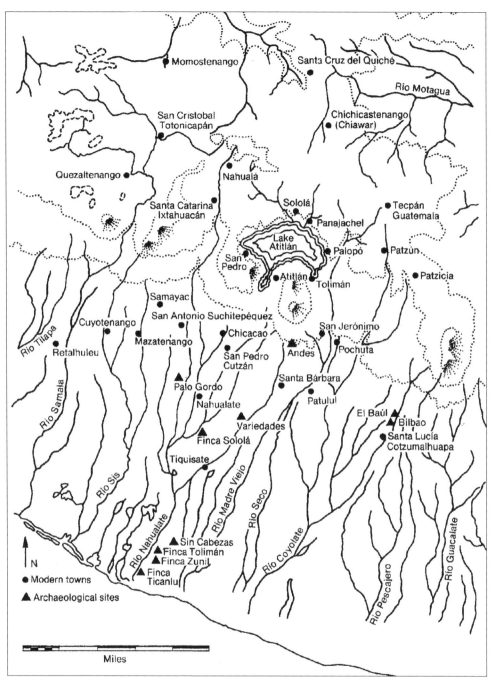

Fig. 2.6. Map of the Lake Atitlán region. Santiago Atitlán is located on the south shore of the lake, alongside a narrow inlet. Prior to the Spanish Conquest, the Tz'utujils controlled the rich cacao-growing fields along the coastal piedmont. (Adapted by Sandra Orellana [1984, Fig. 1] from McBryde 1947.)

The Altarpiece in the Context of Tz'utujil History 33

would correspond to the Late Postclassic phase of Chiya', beginning ca. A.D. 1200–1250 (Carmack 1981, 52; Orellana 1984, 36). Because they had arrived last at Tulan, the Kaqchikels took up an intermediate position between the K'iche's and Tz'utujils as a warrior class in the service of their more powerful neighbors.

The descendants of these warlike Maya bands slowly dominated the central highlands, eventually extending their influence from the Pacific Coast to the borders of the Petén rainforest. In the process, they took wives from the local populace and adopted their language and much of their culture. Thus, although the militaristic polities of the K'iche's and Tz'utujils were a relatively late creation, native highland Maya texts claim that they were heirs to a highly developed cultural tradition from both the highlands and the Gulf Coast lowlands that preceded them by at least two millennia.

After the separation of the highland Maya lineage groups at Chi Pixab and their occupation of the western highlands, there is no indication of any close political or military ties between the Tz'utujils and K'iche's. Carmack suggests that the confederacy between the two amounted to little more than agreement to respect the other's sphere of influence, affinal ties through bride exchange, and joint celebration of important religious ceremonies and accession rites at each others' capital cities (Carmack 1981, 68; Chonay and Goetz 1953, 185; Betancor and Arboleda 1964, 98).

Open hostility between the two groups began during the reign of the K'iche' ruler K'iq'ab', who extended his empire in part at the expense of the Tz'utujils. During the annual rites honoring the god Tohil at Q'umarkaj (ca. A.D. 1470), the Tz'utujils participated in an attempted coup against K'iq'ab'. Although the king survived, the incident severely weakened the K'iche's and inaugurated a prolonged series of disastrous wars. The ensuing conflict involved nearly all the highland Maya in a tangled web of rapidly shifting alliances and betrayals until the time of the Spanish Conquest in 1524 (Chonay and Goetz 1953, 188–189).

A serious revolt broke out at Chiya' on September 2, 1521, in which the heads of the preeminent Ahtziquinahay lineage, Tepepul Ahtziquinajay and Qitzihay, were expelled from their city by members of a secondary Tz'utujil lineage (Recinos 1953, 117–118). The banished lords appealed to the Kaqchikels at Iximche' for assistance and twelve days later the Ahtziquinahays were restored to their thrones. The

alliance between the lords of Chiya' and the Kaqchikels was short-lived, however, for soon afterward the Ahtziquinahays allied with a pretender to the Kaqchikel throne. Although the revolt was quickly put down, the resulting enmity between the two groups would prove disastrous a few years later when Spanish invaders turned the dispute to their own advantage. Years of interprovincial rivalries left the highland Maya unwilling or unable to settle their differences and present a united front against the Spanish threat.

SPANISH CONQUEST AND THE
SURVIVAL OF THE OLD HIERARCHY

Weakened by years of disastrous internecine wars, plague, and unusually poor harvests and drought, the kingdoms of highland Guatemala were reduced to a shadow of their former strength. It was in this state that Spanish conquerors found them.

Hernán Cortés, conqueror of the Mexica empire centered at Tenochtitlan, heard reports of rich lands to be had southeastward in what is today Guatemala. He sent his captain, Pedro de Alvarado, to subdue any resistance in that direction and to claim the area for Spain. The small invading force under Alvarado's command consisted of 120 cavalry troops, 300 infantry (armed with arquebuses, crossbows, swords, and bucklers), and 4 cannons (Hill 1992, 19). None of the men were regular troops of the Spanish Crown. Most were mercenaries in search of land and wealth. A contingent of several thousand Tlaxcalan allies from Central Mexico also accompanied the Spaniards during the Guatemalan campaign.

In his first letter to Cortés, Alvarado described Guatemala as "the wildest land and people that has ever been seen. . . . We are so far from help that if Our Lady does not aid us, no one can" (Alvarado 1946 [1524], 457–459). The K'iche's tried to arrange a hasty alliance with other highland Maya groups to meet the threat, but were rebuffed. The Kaqchikels ultimately allied themselves to the Spaniards, whereas the Tz'utujils replied that they could defend themselves without help.

According to the indigenous account of the confrontation contained in the *Títulos de la Casa Ixquin-Nehaib,* the initial conflict between the K'iche's and Spaniards involved magic rather than the force of arms:

> At midnight, the Indians went to fight with the Spaniards along with their captain who had transformed himself into an eagle. They came to kill Governor Tunadiu [Tlaxcalan for "sun," a title given to Alvarado because of his power as well as his blonde hair], but they could not because a very white young girl defended him; and although they desired greatly to enter the camp, when they saw this girl they fell to the ground and could not get up. Then they saw many birds without legs, and these birds surrounded the girl, and although the Indians wished to kill her, these birds defended her and blinded them. (Recinos 1957, 87–88; translation by author)

Bricker suggests that the young girl defending the Spaniards was the Virgin Mary and that the footless birds were doves representing the Holy Spirit (1981, 39–40). In the sixteenth century, Spaniards commonly carried tokens of Christianity into battle as a sign of God's favor and protection. The K'iche's may well have seen banners or even sculpted images of the Virgin in the Spanish encampment. A wooden sculpture of Mary now in a side chapel of the National Cathedral in Guatemala City was purportedly carried into battle by Pedro de Alvarado and may have been the one referred to in the chronicles (Freidel et al. 1993, 329). Regardless of the historical source of the legend, the K'iche' account interprets the battle as a conflict not of arms but of supernaturals, in which the divinities brought by the Spaniards triumphed over those of their own military leaders. This victory was decisive and led to the overthrow of the old order of Maya religion. The *Annals of the Kaqchikels* thus concludes its account of the battle with the statement that, until then, "the wood and the stone were worshiped" (Recinos 1953, 119). Afterward, the carved images of the Maya were replaced by images of Roman Catholic deities and saints.

Alvarado's description of the war makes no reference to supernatural events (1946 [1524]). The first major engagement between the K'iche's and Spaniards took place in the Valley of Xelajuj (modern Quetzaltenango) on February 22, 1524. On that day, the main body of ten thousand K'iche' warriors led by Lord Tekun Umam, the grandson of king K'iq'ab', attacked in force. The K'iche's, armed with bows and arrows, spearthrowers, obsidian-tipped lances, and obsidian-edged wooden clubs, were no match for the firearms and artillery pieces of the Spaniards, which could kill with devastating effect from long range. Nevertheless, the K'iche' description of the battle was again

couched in supernatural terms in the native chronicles. The account in the *Títulos de la Casa Ixquin-Nehaib* relates that Tekun Umam entered the fray as a divine lord with the power to transform himself into a bird of prey:

Then the captain Tekun rose up in flight, having transformed himself into an eagle covered with plumes that grew . . . of their own accord. They were not artificial plumes. He also bore wings that also grew from his body; and he wore three crowns, one was of gold, another of pearls, and the other of diamonds and emeralds. (Recinos 1957, 89–90; translation by author)

The text goes on to relate that Tekun Umam was able to get close enough to Alvarado to cut off the head of his horse with a single blow from his obsidian club. Soon after, however, Alvarado struck down his opponent with a lance. Once their leader had fallen, the forces of the K'iche's fell apart and were routed. Alvarado left the field wounded in one leg, which left him with a slight limp the rest of his life (*Isagoge Histórica* 1935 [ca. 1700], 335).

The Maya account of the conquest ends with the fall of Tekun Umam. Bricker suggests that this is because once the gods had been defeated, the fall of the K'iche' kingdom itself was inevitable and anticlimactic (1981:40). In his letter describing the conflict to Cortés, Alvarado mentions the battle as only one of several skirmishes, focusing instead on the later conflict at the K'iche' capital, Q'umarkaj (1946 [1524]).

Alvarado entered Q'umarkaj (called Utatlan by the Tlaxcalan allies of the Spaniards) without resistance on March 7, 1524, at the invitation of the K'iche' kings Oxib' Kej and Belejeb' Tz'i'. Once inside the city, Alvarado suspected a trap and ordered the arrest and execution of its rulers:

As I knew [the K'iche' kings] to have such ill will toward the service of His Majesty, and for the good and tranquility of the land, I burned them, and I commanded to be burned the town of Utatlan to its foundations, for it was dangerous and strong. . . . All they that were taken prisoners of war were branded and made slaves. (Alvarado 1946 [1524], 458; translation by author)

Whether Alvarado's suspicion of treachery was well founded is not known, although it is entirely possible that the K'iche's would try any available means to save their city against invaders with superior armaments. The *Annals of the Kaqchikels* merely recorded that "the heart of Tunatiuh [Alvarado] was without compassion for the people during the war" (Recinos 1953, 120). In his *Very Brief Account of the Destruction of the Indies*, composed between 1540 and 1542, Fray Bartolomé de las Casas wrote that the K'iche' lords were executed for failing to satisfy Alvarado's demand for gold, which is rare in Guatemala, and described the subsequent ill treatment that other highland Maya groups received at his hand:

> *Guiltless of other fault and without trial or sentence, he immediately ordered them to be burned alive. They killed all the others with lances and knives; they threw them to savage dogs, that tore them to pieces and ate them; and when they came across some lord, they accorded him the honour of burning in live flames. This butchery lasted about seven years from 1524 to 1531. From this may be judged what numbers of people they destroyed. . . . He and his brothers, together with the others, have killed more than four or five million people in fifteen or sixteen years, from the year 1524 till 1540, and they continue to kill and destroy those who are still left; and so they will kill the remainder. (MacNutt 1909, 352–353)*

Fig. 2.7. "The Battle of Tecpán Atitlán" as depicted in the Lienzo of Tlaxcala. This painting gives some idea of the dress and weapons utilized by the highland Maya of the Lake Atitlán region at the time of the Spanish Conquest. (From Orellana 1984, Fig. 8.)

Although Las Casas' estimates of the death toll caused by Alvarado and his brothers in Guatemala are likely exaggerated, they are not wildly inaccurate if disease and malnutrition are taken into consideration. Similar depopulation took place among the Tz'utujils. In 1524 the population of the Tz'utujil kingdom was 48,000, including 12,000 male tributaries. By 1585 this number had fallen precipitously to the point where only 1,005 tributaries remained (Betancor and Arboleda 1964 [1585], 95; Orellana 1984, 142). Betancor and Arboleda attributed this depopulation to disease and mistreatment by Spaniards following the war:

And many Indians from this town [Santiago Atitlán] died in the war, while others died in the gold mines. And those Indians that went to the mines were taken by the Spaniard encomenderos *who administered this town at that time. And according to the Indian lords, there were 240 Indians taken for the mines every ten days. Others died of smallpox, measles, fever, blood which ran from their noses, and other epidemics and labor that they were subjected to. . . . For this cause the population has diminished because of the great labors that they were required to pay, since the Spaniards used them as burden carriers in their fields and estates. And for this reason, due to the wars and the illnesses, there are few Indians left, having reached the number that remain today. (P. 95; translation by author)*

After the fall of Q'umarkaj, Alvarado and his army set up a temporary camp of occupation at Iximche', the capital city of his Kaqchikel allies. There Alvarado inquired whether there were any other enemies that needed to be pacified. In response the Kaqchikel rulers indicated that the nearby Tz'utujils were a dangerous people who had waged war on them many times in the past. Three embassies of messengers sent to Chiya' to negotiate a peaceful surrender were killed outright, prompting Alvarado to invade in force with 60 cavalry, 150 Spanish infantry, and several thousand Kaqchikel and Tlaxcalan allies (Alvarado 1946 [1524], 460; Orellana 1984, 113; Carlsen 1996, 142). East of present-day Santiago Atitlán, the Tz'utujils formed a defensive line against the attack, which was quickly broken up by Spanish crossbowmen. Some of the defenders were able to escape by jumping into Lake Atitlán and swimming to a nearby island. Others

were slaughtered by the late arrival of 300 Kaqchikel war canoes. The battle is commemorated in the Lienzo of Tlaxcala, painted soon after the conquest (Fig. 2.7).

That evening, Alvarado and his troops spent the night in a maize field and prepared for a siege of the capital the following morning. Chiya' is protected on three sides by water and the remaining approach to the west abuts the slopes of a volcano, making it easily defensible from hostile attack. The lords of Chiya', however, had apparently seen enough to know that defeat was inevitable and abandoned the city without a fight (*Isagoge Histórica* 1935 [ca. 1700], 364). Alvarado sent several captured Tz'utujils into the mountains to invite the fleeing inhabitants to return to their homes under the promise that they would not be harmed. But if they did not return, he threatened to continue hostilities, burn their towns, and destroy their maize and cacao fields. Within three days the ruler of Chiya', Joo No'j K'iq'ab', declared fealty to the Spanish king, commending Alvarado for his skill in war and noting that until that day, "his land had never been conquered, nor had anyone entered her under force of arms." (Alvarado 1946 [1524], 460). The Tz'utujil lord presented the victor with abundant gifts of tribute and promised that he would never again resume hostilities.

Despite the Tz'utujils' reputation as fierce warriors with a penchant for shifting alliances, the ruler of Chiya' never rebelled openly against the Spaniards. The Lake Atitlán region remained one of the most pacific in the country. This lack of aggression is unusual, considering the succeeding decades of forced labor and exorbitant tribute demands that drove other Spanish "allies" to take up arms (*Relación de los caciques* 1952 [1571], 436).

García Peláez suggested that tribute demands were almost as devastating to the Maya as the conquest itself: "The Indians that escaped slavery in the war, were subjected in peace to tribute, and the tributaries given in *encomienda* to the conquistadores, under whose power slavery, tribute, *encomiendas*, confiscation, exile, and death were all one and the same in peace and war" (García Peláez 1943 [1851], 81 [translation by author]; see also Ximénez 1929–1931 [1722] 3, 62).

The Kaqchikels responded more violently to Spanish demands. Soon after the defeat of the Tz'utujils, Alvarado demanded that his former allies at Iximche' deliver piles of gold in tribute, including all

their precious vessels and crowns (Recinos 1953, 123–133). When they did not bring what he asked for immediately, he threatened to torture and burn the kings alive, just as he had done with the K'iche's. After only half of the tribute requested could be gathered, "a man, an agent of the devil, appeared and said to the kings: 'I am the lightning. I will kill the Spaniards; by the fire they shall perish. When I strike the drum, depart [everyone] from the city'" (ibid., 124). Alvarado enlisted Tz'utujil troops to help quell the ensuing five-year insurrection, during which Iximche' was razed. Although the Kaqchikel kings finally surrendered and were given a pardon for their actions, the Spaniards ultimately hanged the Kaqchikel king Ahpozotzil Cahi Imox anyway "because [the Spaniards] were angry" (ibid., 132–133).

In gratitude for his help in quelling the insurrection, Alvarado allowed king Joo No'j K'iq'ab' to remain as the *cacique* at Chiya'. A *cacique*, the colonial Spanish title for a native ruler, was exempt from tribute and labor obligations. Spanish law considered *caciques* to be the direct vassals of the Crown, not subject to the orders of local governors or military administrators. Those who proved their loyalty to the king were also allowed to use the Spanish title *don*, own and ride horses, display a coat of arms, and possess weapons.

At some point after the conquest, the Tz'utujil king adopted the name don Pedro. He remained in power at Chiya' until his death, when his son don Juan acceded in his place (r. 1540–1547). In 1630 the aged *cacique* of the Tz'utujils was don Bernabé, who had in his possession a painted *lienzo* cloth showing his grandfather, Joo No'j K'iq'ab', greeting the first Spaniards with gifts (Orellana 1984, 168). The office of *cacique* thus remained in the old ruling family well into the seventeenth century, preserving much of the preconquest power structure without serious disruption.

Due to the violence and ruthlessness of the Spanish Conquest under Pedro de Alvarado, few highland Maya kings survived to fill the role of *cacique*. Alonso López de Cerrato, who came to power as colonial governor of Guatemala in 1548, instituted reforms aimed at imposing legitimate Spanish law and easing the tribute and labor requirements for the Maya. He lamented that "when the Spaniards entered this land, they killed some *caciques* and removed others from their thrones to such an extent that in all this province there is almost no natural nor legitimate *cacique*" (*Relación Cerrato* in Carmack 1973, 379). The orderly continuation of an unbroken sequence of Tz'utujil lords after the Spanish Conquest is thus exceptional among the highland Maya.

The surprising degree of conservatism in Tz'utujil society and religion compared to many other highland Maya communities may in part stem from this early colonial political arrangement. While the lords who ruled the major K'iche' and Kaqchikel lineages were tortured and executed at the hands of the Spaniards, and their capital cities burned, Alvarado left the Tz'utujil ruling dynasty intact to administer its affairs much as they had done prior to the conquest. It is likely that the Tz'utujils considered this a sign of divine favor and were thus less susceptible to radical shifts in their indigenous worldview. Maya rulers claimed to be the embodiment of divine power to act in earthly affairs, a belief that alarmed Spanish authorities. In 1552, López de Cerrato wrote a warning that native *caciques* like don Pedro wielded tremendous religious as well as political power over their subjects and could prove dangerous if they were to rebel, "because anciently they revered [the *caciques*] as gods, and if this persists, the lords could raise the land easily" (Carmack 1973, 379).

The survival of the Tz'utujil king and his continued dominance in Chiya', where the old temples still stood, must have seemed a confirmation to the local populace that the old order continued to hold relevance in postconquest society. In other regions the shock of the conquest was far more violent and abrupt, perhaps making the adoption of Roman Catholicism more compelling as a way to fill the vacuum. Remesal noted that the death of the K'iche' kings was a devastating blow which continued to have an impact long after the fall of their capital (1964 [1617], 81). The fate of the K'iche' and Kaqchikel kings and their cities not only broke up the old political order, but attested the powerlessness of their patron gods to save them from destruction. The Tz'utujil gods did not suffer the same humiliation.

THE EARLY COLONIAL PERIOD AND THE FIRST EVANGELIZATION EFFORTS

Father Remesal wrote at the beginning of the seventeenth century that Alvarado and his followers initiated the conquest of Guatemala to accomplish four purposes—to enlarge the domain of Spain, to extend the Catholic faith, to achieve immortal fame, and to enrich themselves (1964 [1617], 81). There is nothing to indicate, however, that there were any serious attempts to convert the highland Maya during the first years after the Spanish Conquest. In his letters to

Cortés, Alvarado mentions that he planned to attack the Tz'utujils "to bring the Infidels into the service of his Majesty," the king of Spain (1946 [1524], 460). After the fall of Chiya', Alvarado wrote that he received the lords from the Lake Atitlán region after his victory and "made them know the greatness and power of the Emperor, and that he pardoned them if they would be good and not make war with any in the region as they were now vassals of His Majesty" (ibid.). Alvarado's writings make no mention of religious indoctrination, nor did missionary priests accompany his troops. When the Tz'utujil ruler was baptized, he took his new Christian name, don Pedro, but Father Ximénez doubted that this took place when Alvarado invaded Tz'utujil territory. He suggested that the baptism took place several years later when the first missionaries arrived in Guatemala (Ximénez 1929–1931 [1722], 128).

For many years following the initial conquest, there seems not to have been a regular Spanish presence in Chiya' at all. Pedro de Alvarado assigned half of the Tz'utujils' tribute payments to himself and the other half to Sancho de Barahona el Viejo in the form of an *encomienda*, an institution whereby the Crown authorized Spaniards who participated in the conquest to collect tribute and demand labor from the Indians in return for services such as military duty and providing for the spiritual welfare of Indians under their control (Orellana 1983, 137). Following the deaths of Pedro de Alvarado and his wife, the king of Spain seized their half of the Tz'utujil payments, while the Barahona family continued to receive tribute into the seventeenth century (Carlsen 1997, 89). But Sancho de Barahona and his descendants never resided in Tz'utujil lands, and the *cacique* don Pedro was free to administer his former kingdom as he saw fit, so long as the tribute payments were delivered without incident. Although these financial demands were often exorbitant, Carlsen suggests that the Tz'utujil may have considered them a tolerable payoff to deter Spanish meddling in their political affairs as long as the land and means of production remained in their hands (1996, 147).

Spanish influence in matters of religion declined further in the first decades after the conquest. During this early period, it was left to the Spanish conquistadors who held *encomiendas* to indoctrinate the Maya in the Catholic faith. Yet, despite their legal obligations, the Barahona family made no serious attempts to convert the Tz'utujils in their charge, and even refused to contribute funds to build a church in Santiago Atitlán (*Relación de los caciques* 1952 [1571], 437–438). Fray

Bartolomé de Las Casas decried the policy as a failure everywhere in the New World, asserting that most *encomenderos* failed to keep their religious obligations, being themselves vicious and woefully ignorant of even the most basic tenets of the Catholic faith. He cited the case of one Juan Colmenero who held a large Maya town in *encomienda* in exchange for his promise to be the pastor for the people there: "He who, when he was examined by one of our friars once, did not know how to make the sign of the cross, and when asked what he was teaching the Indians of his town, answered that he gave them to the devil" (Las Casas 1971, 176–177; translation by author). In another instance, Las Casas reported that in a certain province the Maya voluntarily surrendered their "idols" to the Christian friars, only to have the local *encomendero* cart in loads of replacements from other regions to their market to sell and barter them in exchange for slaves (p. 177).

Roman Catholicism was not formally established in Guatemala until 1534, when Bishop Francisco Marroquín arrived in the Spanish capital city of Santiago de los Caballeros, recently founded by Pedro de Alvarado. Over the next few years, Marroquín sent a few missionary friars with portable altars to the various Indian towns and villages to baptize the inhabitants and destroy any remnants of "idolatry" and "paganism" which might have survived. These evangelization efforts focused on the *caciques* and other native leaders in the hope that they would set an example for the rest of the people. (The Tz'utujil king was probably baptized in conjunction with one of these early missionary forays.) Baptism was a necessary step for any Maya of noble birth who aspired to a place in the new political order, since without it the Spanish authorities would not recognize their legitimacy or territorial claims. In addition, baptism afforded some protection from the excesses of Spanish rule. Without it, unconverted natives were subject to enslavement until the reforms of Governor Cerrato abolished the practice after 1548.

Early Maya converts probably understood baptism as no more than a vague acknowledgment of the power of the new Christian divinities and a promise to incorporate them into their worship. The missionary friars might have intended them to understand it as a renunciation of the old Maya gods, but it is doubtful that they did. As Cervantes writes, "the initial enthusiasm of the Indians to accept Christianity had more to do with the Mesoamerican tradition of incorporating alien elements into their religion than with any conviction about the exclusivist claims of the Christian faith" (1994, 42). Fray

Gerónimo de Mendieta complained at the end of the sixteenth century that native forms of worship continued unabated in his parish despite the Indians' acceptance of Christian deities:

And among the idols of the devils were found as well images of Christ our Redeemer and of Our Lady, that the Spaniards had given them, thinking that with them they would be content. In addition if they had 100 gods, they would want 105, and more if they were given more. And as the friars sent them to make crosses and place that at all crossroads and entrances to their towns, and in some of the tall hills, they placed under or behind these crosses their idols. And pretending to worship the crosses, they did not worship them but rather the figures of demons which they had hidden. This after their own sanctuaries and public idols were destroyed. (Mendieta 1993, 233–234; translation by author)

None of the first missionaries to Chiya' spoke the Tz'utujil language, making the indoctrination of those to be baptized highly questionable. Nor did the missionaries remain in one place for long periods of time. Orellana contends that few Tz'utujils were converted by the first Roman Catholic priests, and when they moved on, the bulk of the population continued to practice their native religion as before (Orellana 1984, 195). Early efforts to evangelize the Tz'utujils resembled in many ways the military conquest of the region—a brief show of force to establish predominance and secure the fealty of the ruler, followed by long periods of relative noninterference.

CONGREGATION OF SANTIAGO ATITLÁN

To aid in the process of conversion, Spanish missionaries initiated the consolidation of formerly scattered highland Maya settlements into large nucleated centers in a process called "congregation." In a letter to the king of Spain, Bishop Marroquín insisted that this was essential to facilitate the Maya's indoctrination in the Christian faith since "in the Province of Guatemala, the greater part is mountainous with houses being very far apart" (Estrada Monroy 1979, 116). This made it impossible to reach everyone. Congregation also solved administrative problems related to the collection of tribute and tithes. Spanish settlers supported the policy because it assigned restricted territorial limits to Indian lands, making room for the expansion of

their own estates. Unfortunately, the crowded conditions of the newly congregated cities also created an ideal environment for the rapid spread of disease, while the constriction in available land for cultivation fostered famine and malnutrition.

Because the older fortified center at Chiya' was difficult to reach and too small to accommodate a large population, in 1547 a new town was founded at its present location across the bay. At first the settlement bore the same name as the older abandoned center, Santiago Chiya'. Like most other Guatemalan Indian towns, however, Spanish authorities ultimately adopted the Tlaxcalan translation of the Maya toponym in their records. By at least 1585 the town was called Santiago Atitlán, the latter name being the Tlaxcalan translation of *chiya'*, meaning "by the lake."

The congregation of Santiago Atitlán was carried out by two Franciscan missionaries, Fray Francisco de la Parra and Fray Pedro de Betanzos, who gathered Tz'utujils from the old capital at Chiya' as well as from numerous settlements along the southern shores of Lake Atitlán and the surrounding mountains. In a letter to Phillip II, Fray Betanzos described the Indians he helped bring to the new city as "elusive and frightened," suggesting a degree of reluctance on the part of the Tz'utujils to abandon their traditional homelands (Orellana 1984, 122). The Franciscans founded a monastery next to the church for the use of future missionaries, although there were apparently no resident priests in town until the arrival of Fray Juan Alonso and Fray Diego Martín in 1566.

The process of congregation followed a uniform pattern throughout Guatemala (Betancor and Arboleda 1964 [1585]; García Peláez 1943 [1851], 161–166). First, at the center of the proposed site a church was erected, fronted by an open plaza or *atrio* where large assemblies could gather for public ceremonies and indoctrination. The rest of the town was organized into squares divided by streets laid out to the cardinal directions. While the new settlement was under construction, families planted their maize on plots the Spaniards assigned to them in the nearby countryside. When the crops were ready to harvest, the older pre-Columbian structures were destroyed to prevent reoccupation, and the people moved into their new homes. Christian missionaries staged elaborate dances and festivals to celebrate the event "so that they would forget their ancient dwellings" (García Peláez 1943 [1851], 163).

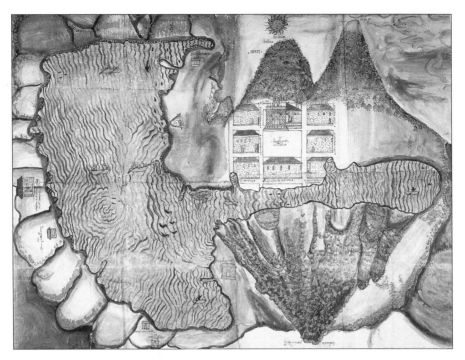

Fig. 2.8. In this beautifully painted map of the recently congregated town of Santiago Atitlán, the town itself is shown nestled at the foot of three great volcanoes. The main body of the lake may be seen on the left, dotted with fishing boats. A whirlpool marks its center, perhaps reminiscent of the turbulent waters from which the world emerged at the time of creation in Atiteco myth. Even today, vortices in the lake are considered portals to the place where creator deities live. (Courtesy of the Nettie Lee Benson Latin American Collection, General Library, University of Texas at Austin.)

Santiago Atitlán follows the general plan of most major Maya congregated communities in the sixteenth century, although because of the irregularity of the terrain the Spanish arrangement of streets set at right angles to form squares extends for only a few blocks around the central district. The town is situated on a lava terrace which rises from a narrow arm of Lake Atitlán toward the slopes of two great volcanoes to the east. A third volcano dominates the western horizon above the ruins of Chiya' to the west. A map of the town drawn about 1585 shows the central district as it existed a few decades after congregation, with its church occupying the central position, along with a monastery for visiting missionaries (Fig. 2.8).

The intensive building and missionary efforts in Santiago Atitlán in the half century following congregation ended soon after the close

of the sixteenth century. Carlsen suggests that one of the major reasons for the Spanish presence there was to exploit Tz'utujil cacao orchards in the coastal piedmont (1996, 144). When the cacao industry collapsed a few decades later, there was no longer an incentive to remain and the Franciscans eventually moved on to more economically stable communities. It is also likely that the rapid drop in population at Santiago Atitlán during the sixteenth century made it unable to support the financial needs of a monastery of full-time mendicant priests. After they left, the church and abandoned monastery fell rapidly into disrepair. By 1683 the Tz'utujils submitted requests to withhold a portion of their tribute to help pay for repairs, although their application was denied (Orellana 1984, 200). For more than 350 years, Santiago Atitlán was without a resident priest and relied on sporadic visits by visiting clergy from other communities to conduct Mass and administer the sacraments. In 1964, following decades of conflict with Guatemalan-born priests over matters of traditionalist worship practices, the archdiocese of Oklahoma City adopted the town. Four years later Father Stanley Francisco (often called Apla's, the Tz'utujil variant of Francisco) Rother of Okarche, Oklahoma, arrived to serve as parish priest.

CHAPTER THREE

The Sixteenth-Century
Church and Its Altarpieces

The foundations of the present church at Santiago Atitlán were laid in 1570 and the building was completed in 1582 (Figs. 3.1 and 3.2a). Within three years, five resident priests were living in the monastery under the leadership of Fray Pedro de Arboleda. The church is one of the oldest in Guatemala and is unusually well constructed of stone masonry with a plastered floor. The original roof consisted of a wooden framework covered with tiles (*Relación de los caciques* 1952 [1571], 437). Father Rother replaced the older roof with corrugated metal soon after the 1976 earthquake.

The plan of the church is consistent with the most common of sixteenth-century designs, consisting of a single continuous nave and no side aisles or transept (Fig. 3.2b). The altar (O) is set well out in front of the eastern wall of the apse so that the priest may face those attending Mass while preparing the Eucharist, with the main altarpiece serving as a monumental backdrop. Such single-nave churches were part of the sixteenth-century Spanish reform movement to return to the simplicity of the apostolic age (Kubler 1948, 2:239–242; Peterson 1993, 153).

Because the Barahona family refused to assist in the construction of the church, the entire cost in labor and materials appears to have been supplied by the Tz'utujils themselves (*Relación de los caciques* 1952 [1571], 437–438). Although a burden financially, this provided a certain degree of autonomy, allowing the Maya to incorporate traditional Maya dedicatory offerings into the fabric of the new building. During renovation efforts in the church complex carried out under Father Rother, workmen discovered remnants of a pre-Columbian platform

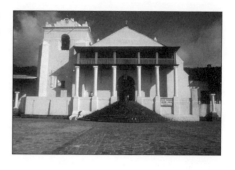

Fig. 3.1. Church at Santiago Atitlán, west façade. It is one of the oldest churches in Guatemala, construction beginning about 1570.

beneath the foundations of the church, indicating that its original builders followed the common New World precedent of building Roman Catholic churches over native shrines (Farriss 1984, 309; Wagner 1997, 3). Stones from the older temple were likely incorporated into the walls of the new church. In this way, missionaries hoped to demonstrate the victory of Christianity over heathenism while preventing the Maya from using the space to perform their ancient rites. But even today, amid the ruins at Chiya' a number of simple altars are set up where Tz'utujils openly leave offerings to the old kings and their deities without interference from Catholic authorities.

It is unlikely that the Maya would perceive the construction of a new church over the remnants of one of their temples as the permanent death of the old gods once worshiped there. It was a rather common practice among the ancient Maya to periodically demolish their pyramid temples and build over them, maintaining the sanctity of the space while reinforcing its power with ever-grander constructions. Beneath the floors of each successive structure the Maya placed caches or elite burials containing precious objects from the previous phase to ensure the continuation of temple's efficacy according to sacred precedent.

While shoring up the foundation of the belltower at the northwest corner of the church at Santiago Atitlán, one of the workers discovered a carved stone box containing a human skull, a few pieces of jade, and a triangular-shaped obsidian piece with an incised design. A Tz'utujil *ajkun* ("shaman") remembered the obsidian object and identified it as an *ilb'al* ("instrument for seeing"), which he said the ancestors utilized to divine the future. Identical boxes with skulls and bits of jade and obsidian were later discovered at the other three corners, apparently buried at the time of the church's construction as foundation caches. Other pieces of carved jade were found in association with a skeleton

found beneath the stones of the stairway leading to the church's west entrance. Many Atitecos are aware of this burial, having come to see it when it was uncovered. Nicolás told me that local tradition claims the skeleton to have been a woman sacrificed to the old gods so that they would not die when the church was built, and that she is called *ruk'u'x qmuq, ruk'u'x iglesia* ("heart of the steps, heart of the church"). Local shamans sometimes list her in prayers when entering the church to carry out their ceremonies.

There are numerous stories current in Santiago Atitlán of other elaborate burials and pre-Columbian stone carvings found beneath the church floor and the adjacent *convento* complex to the north.[1] Many of the stories are likely apocryphal, describing perfectly preserved Tz'utujil kings wearing elaborate feather costumes trimmed with gold and jade and guarded by snarling jaguars or hissing serpents. As in other Guatemalan churches, however, important persons were certainly buried beneath the floor stones for centuries, a practice which continued until almost the 1950s in Santiago Atitlán before local officials prohibited it (Mendelson 1957, 542).

Whenever Atiteco workmen discover such caches and burials at Santiago Atitlán they quickly rebury them in place, making it impossible to confirm their existence, much less the original circumstances of their interment. What is important for the purposes of this study is that contemporary Tz'utujils consider them to be dedicatory offerings which hearken back to the foundation of the church in the sixteenth century. The community church therefore bears perceived power derived from the ancient Tz'utujils through human sacrifice and the cacheing of ritually charged objects that echo Maya rather than Roman Catholic concepts of sanctity.

THE COLONIAL-ERA ALTARPIECES AND THEIR CHRISTIAN SYMBOLISM

Although exactly when the three monumental altarpieces in the Santiago Atitlán church were carved is unknown, their baroque columns and florid style suggest a date no earlier than the seventeenth

[1] The church at Santiago Atitlán once stood at the center of a monastery complex. The old cloister, now surrounded by offices, chapels, and the sacristy, is still commonly known as the *convento*.

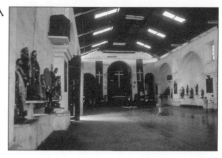

A

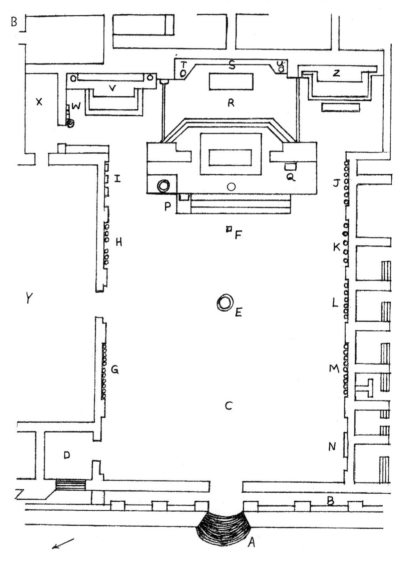

Fig. 3.2. Interior of the church. (a) The three great altarpieces may be seen through the archways at the east end of the nave. Atitecos link these three monuments with the three volcanoes that surround the city. (b) Plan of the church.

Art and Society in a Highland Maya Community

Figure 3.2b Key

A West stairway and entrance
B Porch corridor
C Nave
D Baptistry
E Stone baptismal font
F "World Center" hole
G Saints, Confraternity
of San Juan
west to east:
Christ the Nazarene
St. John the Apostle
St. John the Baptist
Mary Salomé
Child Jesus
Mary of the Maize Twins
St. Simon the Ancient
St. Bartholomew
St. Pascual
Apostle Damian
H Saints, Confraternities of
San Francisco/San Antonio
west to east:
St. Francis
St. Isteo
Christ of Palm Sunday
St. Pascual
St. Anthony
King St. Gaspar
I Glass Cases containing
images of:
Christ of Glory
Black Saint
Virgin of the Conception
J Saints, Confraternity
of San Rosario
east to west:
Eternal Father
Jesus of Glory
?
Apostle Saint the Guardian
Mary of Jesus
Mary of Candlemas
Mary of the Rosary

K Saints, Confraternity
of San Nicolás
east to west:
St. Linus
St. Rufin
St. Nicholas
St. Martin of Tours
St. John the Baptist
L Saints, Confraternity
of San Felipe
east to west:
Licenciado St. Peter
St. Christopher
St. Philip of Jesus
?
Divine Christ
St. Jerome
M Saints, Confraternities
of San Juan/San Gregorio
east to west:
St. Francis
St. John the Lesser
St. John the Great
St. Julian
St. Martin of Tours
Holy Father
Saint Lord of the Sea
St. Gregory
St. Pastor
N Memorial to Father Rother
O Altar
P Pulpit
Q Priest's Chair
R Apse
S Central Altarpiece (Retablo)
T Image of "Christ the Nazarene"
U Image of "God the Father"
V Left Altarpiece (Retablo)
W Great Cross
X Sacristy
Y Convent Complex
Z Right Altarpiece (Retablo)

Fig. 3.3. Left altarpiece of the church: (a) photograph, (b) drawing. The principal image on this monument is a life-sized sculpture of Cristo Sepultado *("Entombed Christ") wrapped in blankets in a glass case below the crucifix. Atitecos appeal to this image for many of their most pressing needs, tapping on the glass periodically to ensure that he is awake and paying attention to their petition. During Holy Week, the image is removed and its moveable arms are nailed to a great cross located to the left of the altarpiece.*

A

century. By that time Santiago Atitlán had no resident priest, and calls for funds to repair and decorate the church went unheeded by authorities in Guatemala City. Most likely, therefore, the Tz'utujils either carved the altarpieces themselves under the direction of visiting priests or commissioned them with local funds. This procedure was typical for the early colonial period, as the writings of the Franciscan friar Gerónimo de Mendieta (d. 1604) tell us:

> *Who built the many churches and monasteries in which the friars reside in this New Spain if not the Indians with their own hands and sweat and with such willingness and joy as if they were building houses for themselves and their children? . . . And who provided the churches with ornaments, silver vessels and all other decorations and embellishment, if not these same Indians? (1993, IV.xvii.422; translation by author)*

The central altarpiece reconstructed by the Chávez brothers is the largest of three great carved wood monuments that dominate the apse of the church. It stands approximately 8.06m. high and 6.507m. wide, with four tiers of niches containing removable images of saints set in an architectural framework of twisted and foliated columns (Figs. 1.3–1.5). The niches decrease in height from bottom to top, perhaps to

B

exaggerate the monument's size by making the upper saints appear to recede into the distance. Nude putti at the base of the monument appear to support the superstructure in a manner analogous to angels holding up the clouds of heaven in contemporary European paintings and prints. The architectural columns separate the saints' niches and draw the eye vertically toward the upper levels, a function characteristic of "pillars of heaven."

The other two altarpieces stand against the back wall in side chapels to the north and south of the apse. All three are visible from the principal entrance at the west end of the nave and are meant to be seen as a group. The Franciscans who founded the church and continued to oversee the region during the colonial period likely intended the altarpieces to represent the Holy Trinity. God the Father occupies the preeminent position at the top of the central altarpiece. The left (north) altarpiece (Fig. 3.3) is dominated by two life-size images of Jesus Christ; one is a crucifix and the other lies in a wooden sepulcher with a glass front. The latter has moveable arms and is nailed to an immense cross during Easter Week.

The right (south) altarpiece is dedicated to the Holy Spirit as the third member of the Trinity (Fig. 3.4). The central image of this monument is María Concepción (Mary of the Conception) holding the infant Christ, recalling the declaration of the angel Gabriel to the Virgin that "the Holy Ghost shall come upon thee, and the power of the Highest shall overshadow thee: therefore also that holy thing which shall be born of thee shall be called the Son of God" (Luke 1:35). The association of the Holy Spirit with María Concepción is confirmed by another image of the Virgin with the same title kept in a glass case to the left of the raised altar. In this version, she holds the dove of the Holy Spirit to her breast instead of the Christchild.

RECONSTRUCTION OF THE CENTRAL ALTARPIECE

Soon after his arrival in 1968, Father Rother instituted badly needed repair and reconstruction work in the church and adjoining *convento* complex to the north. A severe earthquake in 1960 heavily damaged the belltower, roof, and many of the carved wooden altarpieces and nave decorations in the church. After the most serious structural problems were repaired, Father Rother initiated plans to renovate the three altarpieces. The two side altarpieces required only

minor work to reattach fallen pieces and reinforce some of the wood frames which had warped and cracked with age. The huge central altarpiece had suffered the most damage in the earthquake, having fallen over and shattered in a number of places. The pieces were removed from the church soon after the collapse of the monument and left stacked along with other broken fragments in various storage rooms in the parochial complex.

Father Rother was familiar with the work of the Chávez family, who were the only professional sculptors in town in the mid-1970s. He approached Diego Chávez Petzey with the commission to restore the fallen central altarpiece. Shortly thereafter Diego's younger brother Nicolás, then still a teenager, joined the project. Nicolás' main task was to help carve the new panels his brother designed to replace pieces that had been damaged irreparably in the earthquake or which had become too fragile with age for reuse.

At the beginning of the project, Diego gathered together all of the original pieces he could find and spent a year or two reconstructing those that were still usable. All of the architectural supporting columns, capitals, and the nude putti flanking the basal panels are original (Fig. 1.4). Many of the recessed niches and adjacent floral panels survived relatively undamaged, though others are heavily restored or completely recarved based on the design of older fragments (Fig. 3.5; cf. Figs. 1.4 and 1.5). The panels surrounding the two images of Mary at the extreme right and left of the bottom tier of saints are wholly new creations (Fig. 1.5 P, Q, and U), as are the decorative vertical scrolls and volutes extending beyond the outer columns. The saints themselves date from the colonial period (some missing hands and facial features were recarved by the Chávez brothers). New to the altarpiece are the panels at the bottom (Fig. 1.5 V–Z), and moving up, the triangular panels (N, D) at the ends of the second and third tier of saints (including the climbing figures (I; also Fig. 5.14), the "sun vessels" (C; also Fig. 5.3), the palm trees flanking God the Father (B), and the foliated tree (A; also Fig. 5.1) at the summit of the altarpiece.

Diego designed all of the new carvings by sketching them first on paper; then both brothers jointly carved the panels in cedarwood to match the older structural fabric. No single panel is exclusively the work of one or the other. On the rare occasions when the altarpiece is illuminated with electric lights from above the apse, it is easy to distinguish the lighter color of the new panels from the heavily stained older pieces. In general, however, the altarpiece is poorly lit by a few candles set on

A

Fig. 3.4. Right altarpiece of the church, dedicated to the Virgin Mary and the Holy Spirit: (a) photograph, (b) drawing. She is often consulted on matters concerning children in the community.

its plastered base and by a small amount of sunlight from the clerestory windows of the nave and a tiny round window in the side wall of the apse above the archway leading to the left chapel.

Nicolás said that he and his brother were willing to work without compensation other than for food and housing for much of the time because the altarpiece was a sacred object and therefore they could not earn financial profit from the work without offending the ancestors. He described the commission as a *samaj,* a word that means "burden" as well as the forehead strap used by Tz'utujil men to carry heavy

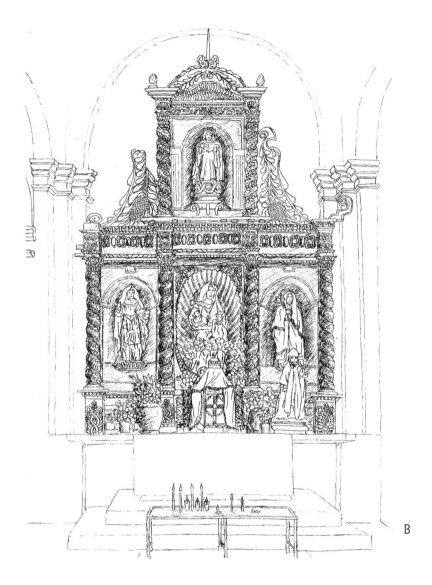

B

objects on their backs.[2] In a more esoteric sense, a burden refers to any task or obligation that fate decrees. This obligation may be to help with community building projects, to donate a year's service in a confraternity or municipal position, or to provide for the welfare of a sick or injured neighbor.

[2] The Spanish word *cargo* carries much the same meaning throughout Mesoamerica today— literally, a burden to be carried, but also a social or religious obligation, particularly service in a saint's cult.

By the time work began on the altarpiece in 1976, Father Rother was forty years old and had been the resident priest in Santiago Atitlán for eight years. In that time, he learned to speak the Tz'utujil language fluently and demonstrated great interest in local history and customs. Unlike most previous priests who opposed, sometimes violently, the more seemingly "pagan" aspects of Atiteco religion, Father Rother supported many elements of indigenous Maya worship as a means of encouraging more active participation by traditionalists in church ceremonies. He attended confraternity rituals in which non-Catholic deities were worshiped openly, and frequently addressed God in prayers as *Ruk'u'x Kaj* ("Heart of Sky"), a local Tz'utujil deity who also appears in the *Popol Vuh* as one of the principal deities involved in the creation of the cosmos (Christenson 2000, 40–56; D. Tedlock 1996, 65–74). Even today, Maya confraternity members who are otherwise wary of the intentions of Catholic authorities recall Father Rother with some fondness and suggest that he may have been one of the many manifestations of their great culture hero Francisco (Apla's) Sojuel. Following his assassination in 1981, the people of Santiago Atitlán refused to allow Rother's body to be returned for burial in Oklahoma unless they could keep the heart. It now resides in a jar buried beneath an elaborate monument located just inside the main entrance to the church. The room in which he was murdered was rededicated as a chapel in his honor.

When it became apparent that large portions of the central altarpiece would have to be recarved, Father Rother suggested that the new replacement panels reflect contemporary Tz'utujil society, similar to pieces that Diego had carved in the past for local confraternities. He also recommended that the Chávez brothers include ancient Maya motifs in their work so as to emphasize the indigenous heritage of the town. (I have already mentioned the inclusion of the maize god design to represent the Maya version of the Christian "bread of life.") Ultimately, Diego chose not to use other such symbols because to him the form was as alien to the modern Tz'utujils as the vestments and ritual paraphernalia that Father Rother brought from Oklahoma. Instead, Diego offered to add a series of five low-relief panels at the base of the altarpiece which would incorporate important aspects of Atiteco religious life, both orthodox Catholic as well as what he considered to be the older Maya form of Christianity practiced in the confraternities (see Figs 1.5 *V–Z*, 3.5, 6.1, 6.7, 6.26, 6.32, and 6.36).

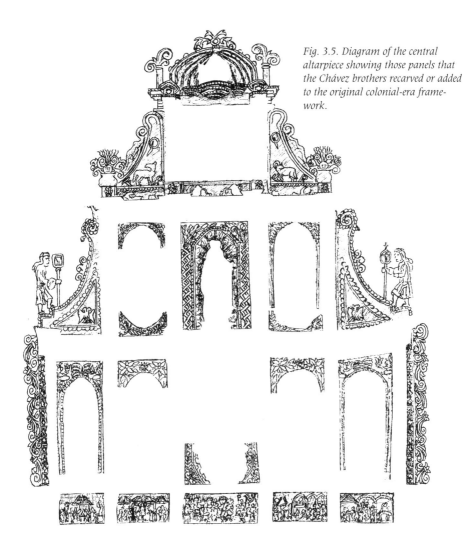

Fig. 3.5. Diagram of the central altarpiece showing those panels that the Chávez brothers recarved or added to the original colonial-era framework.

Father Rother readily agreed to this. Both of the Chávez brothers remember that the priest enjoyed looking over the preliminary sketches Diego made for the panels.

Throughout the period of the altarpiece commission, the Chávez brothers visited traditionalist Maya shamans, community elders, and aged people who had been active in the spiritual life of Santiago Atitlán, encouraging them to suggest potential themes for the new altarpiece panels and to relate any myths or ritual prayers that they

could recall. Diego compiled a large number of written myths, drawings, and historical accounts based on these visits which he employed while designing the altarpiece. Although Father Rother contributed possible ideas for the lower panels, he never rejected any of the Chávez brothers' designs or dissuaded them from including Atiteco divinities and rituals that might otherwise be considered inappropriate for a Roman Catholic church.

This is particularly evident in the appearance of Maximon, a local Atiteco deity, in the second basal panel of the altarpiece (Figs. 3.6 and 6.7). The figure always appears in public wearing a wooden mask with a cigar inserted in its mouth. Among other attributes, this divinity is characterized by hypersexuality, witchcraft, madness, and the sterility of the dry season. During Easter observances, Atitecos carry Maximon in triumph to a small chapel near the church. There he presides over the death of Christ while receiving offerings of incense, money, and copious amounts of liquor. In this role, Atitecos sometimes address him as Judas Iscariot or Pedro de Alvarado, both archetypal god-destroyers. Most traditionalist Atitecos, however, call him Mam ("grandfather" or "ancient one") because they say he is older than Christ and the saints, having been born before the first dawn.

In this century, the Mam has been a lightning rod for controversy in that he represents the most prominent example of the irregularity of traditional Tz'utujil worship from a Roman Catholic standpoint. Lothrop reported that in 1912 a Catholic bishop tried to have the image burned as a "pagan idol" but was himself driven out by a mob armed with clubs and machetes (1929, 23). A more serious threat occurred in 1950 as recorded by Mendelson (1957, 332–352). In that year, a Dominican priest named Godofriedo Recinos arrived from across the lake to officiate during Easter Week. He became enraged at the sight of the Mam receiving offerings on the church porch. Threatening to destroy the image, he ran to his quarters to retrieve his pistol, shouting, "I die for the truth but let's see that you go too, and to hell for a pack of idolaters and savages that you are!" (p. 332). Popular legend says that the priest got off three shots before he could be subdued, although none harmed the Mam. One of the bullets is still kept in the bottom of the Mam's chest of clothing as a relic. The priest refused to say Mass unless the people stopped worshiping the image. This caused an even greater division in town, and prompted a delegation of Atitecos to call on the priest and warn him that if he persisted

in his actions, the Mam would curse him with madness. A compromise was finally reached in which the Mam's guardian, an important priest-shaman from the Confraternity of Santa Cruz, could replace the image on the church porch. Nevertheless, no one could worship it publicly while the priest was around.

Six weeks later, Recinos returned with his Father Superior and another priest in a motor launch and attacked the image of the Mam in his confraternity house with a machete. After exorcizing the sanctuary of devils, the priests chopped off the image's head and confiscated two of his ancient masks before escaping across the lake. Although confraternity elders quickly fashioned a new head, the loss of the ancient masks was a terrible blow. At first it was rumored that the Pope himself had heard of the Mam and called him to Rome for consultation. When the truth became evident, traditionalists were outraged, and they continue to harbor bitter feelings against orthodox Catholics in town who failed to condemn the theft.

One of the masks somehow made its way to the Museé de l'Homme in Paris. In 1979, while the Chávez brothers were carving the altarpiece panels, the French embassy in Guatemala sent a delegation to Santiago Atitlán to return the mask to its rightful guardians (Tarn and Prechtel 1997, 178–183). The other mask is still missing.

Considering the controversial history of the Mam, it is all the more significant that Father Rother sanctioned his prominent appearance on the central altarpiece of the church, where he is depicted with offerings and flanked by a pair of devout worshipers. The Chávez brothers insist that Father Rother not only approved the design but encouraged them to include other elements derived from confraternity rituals so as to more accurately portray all aspects of the spiritual life of the community.

Perhaps the most eloquent expression of this cooperative effort is to be seen in the two carved figures climbing the sides of the altarpiece at opposite ends of the second tier of saints (Figs. 1.5 *I*, 3.5, and 5.14). On the right, the climber holds a Bible as well as a monstrance displaying a crucifix and topped by a Christian cross. On the other side, the second figure holds in his right hand the mask of the Mam complete with a cigar protruding from its mouth. In the climber's left hand he holds a staff bearing the image of a cup which Diego Chávez says contains *psiwan ya'* ("canyon water"), a powerful homemade alcoholic brew that traditionalists drink on ceremonial occasions to

help put them into an ecstatic state conducive to communion with ancestral spirits. Local orthodox Catholics and Protestants alike single out this drunkenness as an evil holdover from "paganism" and regularly decry the practice.

Diego's none-too-subtle inclusion of the Mam's mask and a drinking vessel demonstrates his insistence that all aspects of traditional Atiteco faith are legitimate and worthy of public display. Diego suggests that he placed the two climbing figures at the same level on the altarpiece to show that they are equally valid forms of worship:

> *Even though both climbers follow different paths toward the tree at the top of the altarpiece, they have the same destination, which is the* ruk'u'x kaj, ruk'u'x ruchiliew *("heart of the sky, heart of the earth"). Each works to bring about rain and abundance. The Mam and Christ both suffer and give their blood. For the Mam this blood is* psiwan ya'. *For Christ it is wine. Both give life. I have heard some people say that the two climbers show the death of one religion and the life of the other. But I do not believe that one can replace the other. The Maya religion will not end if we as a people do not end.*

Yet Diego also emphasized that the figures on both sides of the altarpiece are Maya *cofrades* (elders in the traditionalist confraternities) wearing the *xkajkoj su't* headdress that is emblematic of their office. According to Prechtel and Carlsen, the burden of carrying the sun across the sky falls on these confraternity elders because the ceremonies and dances they perform "serve to feed specific segments of time" and ensure that life continues (1988, 128). The confraternities are a system of religious brotherhoods independent of the Church and in many respects function in direct conflict with it (the worship of the Mam in the Confraternity of Santa Cruz being a prominent example). The antagonism between the two religious organizations has caused a great deal of friction over the past few decades, with the result that few confraternity members attend Mass or even set foot in the church when a Catholic priest is present. It is just this situation that Father Rother hoped to address with the inclusion of traditionalist elements in the altarpiece.

The altarpiece presents a mixture of Atiteco as well as Roman Catholic motifs, but it does so on Maya terms, with the artists selecting and refining the iconographic scheme so as to be relevant to the experience of the Tz'utujil people. The relationship between artist and

B

Fig. 3.6. The Mam/Maximon. (a) Normally the image of the Mam is housed in the Confraternity of Santa Cruz, where he receives numerous petitioners seeking his help with regard to business, travel, and affairs of the heart. (b) On the second basal panel of the altarpiece his image is depicted suspended in a tree, as it is during Holy Week observances when he is venerated as the deity who presides over the death of Jesus Christ and facilitates his resurrection to new life.

A

patron is best characterized as collaborative, a bilateral interaction in which both Catholic priest and Maya artists were active participants. Similar processes took place in the early colonial era when native artists and architects worked with Spanish missionaries to construct and decorate Christian churches in the New World. In her study of the sixteenth-century mural decorations in the monastery church at Malinalco, a Nahua-speaking town in central Mexico, Jeanette Peterson characterized this type of collaborative project as a dialogue ‹ involving continual feedback between artist and patron, subtly incorporating the worldview of each into a new and powerful art form: "Such joint native-friar projects . . . demonstrate not only the sustaining power of older indigenous views, but their viability, capable of effecting subtle transformations from the Nahua to the Christian and back again. As active participants, native scribes and artists helped to shape Christian texts and imagery to reflect their own world view and belief system" (1993, 7).

The reconstruction of the altarpiece came to an abrupt halt with the assassination of Father Rother on the evening of July 28, 1981, likely for his outspoken support for Tz'utujil rights in the face of increasing persecution by the Guatemalan army. No significant work has been done on the monument since that time. Diego planned to

spend another few months refining the faces and costumes of some of the figures in the lower panels, although the major design elements had all been completed and put into place. Diego also mentioned that he had planned to lacquer the wood to preserve it, and lamented that some of the high-relief figures have already been damaged. He did not regret failing to fulfill one of Father Rother's requests. Prior to his death, the priest had purchased three pounds of powdered gold paint with which to cover the altarpiece. The Chávez brothers delayed using the paint as this would have detracted from their concept of the monument as a mountain.

Despite the continued threat of violence, the altarpiece was dedicated with elaborate ceremonies over a fifteen-day period approximately a year after work was suspended. Confraternity elders kept incense braziers burning constantly before it to purify it as the new home for the saints placed within its niches. On several occasions, confraternity elders accompanied by a large drum and *chirimía* flute visited the church in solemn procession to give offerings and pray for the welfare of the community. Shamans also brought offerings, including obsidian blades wrapped in their own hair as a symbol of autosacrifice. They laid these at the base of the monument's carved columns to "give them strength and feed the heart of the altarpiece."

THE ROLE OF THE CENTRAL ALTARPIECE IN TZ'UTUJIL SOCIETY

For a significant segment of the population of Santiago Atitlán, the altarpiece is acheiropoietic, a sacred object that came into being miraculously without the intervention of human hands. While reconstructing the monument, the Chávez brothers were careful not to cause any further damage to the older pieces because they considered that each had a soul and would punish them for carelessness. Nicolás related a myth in which soon after the coming of the Spaniards powerful Tz'utujil *nuwal* ancestors oversaw the creation of the altarpiece because they wanted a suitable home in the church where the saints could reside:

> *A group of six brothers and six sisters, all powerful* nuwals, *went up into the mountains where the ancient gods live in caves and looked for a tree that would be willing to watch over the saints. Each refused in*

turn until they came to the cedar tree who agreed. While the women played a split-log drum and flute, the men burned incense before the tree and called on its spirit to live on after it was cut down and its wood made into the altarpiece. No one cut down the tree or carved it as sculptors do today because it was the magic power of the nuwals that caused the axe and chisels to do their work. They did not have to touch the tools themselves. When the first axe-stroke hit the trunk, the tree cried out and bled but it did not die. Each subsequent stroke was accompanied by sacred prayers and songs that gave power to the wood and made it strong for its future task. When the saints were placed in the finished altarpiece, the wood of the cedar tree embraced them just as the mountains above town guard the ancient gods and nuwals of the Tz'utujils.

When the Chávez brothers joined the new cedar panels to the old, they had been reassured by faint creaking and settling sounds in the wood which Nicolás interpreted as the older pieces accepting the new and urging the sculptors to hurry in their work so that the saints would not be left without a home. Atitecos tell similar stories about the creation of other sacred sculptures, particularly the carved image of the Mam. Sometimes the ancient sculptors appear in these legends as historical figures such as Francisco Sojuel, who died around the turn of the last century, or his successor Marco Rohuch. In other cases the Tz'utujils ascribe the same works of art to the hand of a divinity or to an act of magic.

In the case of the altarpiece, most Atitecos old enough to remember the renovation work of Father Rother in the 1970s know that the Chávez brothers carved a significant portion of the monument. The work was carried out over a long period of time in a very prominent public place with no attempt to hide the progress of its reconstruction. Yet, at the same time these same persons often say the altarpiece is entirely ancient and ascribe it to the work of *nuwals* at the beginning of time. Mary Helms suggests that the act of "transformative crafting," whereby a ritually significant item is created from an ordinary piece of wood, confers a degree of prestige and awe on artists that places their abilities beyond that of ordinary persons: "Skilled crafting reveals the transformative powers of a creative universe by achieving very explicit and dynamic changes in material form or character" (1993, 107).

Once created, the origins of sacred images like the Santiago Atitlán altarpiece enter the realm of mythic time and space, divorced

from mundane reality and the actions of specific personalities. While drawing one of the narrative panels of the altarpiece carved by the Chávez brothers, I was joined by an aged shaman who struck up a conversation about the monument's origin. He told me that the entire altarpiece was two thousand years old. He then went on to tell me that his grandfather had known the *nuwal* Francisco Sojuel, who was a great sculptor and helped to carve the altarpiece, including the panel in my sketchbook. He added that when Francisco Sojuel worked he did not need to eat maize or other foods to live. Instead he fasted for long periods, working secretly in the mountains making saints' images and altarpieces, and the shaman added that most of the sculptures in town were made by him. I asked when Francisco Sojuel had died and he replied 1907. Was the altarpiece, then, carved about that time? "Just so, in 1907, two thousand years ago when the Spaniards first came to Santiago Atitlán." This confusion over fixed dates reflects the Tz'utujil view that important events recur periodically. For the elderly shaman, "two thousand years" is simply a way of saying that the altarpiece is so ancient that it predates the founding of Santiago Atitlán. It therefore belongs to mythic rather than historic time, in an age when semi-deified ancestors like Francisco Sojuel set the pattern of many aspects of Atiteco worship. It matters little that the historic Francisco Sojuel died about 1907, because this was only one of his manifestations. Sojuel the ancestor has the power to endlessly create and re-create sacred objects that give life and meaning to the Tz'utujil people.

In the same way, many Atitecos who know very well that the Chávez brothers carved the narrative panels below the altarpiece insist that they came into being by magic and date back to the beginning of the world. Nicolás sometimes expressed frustration with this tendency, as it denied him and his brother credit for works that would otherwise enhance their artistic reputation and generate new business. Diego seemed to be less concerned that people think of his work as ancient and otherworldly: "If they wish to see in my work the hand of Francisco Sojuel, who am I to say that they are wrong?" Atitecos today may thus understand the altarpiece to be a unique creation of the Chávez brothers and at the same time perceive it as a timeless vessel for the spirits that reside within it and give it power.

Atitecos frequently tell stories about how they, or a close family member, met Francisco Sojuel or some other ancestral figure in the street. Often these appearances coincide with a crisis that threatens the community. On such occasions, Sojuel advises them how to escape

harm or assures them that he and the other *nuwals* are looking out for them and will protect them. In other stories, Francisco Sojuel is said to appear in disguise and might be anyone. In such cases, he can only be discerned by his good works.

Thus, several Atitecos suggested that Father Rother might have been a manifestation of Francisco Sojuel because he was good to the people and looked after them, unlike many priests that came before him. In addition, he was interested in the traditional religion of the town. When Mendelson worked as an ethnologist in Santiago Atitlán in the 1950s, some suggested that he might be a Sojuel figure: "Even I, after participating in certain rituals, was ominously referred to as the son of Francisco Sojuel as unusual or eccentric individuals are granted miraculous powers and Indians are constantly on the look-out for such characters" (1958a, 125).

I had a similar experience at the beginning of one prolonged period of residence in Santiago Atitlán in 1997. A few weeks after I arrived in town, several men assigned to take care of the church became suspicious of me, particularly when I began to take photographs and make drawings of the altarpiece. There had been a robbery a few months previous in which thieves had lowered themselves into the church from the roof and stolen some of the colonial-era silver decorations from the left altarpiece. I don't know whether the caretakers thought I was a thief, or just resented my presence as an outsider. In any case, I noticed that they began to turn out lights whenever I went in the church as a subtle hint that I wasn't welcome. This continued for about two weeks. I had almost decided to abandon my research work, not wishing to offend the community, when I noticed that the caretakers' attitude toward me suddenly changed. They smiled or nodded to me when I passed them, engaged me in polite conversation, and even volunteered to turn on lights in the darker areas of the church so I could see better.

By this time I had developed a close friendship with Nicolás Chávez and I told him about the recent turn of events. He laughed and said that as a leader of the municipal district where he lived, he had attended a meeting of church officials in which my presence in town came up. One of the men at the meeting said that it wasn't right that I should be spending so much time in the church and proposed that they charge a fee for my drawings and photographs. They debated this suggestion until another man cautioned them not to offend the ancestors by charging money to look at sacred things. Nicolás quoted the official as saying, "What if he is Francisco Sojuel himself and we just

don't recognize him? Do you think the *nuwal* Francisco Sojuel would be pleased if we did such a thing? I think it would be better to leave him alone." Nicolás didn't think I had anything to do with the ancestors, but suggested that it was lucky for me that I could come and go in the church without restrictions because some thought so.

Nicolás Chávez offered a good explanation for this anachronistic blending of historic events and personalities:

> *The Mam has always existed. All powerful gods and saints began when the world began, although they may become old and die. The wooden statue of the Mam in the Confraternity of Santa Cruz was made about a hundred years ago, but this is only one of his forms. Francisco Sojuel was a great* nuwal *who had the power to perform miracles and cause the rain to fall. After he died, he still comes back occasionally to visit us when we need him. Sometimes a portion of his spirit lives in people we may meet on the street. When the* nab'eysils *dance with bundles in the confraternities, Francisco Sojuel enters their bodies.*

The Central Altarpiece
and Tz'utujil Cosmology

T his chapter outlines the place of the altarpiece in the overall symbolic scheme of the church, an arrangement that reflects ancient Maya creation myths, as well as Spanish Christian theology. Beginning with the Spanish Conquest in the sixteenth century, the Tz'utujil Maya of Santiago Atitlán adopted European architectural and sculptural traditions as the principal means of communicating cultural information. The Chávez brothers continued this reliance on European sculptural style in their altarpiece reconstruction, yet they did this without compromising their own fundamentally non-Western worldview by selecting those European forms and motifs which resonate with Maya concepts, or by subtly altering them to conform with indigenous paradigms.

For the Maya, the central myths that inform the way they view the world focus on creation events (Schele and Mathews 1998, 36). The manner in which things began their existence sets the pattern for their relevance in the world. This was also true of the ancient Maya prior to the Spanish Conquest. Perhaps because the corbeled vaults characteristic of pre-Columbian Maya architectural technology did not allow for the construction of large interior spaces, most ceremonies involving large numbers of people took place in open plazas. In Classic Maya texts, the glyphic word for both "plaza" and large bodies of water was *nab*, representing the surface of the primordial sea that once covered the world (Freidel et al. 1993, 159). Massive pyramid-temples and palace structures surrounded these spaces in a manner analogous to the arrangement of mountains rising from the water to support the vault of the sky at the dawn of time. The architecture of ancient Maya

centers thus replicated sacred geography to form an elaborate stage on which rituals could be carried out that charged their world with regenerative power.

Colonial-era European architects and artists shared with the Maya a desire to create a vision of divine order in their sacred buildings. It is in the nature of that cosmic vision that the Maya and European artists differed. Unlike Roman Catholic traditions which place the abode of God and the saints in the uppermost reaches of the sky, the Maya believe that the most powerful divinities dwell deep in the interior of the earth. When gods reveal themselves to the Maya, they do not part the veil of heaven but open wide the maw of the earth in the form of caves accessing the interior of sacred mountains. Pyramid-temples were the ancient architectural manifestation of these mountains, with their tiny elevated sanctuaries serving as portals into the abode of gods dwelling within. Only a few elite persons were allowed to enter these small interior spaces; the majority of the populace observed their actions from the plaza below.

The introduction of European-style church architecture and decoration provided the Maya with the opportunity to present their cosmology in a comparatively vast enclosed space. For the first time, large numbers of worshipers could enter an elevated temple to stand in the midst of a constructed environment completely shut off from the profane world. Yet the Maya were still able to maintain the core

Fig. 4.1. Drawing of a section of the painting located behind the crucifix on the left altarpiece. It shows a stylized view of Santiago Atitlán, with its colonial-era church at the foot of three volcanoes beneath thunderclouds. Nicolás Chávez associated this painting with the creation of the world, the three volcanoes being the first land to emerge from the waters of the lake.

Art and Society in a Highland Maya Community

symbolism of their worldview. The sixteenth-century church at Santiago Atitlán is arranged as a cosmogram, following the model of the world in much the same way that pre-Columbian ceremonial centers once did. It is accessed by means of a long series of steps leading to a raised sanctuary, and its stone floor conceptually covers the underworld from which all life began. The central altarpiece of the church represents the first mountain of creation, and the saints in their niches are presented as if emerging from the entrances of caves in this mountain to interact with those who come to worship them. The Tz'utujils thus continue to identify their sacred places through sculptural compositions that reflect ancient Maya, rather than European, precedents.

THE ALTARPIECES AS THREE MOUNTAINS
SET IN THE PRIMORDIAL SEA

The Chávez brothers succeeded in subtly transforming the central altarpiece from a representation of heaven with saints emerging as if from clouds to one that envisions the altarpiece as a sacred mountain by adding certain motifs and modifying the interpretation of preexisting ones. The vegetal scrolls and volutes at the extreme edges of the first tier of saints, the stylized trees flanking God the Father, and the world tree/maize plant at the crest are all innovations that Diego Chávez designed to give the impression of the verdant surface of a mountain. To further emphasize the effect he added the two Maya confraternity elders climbing upward along a rocky path of decorative beads (see Fig. 3.5). Thus, to achieve the impression of a sacred mountain, the artists did not need to alter the structural design of the altarpiece or use motifs that would clash with its overall Euro-Christian style. It already had the basic shape of a mountain peak, or more specifically, a volcano. Other elements were easily reinterpreted along Maya lines to maintain consistency of theme.

While describing the arrangement of the three altarpieces around the altar, Nicolás pointed out to me a very old and smoke-stained painting on the left altarpiece which serves as a backdrop for a life-sized crucifix (see Fig. 3.3b). Behind the base of the cross is a crudely drawn village representing Santiago Atitlán, including the familiar façade of the church and its domed belltower (Fig. 4.1). Surrounding the village are three volcanoes and the jagged shoreline of Lake Atitlán. Heavy clouds painted above the town emit lightning bolts. In

Atiteco myth, lightning is the force that breaks open the germinating maize seed and allows it to grow out of the earth. Its bolts charge the earth with life-giving power so that whatever is buried within it can rise from the dead. These functions are similar to that of lightning in ancient Maya theology, according to which it cracks open a portal into the underworld to allow the world to emerge (Christenson 2000, 42; Schele and Mathews 1998, 410).

Nicolás told me that the three altarpieces represent the volcanoes that surround Santiago Atitlán as depicted in the painting and related the following creation myth:

> Before the world was made, only Lake Atitlán existed at the center of everything. Everything was covered with water. Then the three volcanoes grew out of the lake and lifted up the sky to support it. Today, when our town is threatened with disaster or enemies try to attack us, these volcanoes come together and form a barrier that protects us from harm.

For the Tz'utujils, Lake Atitlán represents the most important body of water because it was the place where the world first emerged (Fig. 4.2). It is the "true master, the first of all things; the sea comes second" (Mendelson 1957, 445). The ancient highland Maya version of the creation contained in the *Popol Vuh* parallels Nicolás' assertion that the world came into being when mountains rose out of a primordial expanse of water at the beginning of the present age:

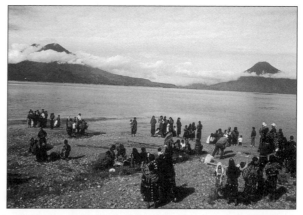

Fig. 4.2. Lake Atitlán, looking south toward Santiago Atitlán. The town is located where the slopes of the three volcanoes come together. San Lucas volcano is on the left, with Santiago visible through the clouds behind it, and San Pedro is to the right.

Art and Society in a Highland Maya Community

THESE then are the first words, the first speech. There is not yet one person, one animal, bird, fish, crab, tree, rock, hollow, canyon, meadow, or forest. All alone the sky exists. The face of the earth has not yet appeared. Alone lies the expanse of the sea, along with the womb of all the sky. There is not yet anything gathered together. All is at rest. Nothing stirs. All is scattered, at rest in the sky. There is not then anything that exists raised up. Only the expanse of the water, only the tranquil sea lies alone. There is not then anything which might exist, for all lies placid and silent in the darkness, in the night.

All alone are the Framer and the Shaper, Sovereign and Quetzal Serpent, They Who Have Borne Children and They Who Have Begotten Sons. Luminous they are in the water, wrapped in quetzal feathers and cotinga feathers. Thus they are called Quetzal Serpent. . . . Then they called forth the mountains from the water. Straight-away the great mountains came to be. It was merely their spirit essence, their miraculous power, that brought about the creation of the mountains and the valleys (Christenson 2000, 40, 43).

According to the *Annals of the Kaqchikels*, the ancient highland Maya associated Lake Atitlán with these first waters of creation. When the Kaqchikels arrived in the region, their king threw himself into the lake and changed himself into Gucumatz ("Quetzal Serpent"), the god who initiated the creation from within the waters that once covered the earth (Recinos 1953, 76–77). Immediately the lake became dark. Then a north wind came up and a whirlpool formed in the water reminiscent of the darkness and chaos of the primordial world. The Tz'utujils were so impressed by this demonstration of power that they ceded the northern shores of the lake to the Kaqchikels.

It is likely that the Tz'utujils chose the setting of their ancient capital at Chiya' as a sacred place reflecting Maya cosmology, which describes the beginnings of life centered at a great body of water from which three mountains grew under the direction of the gods at the time of creation. The location of Santiago Atitlán just across the bay from Chiya' maintains this configuration.

The emergence of three great mountains from the primordial sea closely parallels the mythic history of the Classic Maya creator deity, Hun Nal Yeh, the god of maize. Recent textual and iconographic studies allow us to piece together the ancient Maya version of the creation

story and demonstrate that its basic ideas pervade the religion of eastern Mesoamerica from at least the late Preclassic period through the Spanish Conquest (Coe 1989; Taube 1993; Freidel et al. 1993; Schele and Mathews 1998). In this cycle of myths, the maize god first emerged from the underworld through the cracked carapace of a great turtle, representative of the earth floating on the surface of the primordial sea. Following his rebirth to new life, the maize god traveled by canoe to the center of the sky, where he oversaw the setting of three great stones in the constellation of Orion (Freidel et al. 1993, 80–85). This was the great hearth of the universe where new fire was first kindled, quickening the cosmos and allowing life to emerge. The inscription on the Cross at Palenque adds that the place of creation was called "Lying-Down-Sky, First-Three-Stone-Place" because there the sky once lay unsupported against the earth (Freidel et al. 1993, 69).

Today many rural Maya still have three-stone hearths in the center of their homes. It is around this hearth that the family spends much of its indoor time, gathered at the place where maize, the main staple of the Maya diet, is prepared and cooked to sustain life. Fischer notes that with the advent of modernized house construction and the adoption of the cinder-block stove in the community of Tecpán, few still use three-stone hearths. Local Kaqchikel elders lament this change of design as a detriment to the maintenance of family ties (1999, 485).

The three volcanoes surrounding Santiago Atitlán are analogous to the three hearthstones of Maya myth as the first masses to emerge from the primordial sea. At least one of the volcanoes surrounding Lake Atitlán, now called Santiago, was active at the time of the conquest, reinforcing its identification with the fiery hearth of creation. The last known eruption of Santiago took place in 1866, although afterward it continued to smoke periodically (Orellana 1975b, 840). The original Tz'utujil name for the volcano, Hunqat ("that which burns"), reinforces the connection with fire (Betancor and Arboleda 1964 [1585], 101).

Just as the three volcanoes conceptually grew out of the waters of Lake Atitlán, the three church altarpieces rise above the floor of the church. As mentioned earlier, the space beneath this floor contains a number of burials which Atitecos associate with sacrificial offerings, semideified ancestors, and indigenous kings. Tz'utujils also believe

that the floor of their church constitutes a thin barrier separating them from the underworld, where all the creative and destructive elements inherent in nature gather together.

The most sacred opening into the underworld realm is a small hole called the *pa ruchi' jay xibalba* ("at the doorway of the underworld") or *r'muxux ruchiliew* ("navel of the face of the earth") located 3m. west of the raised altar in the center of the nave's floor (Figs. 3.2 F and 4.3). It is approximately a meter deep and 35cm. across and is normally covered with a removable flagstone. Among traditionalists, this hole is the principal access point leading to the underworld and the symbolic center point of creation (Carlsen 1997, 152). Vogt described a similar concept found among the Tzotzils of Zinacantan, who make offerings at a low rounded mound of earth at the center of the town which they call "the navel" and which they believe to be the spot from which the world extends (1969, 3).

The navel hole at Santiago Atitlán is only uncovered once a year, at midnight prior to Holy Thursday during Easter Week. On the following day, Holy Friday, a great throng of Atitecos gather in the church to watch a massive wooden cross, on which the life-size sculpture of Christ with moveable arms has been nailed, being lowered into the hole (Fig. 4.4). The placement of the cross of Christ in the ground signifies not only his entrance into the underworld in death, but also represents the means by which the resurrected God reemerges to new life from the center point of creation. One of the sacristans who participated in the ceremony told me that the cross is "planted" in the ground just as a seed is planted. Christ on the cross is thus reborn "just like new maize plants."

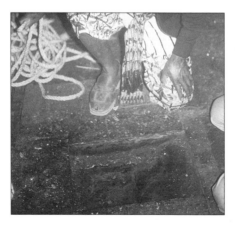

Fig. 4.3. "Navel of the face of the earth" hole located in the nave of the church. Traditionalist Atitecos believe that this is the principal entryway into the underworld realm of their ancestors.

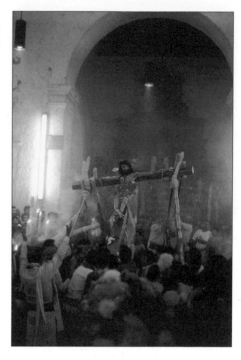

Fig. 4.4. Raising of the cross of Christ during Easter Week celebrations. The cross is placed in the "navel" hole indicating that Christ is reborn from the underworld like a tree or maize plant.

According to local Atiteco myth, the *r'muxux ruchiliew* represents the most powerful of a series of "cave" openings into the underworld. All of the caves branch outward from beneath the floor of the church, and each is associated with water or rain. The caves are also believed to be the dwelling place for numerous souls of the dead. Among the Kaqchikel, caves are ritually powerful because they lead toward the "heart" of mountains where the regenerative powers of the earth are centered (Fischer 1999, 483). In a similar way, traditionalist Atitecos believe that the regenerative nature of the earth is controlled through ritual first established by the ancestors of the community. As a result, caves, both real and symbolic, represent access points whereby the living may approach the dead. The Maya of Jacaltenango also considered the center of their church to be dedicated to the souls of the dead, who could be approached there in prayer (La Farge and Byers 1931, 93). Nicolás Chávez told me that sometimes the ancient ancestors can be heard late at night performing dance rituals and discussing the problems of the community. He claims to have heard them himself when he worked alone after sunset during the altarpiece reconstruction project.

Nicolás listed the following endpoints for the caves or passageways beneath the floor of the church:

1 The "navel of the world" hole in the floor of the nave.

2 A tiny hole located under a pitcher of water in the north wall of the baptistry beneath the dome of the church's belltower. Members of the Confraternity of San Juan insist that powerful shamans were once able to enter the church at midnight where they gained access to other branches of the tunnel system by using magic words to open a portal in the baptistry. Once inside, they could consult the souls of the dead or walk distances in only a few minutes or hours that would otherwise take many days. One shaman lamented that this can no longer be done because the church is now locked up at night.

3 The fountain in the center of the *convento* complex adjacent to the church to the north. A number of Atitecos mentioned that when the foundations for a new fountain at this spot were dug in the time of Father Rother, workmen uncovered a monumental stone serpent. Nicolás suggested that the serpent stone guarded the entrance to this branch of the passageway.

4 A cave which opens out onto the Pacific Ocean.

5 A grotto on the south shore of Lake Atitlán.

6 A cave in the mountains south of town called Paq'alib'al where the greatest of the saints and gods live and create rain clouds.

7 A drainage culvert which vents rainwater from beneath the church complex with an exit point along the west façade just opposite the sanctuary of the Mam. This is the only one of the "caves" that is visible and whose opening is large enough for a person to physically enter (Fig. 4.5). According to Nicolás, the entrance to this culvert once contained a stone "map" to the other six tunnels that people could use to find their way.

Fig. 4.5. Drainage culvert north of the church complex. Many Atitecos believe it to be the terminus of one of several underworld passageways, all associated with water, that are inhabited by ancestral spirits. This one is located opposite the Easter Week shrine of the Mam.

Tz'utujils also recognize a network of caves beneath the church at Cerro de Oro, a dependent community of Santiago Atitlán located several kilometers northeast on the lake shore. The church there is built into the base of a hill that once constituted the core of an extinct volcano. A cleft in the hill below and to the west of the church serves as an important pilgrimage shrine. Its walls are blackened with old incense smoke and there are always remnants of offerings at its deepest point. *Ajkun* shamans consider this to be one of the principal access points to a network of caves that extend beneath the foundation of the church as well as into the subterranean throne room of the old Tz'utujil kings. Hermitte describes a similar system of mythic caves beneath the village of Pinola, a Tzeltal-Maya community described by its inhabitants as the *yolil b'aumilal,* or "navel of the world" (1964, 45). In these caves, the *ch'ulel me'tik tatik* (the ancestral "spirits of the Mother-Fathers") live in luxurious homes. Although the caves are far apart from each other, these ancestors pass easily from one to the other "by traveling along the subterranean passages which establish an easy and fast path" (1964, 58).

The Atiteco belief that the "navel of the world" in the church leads to a network of magic underworld tunnels likely ties the building to ancient pan-Mesoamerican concepts of mythic origins from caves. According to the *Popol Vuh* and other highland Maya texts, the ancestors of the K'iche'an people, including the Tz'utujils, originated at a place called Wuqub' Pek, Wuqub' Siwan ("Seven Caves, Seven Ravines") (D. Tedlock 1996, 151–152; Recinos 1957, 123, 174). The equivalent in Central Mexican mythology is Chicomoztoc ("Seven Caves"), the legendary origin place of the Early Postclassic Toltecs and the many Nahua groups who allege Toltec ancestry (Davies 1977, 35–37; Tezozomoc 1975, 14–15; Torquemada 1943, I.x.31). In all likelihood the Seven Caves legend predates the Toltec era. Beneath the Pyramid of the Sun at Teotihuacan (Fig. 4.6) is a partly artificial cave consisting of a central tunnel and six branches that represents in physical form the ancient place of origin (Heyden 1975, 1981; Taube 1986). When discovered, the underground tunnels contained abundant offerings of fish bones and shells, suggesting that the inhabitants of Teotihuacan considered this place a symbolic watery underworld. Archaeologists uncovered remnants of drainage canals that once carried water into the center of the cave to further emphasize this illusion, although there is no evidence of any natural springs in the area.

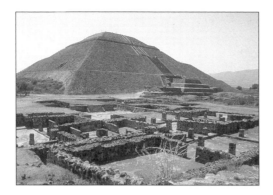

Fig. 4.6. Pyramid of the Sun, Teotihuacan. Excavations at the site revealed a network of artificial caves or passageways beneath the structure, likely associated with the underworld.

A similar west-facing artificial cave (Fig. 4.7) runs beneath the acropolis at the ancient K'iche' capital of Q'umarkaj; Dennis Tedlock believes the cave complex to be the highland Maya version of the seven caves of origin (D. Tedlock 1996, 296; see also Brady 1991; Brady and Veni 1992). Like the foundation tunnels beneath the Pyramid of the Sun at Teotihuacan, the Q'umarkaj excavation consists of a long central tunnel with six side branches. The innermost chamber is situated directly beneath the central plaza of the city, bordered by three temples that may have represented the three mountains of creation (Fernández Valbuena 1996, 74–79). Traditionalist Maya from throughout the highland region continue to undertake pilgrimages to this "cave" to make offerings to sacred ancestors and deities that they believe reside there. Tedlock's K'iche' collaborators noted that it is a dangerous place because it represents the "open mouth of the World" through which one might fall (1996, 332).

Fig. 4.7. Artificial "cave" beneath the ruins of Q'umarkaj, the ancient capital of the K'iche'-Maya in highland Guatemala. (a) The entryway gives access to a network of underground shrines. (b) The interior-most is located directly beneath the Temple of Tojil, the principal cult structure of the site.

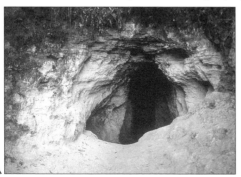
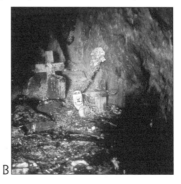

A B

The Central Altarpiece and Tz'utujil Cosmology 81

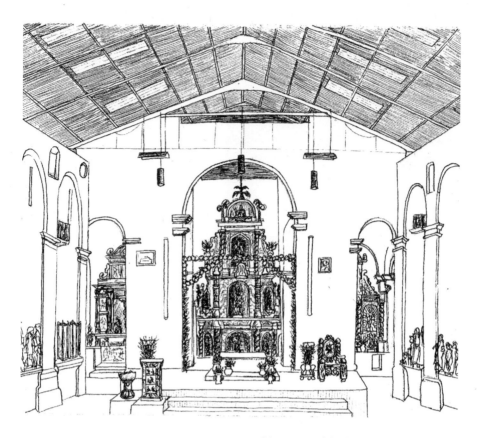

Fig. 4.8. Drawing of the interior of the church at Santiago Atitlán, showing the location of the three great altarpieces.

The mythic tunnels that Nicolás describes beneath the church at Santiago Atitlán are similar to those at Teotihuacan and Q'umarkaj in that the largest access point is a large hole on the west side of the building with branches extending from a central passage. The tunnels are all associated with water and the underworld realm of the ancestors, and shamans are said to have the power to access them to make offerings and converse with supernaturals within. The most powerful endpoint of this underground network is the "navel of the face of the world," the small hole located in the center of the nave of the church. The three altarpieces flanking and behind the altar to the east of the church's "navel" hole (Fig. 4.8) are analogous to the three-temple complex at Q'umarkaj, representing the three mountains of creation set above the watery underworld.

Diego Chávez pointed out that the scallop shell designs decorating the capitals of the lower pillars of the altarpiece, as well as the shell-like form of the saints' niches (Fig. 1.4), prove that the ancients intended people to understand that the monument is a mountain riddled with sacred caves where water and rain are born. The saints emerge from these caves to give their blessings. The original colonial-era sculptors likely used scallop shells as a symbolic reference to Santiago (St. James the Apostle), the patron saint of the town and the central figure in the lower tier of saints (Fig. 1.5 *S*). In European art, St. James is generally portrayed with a scallop shell, symbolic of his reputed journey by sea to Spain, where he established a church at Compostela (Ferguson 1954, 124; Farmer 1987, 222). From medieval times to the present, travelers to the shrine of St. James at Santiago de Compostela have identified themselves as pilgrims by wearing a scallop shell in honor of the saint. For the Tz'utujils, however, shells represent portals to the underworld because of their association with large bodies of water such as Lake Atitlán. Shells are also representative of caves because it is believed that these lead to the primordial waters that lie underground and from which rain clouds are born. Thompson noted that among the ancient Maya, shells also served as a symbol for the subterrestrial region and its divine inhabitants, particularly those associated with the earth and rebirth (Thompson 1960, 133).

Caves and shallow rocky recesses are rather common in the mountains surrounding Santiago Atitlán. Many are heavily stained by incense smoke and littered with the remains of candles, flower petals, alcohol bottles, and other ritual offerings. Caves serve as liminal places for the Maya in which individuals may access the world of the spirit and directly approach ancestors and mountain deities. Such cave worship has been a widespread phenomenon in highland Guatemala from pre-Columbian times to the present (Lothrop 1933, 83; La Farge 1947, 128; Oakes 1951, 7; Thompson 1970, 272–276; Orellana 1984, 99; B. Tedlock 1986, 128; Stone 1995, 38–39). According to the *Título Totonicapán,* the gods of the various highland Maya lineages called on the first men to place their carved images in mountain caves before the first dawn and there they could be consulted (Carmack and Mondloch 1983, 184). Las Casas noted that in the sixteenth century the Maya

believed that caves were mouths opening into Chixibalba (the highland Maya name for the underworld) and that the old gods lived there (Las Casas 1967 [ca. 1550], II.clxxx.347). He further wrote that the Maya kept their gods' images in caves, for this demonstrated greater reverence than would be shown by keeping them constantly on view. On special occasions, the people carried their gods in procession to the temples, where they placed them in sanctuaries (Las Casas 1967 [ca. 1550], II.clxxvii.216). The ancient highland Maya probably perceived their temples as effigy mountains and believed that the sanctuaries, like the Santiago Atitlán altarpiece, represented the gods' cavelike homes (Bassie-Sweet 1991; Schele and Mathews 1998, 417). The anonymous authors of the *Popol Vuh* referred to the mountain in which the gods were hidden as a pyramid (D. Tedlock 1996, 159).

Both Diego and Nicolás Chávez suggested to me that while there are several important cave shrines around Santiago Atitlán, the niches on the altarpiece refer to the most sacred of local caves, called Paq'alib'al, located in the mountains to the southwest. The likely derivation of this name comes from *pa* ("at") *q'alij* or *q'alaj* ("to reveal, to make clear, to appear") *b'al* ("place or instrument"), thus "at the place of revelation or appearance." Nicolás described Paq'alib'al in this way:

> *All the great saints and* nuwal *ancestors live in Paq'alib'al. Their spirits live there in the center of the mountain. This is also where the south wind is born. Strong rains come from this cave because that is where the clouds are formed. There is always the sound of wind coming out of the cave because this is where the ancients live. The entrance is guarded by two pumas and two jaguars and is adorned with abundant fruits such as corozos, bananas, melacotones, plantains, zapotes, cacao, and pataxtes to show that the heart of the* nuwals *are present inside and that they have power to give abundance and fertility. Inside is a gigantic snake one meter thick and fifty meters long that watches over the saints.*
>
> *Many times there is a woman named María Castelyan standing at the entrance who gives food, or perhaps she is the Virgin Mary. There is also a stone statue of Mary set on a jade base that shines like a light. At other times only jaguars and deer circle around the entrance. At New Year's a light appears in the cave. Near the cave in a small ravine is a giant* po'j *tree where angels rest when it rains, and inside the branches are clouds. The branches are covered with squirrels and birds. A peccary circles the trunk when it is about to rain because clouds and*

the first rays of dawn begin at this tree. Tremors shake the earth every five minutes there because this is where the nuwals *live when they leave Paq'alib'al. My great grandfather did not believe in this tree and wanted to use its wood to build a* cayuco *[a roughly hewn plank canoe] and to burn for firewood. When he began to cut the* po'j *tree, it bled. Immediately he had a stroke and he remained half-paralyzed for the rest of his life. Another man, who didn't believe in the tree, tried to climb it and became a monkey.[1] During the rainy season people gather leaves from the tree at full moon because they are good for medicine.*

Nicolás told me that the carved wooden cross adorned with leaves atop the altarpiece (Figs. 1.5 A and 5.1) represents this tree at Paq'alib'al, and that rain clouds come from there because it is the birthplace of life and all good things. The tree near Paq'alib'al recalls the pan-Maya notion of a world tree that grows out of the underworld to center creation (Miller and Taube 1993, 57; Freidel et al. 1993, 55). Robert Carlsen notes that in Tz'utujil belief, an ancestral deity known as R'tie Chie ("Mother Tree") exists at the center of the world. From this tree, "all things derive their life-giving sustenance" (Prechtel and Carlsen 1988, 126). According to the *Chilam Balam of Chumayel,* the ceiba tree is the "first tree of the world" and first appeared at the dawn of time (Roys 1967, 102).

The presence of María Castelyan, a divinity who appears in many Atiteco myths dealing with creation events, further suggests that Paq'alib'al is a cosmic location related to the birth of the world. As the aged patron deity of Lake Atitlán, she oversaw the birth of the three volcanoes and wove the fabric of the night sky and the mantle of the earth on her backstrap loom. In one important cycle of myths, María Castellana (Castelyan) is an aged grandmother figure, also known as Francisca Batz'b'al (Francisca "Thread Maker"), who participated in the first planting of maize as well as the first grinding of its grains into edible dough (Tarn and Prechtel 1986, 176–177; Prechtel and Carlsen 1988, 122–132). She is also tied with the first creation of the Mam: "It is she who primarily calls the Mam into being; he is her child until he stands up, then, after she dances with him, he is her husband" (Tarn and Prechtel 1986, 177). In her younger form, as the wife of the Mam,

[1] This incident is a likely reference to a tale in the *Popol Vuh* in which the Hero Twins trick their half brothers into climbing a tall tree to retrieve some birds and were converted into monkeys (Christenson 2000, 90–94; D. Tedlock 1996, 105–108).

María Castelyan is associated with witchcraft, promiscuity, and the ability to drive men mad, tangling them up in the threads she spins. An important image of María Castelyan (Fig. 4.9) is kept in the home of the *telinel*, guardian of the Mam. Although heavily swathed in scarves and other articles of clothing, the head of this figure is visible wearing a mask nearly identical to that of the Mam (Fig. 3.6b), with the characteristic cigar inserted in her wooden lips.

Myths concerning Paq'alib'al and the tree nearby are widely known in Santiago Atitlán, although almost no one but *ajkun* shamans go there. This is partly because of the distance (it is approximately 17km. from the nearest road up a very steep trail) and partly because it is considered a dangerous place. Nicolás has never been there, although his father has visited it several times. Nicolás' son accompanied his grandfather to Paq'alib'al on one occasion and claimed that he witnessed the elder Diego open wide the cave's entrance after a brief prayer and walk past one of the jaguars inside.

An *ajkun* who visits the cave periodically gave me a description which agrees for the most part with Nicolás' account and adds some important details:

Fig. 4.9. María Castelyan, creator deity and wife of the Mam, lying
in her glass chest in the house complex of the telinel priest.

Before the nuwals Francisco Sojuel and Marco Rohuch disappeared, for they did not die, they said that they would leave a sign in front of their home at the cave of Paq'alib'al to show that they still live. This sign was the presence of great piles of fruit—bananas, melacotones, pataxtes, and cacao. The last time that I was there I saw beautiful maize fields and bean plants all around it which grew to a miraculous degree. Peach trees and apple trees also grew nearby which were full of parakeets.

Ajkuns go to Paq'alib'al to ask for rain and to speak to the old ones that live there. When you go inside you may be gone for three days, but it only feels like a few minutes. The entrance to the cave is half a meter high, but when an ajkun goes there he knows how to ask the mountain to make the hole large enough to walk in without stooping over. Inside are five pumas who guard the cave. The largest puma is named Francisco, the second Diego, the third Juan, the fourth María, and the fifth Marco. These are the animal substitutes for the ancient ones. When the cave opens, they roar but if one is pure of heart and holds up his hand, they allow him to enter without biting him. For the first few meters, the cave is dark and cramped, but then it opens into a large chamber that is brightly lit as if in daylight and it is never cold or hot. Inside is a room with a throne guarded by two giant snakes with limitless length because there is no end to their tails. Sometimes a man is there wearing Atiteco clothes and an old straw hat like Atitecos used to wear a long time ago and asks what the person wants. This is Francisco Sojuel. There is always incense and smoke coming out of the cave and candles burning at the entrance even when there is no one there. Clouds are born from the cave and light rain falls constantly at the entrance because rain comes from the deepest part of the mountain. Did you notice that it rained all last week even though it is the dry season? That is because two ajkuns went to Paq'alib'al to ask for rain. At noon, a bell is often heard inside louder than the one in the church and earthquakes shake the earth every five minutes.

The five pumas in the ajkun's description are named, being the "animal k'exel ['substitutes, replacements, counterparts'] for the ancient ones." He later listed the same five names in a ritual prayer at the Confraternity of San Juan and explained that they are five of the greatest nuwals who once lived in Santiago Atitlán—Francisco Sojuel, Juan Kihu, Diego Kihu, María Castelyan, and Marco Rohuch — all of whom now live inside the mountain where they watch over the

people. The appearance in human form of Francisco Sojuel in the cave is consistent with the role of Paq'alib'al as a place where deified ancestors may be consulted.

The jaguars and pumas associated with Paq'alib'al are typical of Maya cave imagery. Zinacantecos, dressed as jaguar impersonators, perform rituals in sacred caves in the hills above their town (Vogt 1981, 130; Stone 1995, 43), jaguars are closely identified with mountain deities among the K'iche's, and the "particular association jaguar-mouth-cave-earth is so widespread as to be considered a pan-American mythic invariant" (B. Tedlock 1986, 128).

Both Nicolás and the *ajkun* agree that a giant serpent guards the interior of the cave. In the latter account, the body of the serpent is "endless," extending deep into the cavern's interior. It is possible that the serpent is a zoomorphic metaphor for the winding passageway of the tunnel itself which leads out of the underworld. In Classic Maya iconography, ancient kings and other elite individuals have the ability to open a portal into the underworld by conjuring a gigantic snake, called a "vision serpent" (Stuart 1988, 183–185; Freidel et al. 1993, 207–210; Miller and Taube 1993, 150). Through the open maw of this monster individuals descend into the underworld. Thus on the sarcophagus lid of Hanab Pakal at Palenque, the deceased lord falls into the open jaws of the underworld in the form of an open-mouthed serpent.

Alternatively, ancestral spirits could emerge from the underworld serpent's jaws to communicate with mortals or bestow tokens of power, as seen on Lintel 25 from Yaxchilán (Fig. 4.10). Cave entrances are often pictured in pre-Columbian art as the open mouth of a serpent or jaguar as the most prominent physical symbol of an underworld portal in the earth (Bassie-Sweet 1991; Stone 1995, 23) (Fig. 4.11).

In Atiteco mythology, giant serpents are often associated with the interior of the earth where they attend or surround sacred ancestors. Thus the ancient Tz'utujil king Tepepul is said to sit on a throne in the center of the mountain beneath the ruins of Chiya' (or, alternatively, another hill across the bay called Cerro de Oro) flanked by two giant serpents. Another serpent coils around the abode of María Concepción, who lives at the bottom of Lake Atitlán. The monumental stone serpent found beneath the fountain in the *convento* of the Santiago Atitlán church is important in this regard, since this location is considered one of the "caves" beneath the foundations of the church complex.

Fig. 4.10. Yaxchilán Lintel 25. In this panel, the founder of Yaxchilán's dynasty emerges from the jaws of a serpent bearing the instruments of sacred warfare. In Classic Maya iconography, the serpent represents a portal to the underworld. (Redrawn after Linda Schele, in Freidel et al. 1993, Fig. 4.3.)

The Central Altarpiece and Tz'utujil Cosmology 89

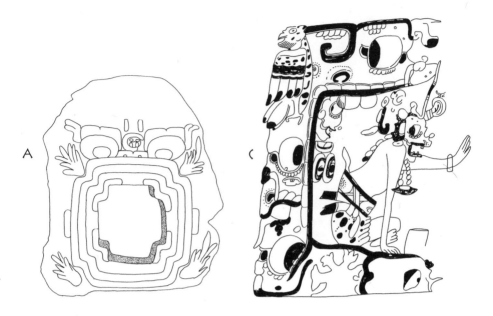

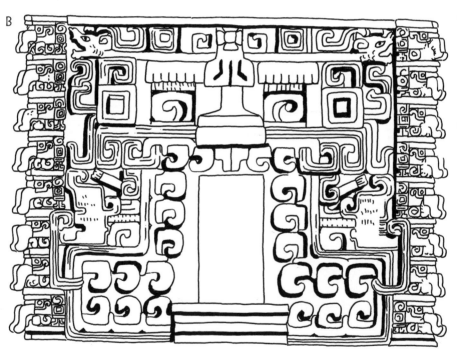

Fig. 4.11. Cave entrances depicted as open zoomorphic mouths. (a) Chalcatzingo Monument 9, ca. 700–500 BC. (b) Building 1, La Tabasqueña, Campeche, ca. AD 800–1000. (Redrawn after Andrea J. Stone 1995, 25.) (c) Polychrome vessel depicting the god Chak in a cave, ca. AD 600–850. (Redrawn after Andrea J. Stone 1995, 35.)

Art and Society in a Highland Maya Community

After describing Paq'alib'al, Nicolás took out a copy of a drawing that I had made of the altarpiece (See Figs. 1.4 and 1.5) and pointed out that the monument represented the mountain of Paq'alib'al and that the saints are to be understood as emerging from caves:

The men climbing the sides of the altarpiece are going to pray at the mountain shrine of Paq'alib'al. The trees, plants and flowers along the sides of the altarpiece and around each niche represent the miraculous fruit and trees left by the nuwal *ancestor Francisco Sojuel. The twisted columns are the snakes that guard the inside of the cave. The tree at the top of the mountain is the sacred tree that stands nearby where clouds rest before rising into the sky. The pots on either side of the upper tier represent the earth and the sun may be seen rising out of it on one side of the mountain and setting on the other. The pinecones above the second tier of saints are the teeth of the jaguar that stands at the entrance of the mountain and guards it.*

I describe these motifs in greater detail in the next chapter, but it is important to recognize at this point that although the Chávez brothers present individual symbols on the upper panels of the altarpiece as discrete iconic entities, each with their own set of mythic associations, their interpretation is consistent with the overall theme of a fertile mountain opened wide to reveal the divine individuals that dwell within. Paq'alib'al (place of revelation) serves as the major referent to this underworld portal in the physical geography of the region, although elements of the myth also recall the sacred order of creation at the center of the world. The artists added new motifs to the ancient altarpiece, such as the tree at the summit, maize gods, and climbing Maya confraternity elders, to reinforce this concept. Others, such as the pendant pinecones, floral motifs around the niches, and twisted columns, are reinterpreted according to local Atiteco cosmology in a way probably unimagined by whomever designed them in the colonial period, if a European.

RE-CREATING THE COSMOS: THE EASTER MONUMENTO

In traditional Tz'utujil cosmology, the creation of the world is not a singular event in the distant past. Like the agricultural cycle of maize and the movement of the sun, the cosmos goes through orderly phases

of birth, maturity, death, and rebirth. If life-sustaining rituals were not performed at appropriate times tied to the calendar year, the cycle would be broken and existence would cease. For many Atitecos, the central altarpiece at Santiago Atitlán is more than a symbolic representation of the mountain of creation. It is a focal point for regenerative power, charged with the same animative presence that gives the saints in its niches their ability to bestow divine blessings.

The need to re-create the world anew, however, runs counter to the static nature of the monument. The removable saints are taken out of their niches and carried in procession, their clothes are periodically washed and changed as a token of renewal, but the altarpiece itself is far too massive to be moved or altered in any appreciable way. Instead, Atitecos construct a temporary altarpiece of nearly identical form and material immediately in front of it at the crucial point of the year when the major gods are perceived to die—during Easter Week. This temporary structure is called the Monumento (Spanish for "monument").

Early in the morning of the Monday prior to Easter, a large group of Atitecos arrive at the church to thoroughly clean it. They drape a large cloth across the left altarpiece, where the most important images of Christ are located, as a symbol that he is no longer accessible, having descended into the underworld (Fig. 4.12). The cloth remains in place for five days, analogous to the five delicate days that fall at the end of the traditional Maya calendar. At the same time, an officer of the church uncovers the hole in the floor of the nave that represents the "navel of the world" and removes loose debris from it, which he carefully gathers into a bag. Confraternity elders remove the saints from their niches along the sides of the church and lay them on mats in the center of the church floor. A battery of men and boys then thoroughly sweep the inside walls of the church with long-handled brooms, while others climb into the rafters to remove all traces of dirt and cobwebs, filling the air with so much debris that it becomes difficult to breathe. Some of the men climb rickety pole ladders to chip away loose bits of paint and plaster, which crash to the floor. When I asked why they did this, they said that when the plaster begins to separate from the wall it means that it no longer wishes to work for God and must be taken away. (Along the north wall of the church a large section of plaster has fallen, revealing remnants of a polychrome mural presumably dating to the early colonial period.) A year's worth of candle wax and incense is also carefully scraped from the floors and saints' niches.

While the men dust and sweep the church, women fill the fountain in the *convento* with water that has been specially blessed by confraternity elders. Nicolás said that in the past the water had to come from the lake, which represents the first waters of the world. Nowadays, however, the women fill their jars from modern taps. Once the church has been thoroughly dusted and scraped clean, the water is used to scrub the floor until it shines. Similar lustrations take place throughout town in the confraternity houses as well as private homes. Atitecos believe that dust and other debris attract demons from the underworld, so rather than discarding the sweepings, traditionalists carefully collect them in bags and offer them at shrines dedicated to divinities connected with death and illness, particularly that of the Mam. Cleansing represents a spiritual as well as physical renewal since it prepares the way for the world to be reborn.

Once the church has been thoroughly swept and washed clean, a select group of male Atitecos assemble to construct the Monumento. Like the altarpiece, it represents, according to Nicolás, the "entryway into the home of the ancestors at Paq'alib'al." The structure's framework of horizontal wood planks is supported by colonial-era twisted columns of the same age and type used on the central altarpiece.[2] Once the framework is set up, the men loop twisted ropes around it to create an immense gridwork, with a green cross or symbolic tree affixed at the top (Fig. 4.13). Nicolás said that it represents the sacred tree of Paq'alib'al, just like the one atop the central altarpiece. Years ago, Atitecos set a large pot upside down on top of the Monumento, representing the surface of the mountain, and inside this pot they placed the cross as a "sprout of maize, the sacrificial tree" (Tarn and Prechtel 1997, 256).

The Monumento remains bare until Holy Wednesday, when a powerful priest-shaman (the *telinel*) carries the wooden image of the Mam to a domed sanctuary adjacent to the church plaza. There the *telinel* places the Mam in the branches of a leafy tree brought from the mountains and set up in the shrine (Fig. 4.14). Worshipers come and go constantly over the next few days, bringing offerings of liquor, cigars, incense, fruit, and money. This is the event commemorated on

[2] The columns are remnants of shrines that once lined the walls of the church but which had fallen apart over the years. Stacks of such fragments are kept in the church's baptistry, confraternity houses, and private homes throughout the town, where they are treated as sacred relics.

Fig. 4.12. Covering the left altarpiece on Holy Monday. The draped monument signifies that Christ is dead and in the underworld.

Fig. 4.13. Framework of the Monumento on Holy Monday. The twisted columns and cords of the structure represent snakes, guarding the way into the sacred mountain behind it.

the altarpiece in panel 2 (Fig. 6.7). The Mam's presence in the church plaza represents his triumph as an underworld lord over Christ and the other saints.

While the Mam receives his devotions, other Atiteco elders oversee the decoration of the Monumento from which the world will be reborn. Young men in two processional columns carry into the church baskets of ripe fruit brought specially from the coast and blessed for this purpose. They hang the fruit from the twisted ropes of the Monumento along with cypress boughs and scarlet bromeliad flowers (Fig. 4.15a). Two other long wooden frames decorated with cypress and flowers are tied to the sides of the Monumento to create a diagonal slope, mirroring the mountain-like shape of the altarpiece behind it (Fig. 4.15b). The decoration of the Monumento is sufficiently heavy that it obscures the altarpiece except for the summit and crestal tree, although a portal is left open at the lower center directly in front of the niche of Santiago so that the saint can be seen. As a result, the saint may conceptually come and go as he pleases. The Monumento thus represents a foliated version of the altarpiece as the home of the saints.

Throughout the process, a woman representing an ancestral grandmother figure presides over the work and directs the young men where to hang the fruit and other decorations (Fig. 4.16). Her presence

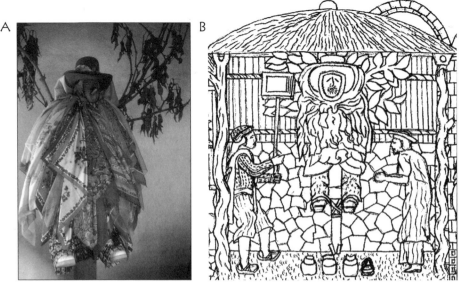

Fig. 4.14. The Mam during Holy Week. (a) The Mam's sanctuary is the last remaining colonial-era posa chapel of four that once stood at the corners of the church's plaza. (b) The Mam within his shrine during Holy Week, receiving offerings, from panel 2 of the central altarpiece.

places the event in mythic time at the beginning of the world. During the entire process, she waves a censer of incense to create a cloud of smoke which represents rain clouds that are born out of the Monumento as if it were a sacred cave. She is one of the oldest living members of the family of Francisco Sojuel and wears an older style of Atiteco costume used only by the principal women of the community on ceremonial occasions. This includes a simplified version of the winding headband which Atitecos identify as a "rainbow serpent." Diego Chávez said that the headdress was first worn by the Atiteco deity Yaxper as patroness of the moon, weaving, childbirth, and midwives. The long winding-cloth of the headdress represents the umbilical cord that ties holy women to the sky.

Yaxper also participated in the creation of the world. She, along with María Castelyan and other ancestral women, wove together the framework of the world on their backstrap loom: "They wove their children: birds; jaguars, snakes, and so forth. . . . The 'food of the weaving' thread follows a sinuous line compared to the hidden way of the earth (the 'hills and valleys'), contrasted with the straight path of the sun" (Tarn and Prechtel 1986, 176). The knotting of the twisted ropes and subsequent decoration of the monument represent the weaving of the cosmos on a loom.

The Central Altarpiece and Tz'utujil Cosmology 95

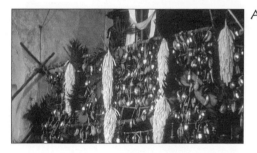

A

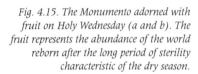

Fig. 4.15. The Monumento adorned with fruit on Holy Wednesday (a and b). The fruit represents the abundance of the world reborn after the long period of sterility characteristic of the dry season.

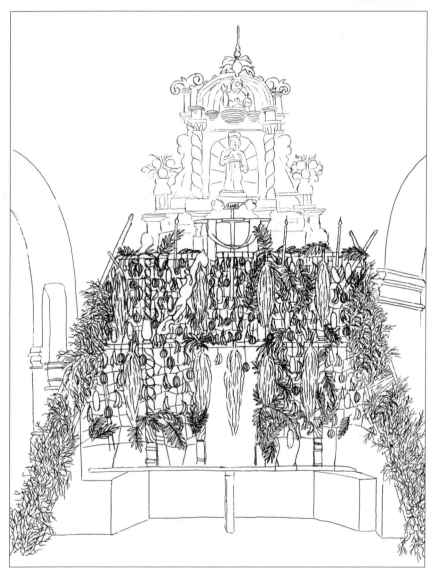

B

Art and Society in a Highland Maya Community

Fig. 4.16. An aged woman, representing one of the ancestors who participated in the creation, oversees the decoration of the Monumento.

The elderly woman present at the construction of the Monumento also wears a special *huipil* consisting of a coarsely woven white cloth with purple stripes and a quatrefoil pattern at the neck embroidered in purple thread (Fig. 4.17a). In ancient Mesoamerican iconography the quatrefoil shape is the most common means of representing portals giving access to the underworld (Fig. 4.17b, c, and d). The Atiteco *huipil* neck opening is consistent with this concept, representing Lake Atitlán as the center through which the world emerges. The three volcanoes of Santiago Atitlán appear on either side of the opening as mirror images. A prominent weaver in Santiago Atitlán told me that when a woman puts her head through the opening between the volcano designs it is as though she is reborn "like the moon" over the lake.

The moon is one of the principal images of Yaxper, whose principal cult image is kept in the Confraternity of San Juan. The attributes and function of Yaxper suggest that she may represent a modern Tz'utujil version of Ixchel (Goddess O), the ancient lowland Maya goddess of the moon, childbirth, and weaving, who also wears a serpent headdress and participates in ceremonies associated with birth and creation. Like Yaxper, she is an aged grandmother figure in her aspect as midwife and divine creatrix. (The links between the two goddesses are considered further in Chapter 5.)

Diego Chávez suggested that the elderly woman, like Yaxper, presides over the decoration of the Monumento because "only women have the power to create new life, and they must be present at the rebirth of the world." Prechtel and Carlsen also noted the close association between weaving and birth in Tz'utujil cosmology, both processes being linked through the aged moon deity addressed simply as "Grandmother" (1988, 123).

While watching the decoration of the Monumento, Nicolás related the following myth to explain its significance:

In the days of Francisco Sojuel there was a great drought and the people asked him to bring rain for their maize. He stood on a leather strap like a horse bridle and pulled himself up into the clouds where he made the rain to fall. But the president of Antigua was angry and had him arrested. In jail, the president asked if he could cause miracles. Francisco Sojuel said that if he liked, he would give them rain as well. He then caused a great rain to fall that killed many people by flood.[3]

The president then sent him to the governor of Sololá who had him thrown off a cliff, but he did not die. Then the governor tried to kill him in the town square. But Francisco Sojuel did not die there. He spoke happily to the people because he was protected by María Castelyan who gave him strength. When the governor of Sololá tried to kill him, great baskets of fruit appeared around him filled with bananas, plantains, corozos, melacotones, pataxtes, and cacao. Afterward, Francisco Sojuel went to live in the cave of Paq'alib'al, but to show that he is still alive the same fruits that appeared around him at Sololá may be seen outside the cave entrance.

The Monumento is hung with the same fruits to show that Francisco Sojuel is present in his mountain home. The cross on top is the one on which Christ was crucified but it is also a reminder of the suffering of Francisco Sojuel. The tree growing near Paq'alib'al is a sign that he is still alive and making rain clouds. The twisted columns and ropes of the Monumento represent the snakes that guard the inside of the cave of Paq'alib'al. These are kept in the house of the woman who represents the grandmother at the building of the Monumento, because she is the lady of the serpents. The cloth she winds around her head consists only of colors with no embroidered decorations like other women wear because this is the true rainbow serpent that protects us. The open space at the base of the Monumento represents the entrance into the cave where the ancestors dwell inside the mountain.

[3] This may be an allusion to the flood of water that destroyed the old Guatemalan capital at Santiago de los Caballeros and killed the wife of Pedro de Alvarado following a heavy rain on September 10, 1541. Many of these apocryphal Atiteco stories involve conflicts with the Spanish authorities at Antigua, although that city was not founded until soon after this catastrophe.

Art and Society in a Highland Maya Community

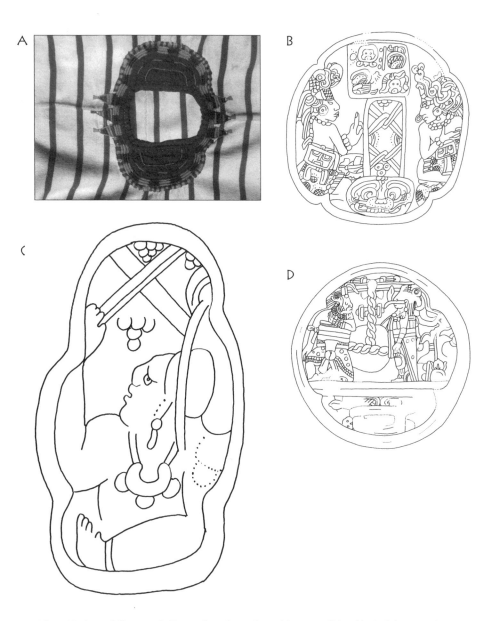

Fig. 4.17. Quatrefoils as symbolic portals to the underworld. (a) Traditional huipil *from Santiago Atitlán. (b) Carved peccary skull, Tomb 1, Copán, AD 376. (Redrawn after B. W. Fash, 1991, Thames and Hudson.) (c) Polychrome vessel with underworld deity, ca. AD 600–850. (Redrawn after Karen Bassie-Sweet 1991, 123, Fig. 38c.) (d) South ballcourt marker, Ballcourt AIIb, Copán, ca. AD 695–738. (Redrawn after B. W. Fash, 1991, Thames and Hudson.)*

Nicolás placed special emphasis on the fact that the ropes used to hang the fruit are twisted like the columns because they represent winding snakes (Fig. 4.18a). Yaxper weaves them together on her loom to provide the framework on which the world is formed and decorated. The coiled-serpent framework may be related to ancient Maya precedent. A Classic period polychrome vessel from ca. A.D. 750–825 depicts the birth of the maize god Hun Nal Yeh, who emerges through a dark underworld portal framed by twisted cords that terminate in serpent heads (Fig. 4.18b). These twisted serpent-cords represent the umbilicus from which the world is born (Freidel et al. 1993, 99). Dunham finds evidence that the modern Yukatek-Maya consider this umbilicus, or "living rope," to be the basic framework upon which both the sky and earth are organized:

A

> There is a suite of myths among the Yukatek, with reflections elsewhere, that describe a heavenly road connected to and sometimes contiguous with a "living rope" filled with blood that descends from the sky, often through the heart of a giant ceiba at an important site. . . . The living rope passes through the world tree at the center of creation. It may be connected, perhaps through the tree's roots and the cenote (the cenote is a sort of the underground equivalent of the tree), to subterranean routes that may somehow recirculate this divine celestial power through the realm of the dead and back to the world of the heavens. (Quoted in Freidel et al. 1993, 425 n. 60)

Both the Monumento and altarpiece follow the same basic organization. A central world tree/cross stands at the top with the twisted serpent cords extending beneath to frame the mountain of creation and guard the principal access to the abode of the ancestors in the underworld. The maize god, Jesus Christ, Santiago, and Francisco Sojuel represent analogous figures who emerge from the underworld to bring life and charge the cosmos with renewed sacred power. The renewal of the earth is reenacted with the annual decoration of the Monumento with fruit, flowers, and cedar boughs. Once this has been

B

Fig. 4.18. Twisted serpents forming the framework of the cosmos. (a, left) Monumento in the church. (b) Polychrome vessel depicting the birth of the maize god, ca. AD 700–850. (Rollout photograph by Justin Kerr 1977—File No. K688.)

accomplished through the resurrection of Christ at the end of Holy Week, the Monumento is dismantled to reveal the great altarpiece behind it. Its physical permanence reassures the community that the world will continue under the protection of familiar saints safely sheltered in the niches of their mountain home.

Traditionalist Atitecos believe that all things that bear power possess their own living *k'u'x* (heart) that embodies the same life-sustaining presence that quickens the ancestors and saints of the community. With the construction and subsequent decoration of the Easter Monumento with evergreen boughs, fruits, and flowers, the "heart" of the altarpiece is restored to its ancient original strength, just as if it were created anew, reborn as the first creation at the beginning of time. It thus becomes the symbolic center of a new world that extends outward to the four directions beyond the walls of the church.

The Iconic Motifs of the Central Altarpiece

T his chapter examines the major symbolic elements present on the main body of the central altarpiece at Santiago Atitlán as they relate to the cultural experience of the Tz'utujils. Although each of these motifs may be read as a discrete symbol with its own mythic associations, each is nevertheless consistent with the overall theme of the altarpiece as a sacred mountain.

THE CRESTAL TREE AS THE *AXIS MUNDI*

The central altarpiece at Santiago Atitlán portrays the fundamental organization of the world, bounded by the horizon at the four cardinal directions. The tree at the top represents a human heart composed of two concentric rings with foliage growing from it and a jade necklace hung between its branches (Figs. 1.4, 1.5 *A*, and 5.1). Diego Chávez purposely left the species of tree ambiguous since he wanted it to represent all life-giving plants. Nevertheless, he frequently referred to it as a maize plant in our discussions. Diego explained that the heart marks it as *ruk'u'x kaj, ruk'u'x ruchiliew* ("heart of sky, heart of earth"). The inner circle represents the sky and the outer one the world below it. The jade necklace identifies the tree as the source of power for the Maya, although he did not wish to elaborate on the meaning of this power or how it functions. Nicolás also identified the tree as maize and said that the altarpiece represents in monumental form the way maize plants are cultivated:

After maize sprouts and begins to grow, the Maya use their hoe to build up a little mound of earth around its stalk to support it. This mound represents the mountain where maize first grew. The real mountain was very large like the altarpiece, but every maize plant has its little mountain.

The association of the altarpiece with the source of maize and sustenance predates the work of the Chávez brothers since we know that in 1953 Mendelson's informants had referred to the central altarpiece as the *mero, mero* ("real thing"), "the place where there is our mother corn, our mother bean, our money" (1957, 444). Thus when Diego Chávez began work on the reconstruction of the monument as a sacred mountain from which maize and other life-sustaining things

Fig. 5.1. Stylized world tree from the top of the central altarpiece. The tree represents the first life to emerge from the earth at the center of creation.

emerge, his designs served to reemphasize concepts which were already current in the community. Robert Carlsen and Martín Prechtel wrote that the people of Santiago Atitlán identify the altarpiece as the *kotse'j juyu ruchiliew* ("flowering mountain earth"), the center point of creation according to Tz'utujil cosmology as expressed by confraternity elders with whom the researchers worked closely (Carlsen and Prechtel 1991; Carlsen 1997). From this mountain grew a sacred tree:

> *In Atiteco myth, before there was a world (what we would call the universe), a solitary deified tree was at the center of all that was. As the world's creation approached, this deity became pregnant with potential life; its branches grew one of all things in the form of fruit. Not only did gross physical objects like rocks, maize, and deer hang from the branches, but so did such elements as types of lightning, and even individual segments of time. Eventually this abundance became too much for the tree to support, and the fruit fell. Smashing open, the fruit scattered their seeds; and soon there were numerous seedlings at the foot of the old tree. The great tree provided shelter for the young "plants," nurturing them, until finally it was crowded out by the new. Since then, this tree has existed as a stump at the center of the world. This stump is what remains of the original "Father/Mother," the source and endpoint of life. The focus of Atiteco religion is in one way or another oriented backward, to the Father/Mother, the original tree. This tree, if properly maintained, renews and regenerates the world. (Carlsen 1997, 52)*

In the *Popol Vuh* and other highland Maya documents, the creator gods searched for a substance from which to make the flesh of mankind. After many failed experiments, they were led to a mountain called Paxil ("Broken Open," "Split," or "Cleft") by the fox, coyote, parrot, and crow before the dawn of the sun. There they discovered the maize from which they fashioned the bodies of the first humans.

> *It was from the places Paxil and Cayala that the yellow ears of corn and the white ears of corn came. . . . The newly framed and shaped people, therefore, found the food that would become their flesh. Water was their blood. It became the blood of humanity. The ears of corn entered into their flesh by means of She Who Has Borne Children and He Who Has Begotten Sons. (Christenson 2000, 128)*

One of the most common themes in ancient Maya art and literature is the emergence of maize from the underworld, either in the anthropomorphic form of the maize god, or as a world tree at the center of creation. Carlsen and Prechtel suggest that the tree atop the Santiago Atitlán altarpiece is related conceptually to pre-Columbian Maya beliefs concerning maize, particularly as manifested in the art and architecture of ancient Palenque (Carlsen and Prechtel 1991). A beautiful example of the deified, vegetal form of maize may be seen in the main sanctuary panel of the Temple of the Foliated Cross at Palenque (Fig. 5.2). In this depiction, the maize plant is carved in the shape of a cross adorned with a precious jade necklace and abundant foliage, similar in concept though not in style to the tree at the top of the Santiago Atitlán altarpiece. Diego Chávez visited Palenque prior to his work on the altarpiece and may have had this image in mind when he designed his version of the world tree. The delicately curling leaves of the Palenque tree cradle tiny maize god heads with long flowing hair indicative of cornsilk. The upper branch is marked by a deity with a mirror fixed in its forehead, indicating that the plant is resplendent, glowing like light reflected from a shiny mirror. The god's earflares display a quincunx pattern suggesting that the tree stands at the center of the four directions of the cosmos.

In the ancient Maya myth of creation, the maize god erected this world tree after emerging from the underworld to support the arch of the heavens (Freidel et al. 1993, 69–75). Being the center point of the newly emergent world, the tree shares with the first mountain of creation what Mircea Eliade refers to as the symbolism of the center, the point of "absolute beginning," where the latent energies of the sacred world first came into being (1959, 36–42). In Maya cosmology, the world tree represents the vertical axis, or *axis mundi*, which stands at the center of all things and passes through each of the three major layers of existence—underworld, earth's surface, and sky. In addition to serving as the vertical pivot point of the cosmos, the world tree also oriented the horizontal plane of the world by extending its branches outward toward the cardinal directions. This concept is indicated on the Tablet of the Foliated Cross by the deity heads along its trunk which face outward to the four directions.

To the left of the maize plant/tree on the Panel of the Foliated Cross, Lord Kan Balam stands in his royal regalia, including the jade net skirt characteristic of the maize god. Beneath him is a *witz* monster with a cleft forehead, the Maya convention in zoomorphic form of

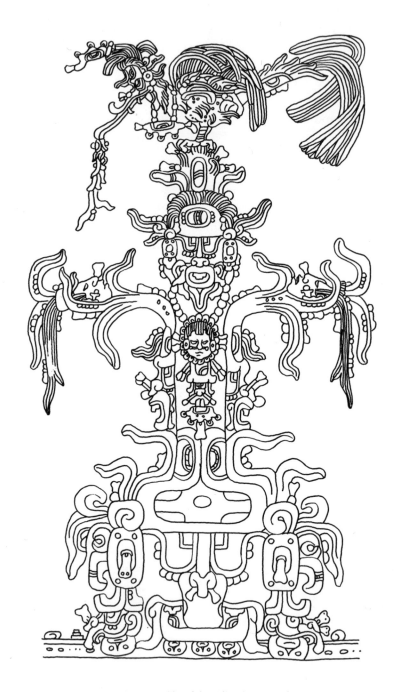

Fig. 5.2. Tablet of the Foliated Cross, Palenque, ca. AD 690.
(Redrawn after Linda Schele, in Freidel et al. 1993, Fig. 1.9b.)

Art and Society in a Highland Maya Community

depicting sacred mountains. Glyphs infixed in the eyes of the monster identify it as Yax Hal Witz Nal ("first true mountain place"), the first mountain of creation (Quenon and Le Fort 1997, 898). Thus Kan Balam represents the resurrected form of the maize god as he emerges from the first mountain of creation to bring new life and erect the cosmic world tree.

Although presented in political terms, the concept is fundamentally the same as that of the altarpiece at Santiago Atitlán. The maize plant/sacred tree atop the monument emerges from its mountain source at the beginning of time to provide life-sustaining nourishment for the people of the community. The tree eventually yields its fruit and dies, making way for the succeeding generations of sacred trees, each of which is brought to life and sustained through ritual.

SUN VESSELS AND THE SACRIFICIAL ANIMALS PANELS

The vessels with the sunburst pattern adorning the periphery of the third tier of the altarpiece further develop the notion that the Santiago Atitlán altarpiece represents the source of life-sustaining maize (Figs. 1.4, 1.5 C, and 5.3). In a discussion concerning this motif, Diego Chávez said that although it ostensibly represents the sun as it rises and sets on the opposite slopes of the mountainside, it also symbolizes all things which give life and provide nourishment, particularly maize:

This design represents the "flower of maize" which grows like a plant from the earth. The pot underneath represents the interior of the earth or death. For the Catholics, the source of life is the sacramental Host and this is what is shown in the pot on the right side of the altarpiece. For us it is the tortilla, which has the same shape, and which may be seen in the pot on the left side. From the top of it rise maize tassels or the hair of the ear of maize. I made them look like sun rays because for us maize is the sun, the most powerful and life-giving of all things. Maize is the "sun" of our existence.

Diego called the design *tz'utuj* ("flower of maize") and indicated that it is the source of life for his people. This is the root word from which the name Tz'utujil ("he/she of the maize flower") is derived, an

Fig. 5.3. Sun vessel motif. The face emerging from the vessel represents both the sun and the bread of life—the sacramental Host for Roman Catholics and tortillas for the Maya. Both signify the flesh of deity given to sustain life.

indication that the motif symbolizes the source of life for the people of Santiago Atitlán specifically. For the Tz'utujils, maize is not only essential to survival, but to all aspects of their cultural identity as well.

Traditionalist mothers in Santiago Atitlán put an ear of maize into the palm of their newborns and eat only dishes made from maize while breast-feeding to ensure that the child grows "true flesh." Once weaned, the child is given food prepared with locally grown maize so that the child will grow to become a legitimate member of the Atiteco community. This tradition has become more difficult to follow in recent times due to a decline in maize production, although residents of Santiago Atitlán would still prefer to eat maize grown nearby.

Vogt noted the belief among the Tzotzil-Maya of Chiapas that "unless people eat maize tortillas, they are never fully socialized, nor can they ever speak BAZ'IK'OP ('the real word,' 'Tzotzil')" (1976, 50). On a number of occasions, Atitecos surprised at my ability to speak highland Maya languages asked whether I ate tortillas or wheat bread like other foreigners. When I told them that I always ate tortillas with my meals they took that fact as an explanation for my knowledge, however faulty, of Tz'utujil. The same association between the ability to speak and maize may be seen in the *Historia Tolteca-Chichimeca,* in which Nahua speakers give barbarous Chichimec messengers a kernel of maize so that they can speak their language properly (Kirchoff et al. 1976, 169).

The climax of the creation as outlined in the *Popol Vuh* occurred when the gods discovered maize within the sacred cleft mountain of Paxil, which they used to form the flesh of humanity (Christenson 2000, 128; D. Tedlock 1996, 145–146). This mythic connection between maize and human flesh likely influenced birth rituals in highland Guatemala for centuries. According to Fuentes y Guzmán, when a male child was born, the seventeenth-century Maya of Guatemala burned blood shed from its severed umbilical cord and passed an ear of maize through the smoke. They then planted the seeds from this ear in the child's name in a specific area of the milpa field. Parents used the maize from this small patch of land to feed the child "until he reached the age when he could plant for himself, saying that thus he not only ate by the sweat of his brow but of his own blood as well" (1969, I:281).

The symbolic connection between the sun, maize, and human beings is an ancient concept evident also in the *Popol Vuh*. In the account of the creation, the gods came together in the primordial sea to determine how the world was to be made. This creative act is described most frequently as a couplet pairing the verbs *awaxoq* ("to be sown") and *säqiroq* ("to dawn"):

"How shall it be sown? How shall there be a dawn for anyone? Who shall be a provider? Who shall be a strengthener? Then be it so. May it be conceived. May the water be taken away, emptied out, so that the level surface of the earth may reveal itself. Then will be the sowing, the dawn of sky and earth. There can be no glory, no clarity to what we have framed and what we have shaped, until humanity has been created, until people have been made," they said. (Christenson 2000, 42–43)

The creation of all things, including humanity, is therefore likened to the fundamental concepts of sowing a maize field and the dawn of the sun. These are not considered independent actions, but equivalent expressions for the same generative event. Among the modern K'iche's, when a woman becomes pregnant, the event is announced by a respected elder of the community at certain lineage shrines. This ceremony is referred to as "the sowing" of the future child (B. Tedlock 1982, 80). In Tz'utujil, as in most highland Maya languages, to give birth is "to dawn" or "give light" (*ya' säq*). In Chichicastenango, children are often called *aläj q'ij* ("little sun"), or *aläj q'ij saj* ("little ray of sun") (Schultze Jena 1947, 25).

In his explanation of the sun vessels, Diego went on to say that life cannot exist without sacrifice. Maize must be crushed on a grinding stone before it can be made into tortillas. The wheat in the sacramental Host must also be ground and baked. The sun can only rise in the east after it has been buried in the west. He pointed out that anciently the Maya sacrificed people, but now they offer deer, turkeys, chickens, incense, or maize, "but it is all the same thing." Gods and sacred animals give their lives so that new life can emerge:

Tortillas, the Host, Jesus Christ, and the sun give life because they are first killed. Tortillas and bread result from the death of maize and wheat so that they can give us life. They are therefore gods. That is why I carved sacrificial animals next to them—a Christian ram on the right, and a Maya deer on the left [Fig. 3.5]. If maize harvests were bad, people went to the nuwals *who made sacrifices and called on Martín as the lord of the mountains to send deer to bless the maize fields. The deer encircled and walked through the maize to bless it. They brought* ruk'u'x way *("heart of food") and left it planted in the fields. Beneath these animals I placed on the altarpiece a deer's antler and a small gourd to gather the blood that is shed during sacrifices [Fig. 5.4].*

In Roman Catholicism, the Eucharist represents an act of perpetual sacrifice in which a priest offers the flesh and blood of Christ to the faithful as a life-sustaining communion. This is an idea which resonates well with ancient Maya beliefs concerning the sacrificial death of the maize god, whose body provides nourishment while carrying within itself the potential to rise again from death.

The syncretism invented by the Chávez brothers to equate tortillas, as the staple of the Tz'utujil diet, with the eucharistic Host is

Fig. 5.4. Cup and antler motif. Both are symbolic of sacrifice, a necessary prelude to rebirth in Tz'utujil theology.

typical of the Maya adaptation of Roman Catholic theology since the sixteenth century. The first thirteen pages of the *Título Totonicapán,* written in 1554 by K'iche'-Maya lords, consists of a modified version of a K'iche'-language treatise on the Old Testament called the *Theologia Indorum,* composed one year previously by the Dominican friar Domingo de Vico (Acuña 1983; Carmack 1983). Although much of the Totonicapán document quotes Vico's text directly with little modification, its authors significantly altered key passages to reflect their own Maya theology. In the story of Cain and Abel, the *Título Totonicapán* substitutes Cain's "unworthy offering" with "forgotten ears of maize," while Abel's sacrificial lambs become well-harvested maize (Carmack 1983, 13–14, 171). This demonstrates that the Maya soon after the conquest associated the notion of divinely acceptable blood sacrifice with harvested maize, just as the Chávez brothers do in their art.

The Chávez brothers honored Father Rother as the spiritual representative of the sacrificed Christ and the Eucharist by placing his initials—"PFR" for Padre Francisco Rother—around the sacrificial animals on both sides of the altarpiece (Figs. 1.5 *D* and 3.5). Diego noted that when the priest blesses the sacramental Host and wine, he generally wears a green cassock (worn throughout the year except on special occasions such as Easter or the Day of the Dead) and holds his arms outstretched like a tree. In this position, he replicates the shape not only of the cross but of the world tree at the top of the altarpiece which looms behind him. A number of Atitecos that I spoke to noticed that when the priest officiates at the altar, he stands immediately in front of Santiago's niche and appears to be emerging from the interior of the altarpiece along with the other saints. They therefore perceive the priest as bringing the Eucharist from the mountain of creation, just as the ancient gods once extracted the first maize from a mountain to form the flesh of humanity.

Father Rother likely understood some aspects of this association as he often wore a green stole embroidered with Maya-style maize gods while officiating at Mass. Nicolás wished to reinforce the notion that the priest represents the divine aspect of maize by carving a maize god on the back of the sacerdotal chair used during worship services, located just right of the raised altar (Fig. 5.5). The legs of this chair are from an older collapsed altarpiece. Nicolás chose these pieces because he interprets the figures carved on them as ancient Maya ancestors who bring the fertility of the earth with them in the form of fruit and maize.

A

Fig. 5.5. (a) Photograph of the priest's chair, carved by Nicolás Chávez Sojuel. (b) Author's drawing of the chair. The maize god motif on the chair's back links the Roman Catholic priest with the ancient Maya deity who sustains life through auto-sacrifice.

Nicolás also identified the small gourd cups and antlers on the altarpiece with sacrifice and likened the designs to rituals carried out in the Confraternity of San Nicolás. Left of the main altar in this confraternity is a chest containing a sacred bundle dedicated to María Castelyan as a creator deity. The chest also contains a small obsidian blade hafted to a forked stick, along with two or three gourd cups (Fig. 5.6). The obsidian blade is used to draw blood in penitential rites, as well as curative bleedings to heal illness (Douglas 1969, 157–158; Carlsen and Prechtel 1994, 98). The gourd cups are used to collect the blood, as well as to serve *maatz'*, the toasted corn gruel that represents a type of sacrament in token of sacrificed maize. Until

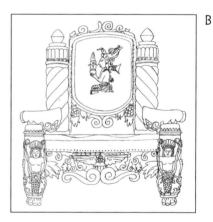

B

recently, confraternity elders smeared blood collected in this way on the mouth of a large stone image located in the foothills east of the church (Mendelson 1956, 43). This act appears to have been related to the preconquest practice of smearing sacrificial human blood on the mouth of the Tz'utujil god Saqibuk (*Relación de los caciques* 1952 [1571], 99), although it was perhaps also influenced by the role of bloodletting in European medicine. A Catholic priest had the stone image destroyed some forty years ago.

Blood gathered at the Confraternity of San Nicolás is now burned on a small mound of ashes in the confraternity house complex or

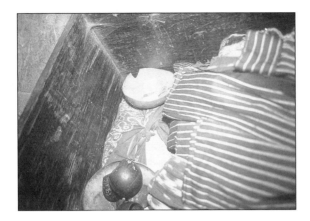

Fig. 5.6. The interior of the María chest in the Confraternity of San Nicolás. The gourd cups are used in bloodletting rituals.

dumped at a place nearby where two paths meet. The head of the confraternity told me that in times past the blood of gravely ill persons was taken by canoe out onto the lake to be dumped. All of these locations are associated with entrances into the underworld.

MAIZE GODS: THE COSMOS AS A SACRED MAIZE FIELD

In the pediments of the niches at the extreme right and left of the first tier of saints are two pairs of pre-Columbian–style maize gods (Figs. 1.4, 1.5 P, 2.3a, and 5.7). As previously mentioned, Father Rother suggested that the Chávez brothers incorporate a Maya motif to represent the Christian "bread of life." The artists chose the maize god since maize is the principal staple of the Atiteco diet and is therefore analogous to Western bread. Yet although Father Rother apparently intended the design to represent Christ as the sole source of spiritual sustenance, it is repeated four times. Diego Chávez told me that the four maize gods symbolize the "directions of the world." The mountain represented by the altarpiece thus grows vertically out of the center where the four cardinal directions meet.

In the *Popol Vuh* account of the creation, once the gods had placed the sky on its mountain supports, they laid out the four corners of the world and stretched a cord between them to establish its limits:

All then was measured and staked out into four divisions, doubling over and stretching the measuring cords of the womb of heaven and the womb of earth. . . . all that exists in the sky and on the earth, in the lakes and in the seas. (Christenson 2000, 39)

Fig. 5.7. Maize god motif from the central altarpiece. The four maize gods depicted on the monument represent the four cardinal directions of the earth.

Like the altarpiece maize gods, the four divisions mentioned in the *Popol Vuh* represent the cardinal directions. In the *Popol Vuh*, the ancient gods laid out the extent of their creation by measuring its boundaries, driving stakes to mark its four corners, and then stretching a measuring cord between the stakes. Andrés Xiloj, a K'iche' priest-shaman who worked with Dennis Tedlock on his translation of the *Popol Vuh*, recognized the terminology of this passage and explained that the gods were measuring out the sky and earth as if it were a maize field being laid out for cultivation (D. Tedlock 1985, 244).

Nicolás also likened the quadrilateral arrangement of the world to the way that a maize farmer lays out his field for planting. While discussing the four maize gods on the altarpiece, Nicolás asked me to take out a drawing that I had made of the church's pulpit/lectern that he had designed before Father Rother's death (Fig. 5.8). He said that both carvings represent the same idea, that the world is organized in the form of a quadrangle just as a farmer lays out his maize field:

Fig. 5.8. (a) Photograph of the pulpit/lectern from the church, carved by Nicolás Chávez Sojuel. (b) Author's drawing of the pulpit/lectern. The artist adapted orthodox Catholic imagery by placing a Maya maize god at the center as the counterpart to Jesus Christ as the principal sustaining deity. He also altered the iconography of the four evangelists by transforming the eagle of St. John into a quetzal bird, sacred to the Maya, and the bull of St. Luke into a deer.

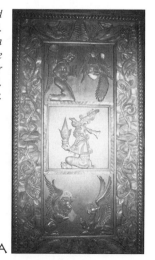

A

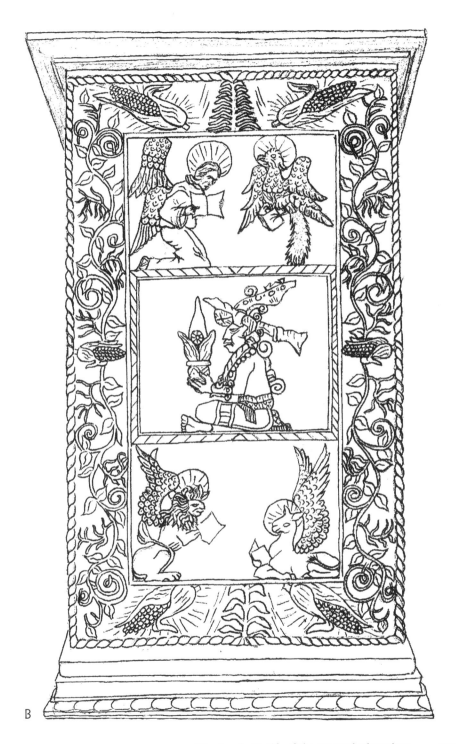

B

Father Rother wanted me to show that words taught from the pulpit of the church are the bread of life. For us, this is maize and so I put a maize god in the center, surrounded by the apostles who wrote the Bible. At first the priest wanted me to carve human faces for the apostles, but I suggested that I use their animal symbols instead.[1] This center part represents the church with its four corners and the altar as a maize god in the middle. Around this I wanted to show the world. I put maize plants above and below to show that the source of life is maize. At the corners I put ears of maize to represent the four directions, and another two on the sides to represent the sky above and the underworld below the earth where the ancestors live. The vines running around the edges are black bean plants which we also grow in the maize fields.

The pulpit, the church, the maize field, and the world itself all describe the same model of a quadrangular space bounded by the four cardinal directions with a center point giving access to the source of life. This pattern recalls the quincunx arrangement in ancient Maya art and architecture which represents the cosmos itself with the four sides generating the limits of creation (Wagner 1997; Schele and Mathews 1998, 26–27). Vogt noted that this same arrangement is central to the cosmology of the modern Tzotzil-Maya of Zinacantan:

Houses and fields are small-scale models of the quincuncial cosmogony. The universe was created by the VAXAK-MEN, gods who support it at its corners and who designated its center, the "navel of the world," in Zinacantan Center. Houses have corresponding corner posts and precisely determined centers; fields emphasize the same critical places, with cross shrines at their corners and centers. (1976, 58)

This pattern is also evident in Santiago Atitlán, where the cultivation of maize represents the basic metaphor for the creation of the cosmos and its spatial orientation. Fray Gerónimo de Mendieta wrote in the

[1] In Tz'utujil thought, gods, saints, and people all have an animal spirit familiar that lives a parallel life and shares the same character as the individual. Saints associated with animals—San Martín with a horse or San Pedro with a rooster—are particularly popular in Santiago Atitlán, perhaps because of this belief. I suppose that Nicolás' preference for the animal forms of the evangelists stems from this concept as well. It is interesting to note a bit of syncretism in the choice of symbols. The angel of St. Matthew and the lion of St. Mark follow accepted canons of Roman Catholic iconography. The eagle of St. John, however, has been replaced with a quetzal bird, sacred to the Maya; the bull of St. Luke has the head and body of a deer, albeit with a bovine tail.

Art and Society in a Highland Maya Community

sixteenth century that rituals and beliefs concerning maize were the most persistent native elements to survive the conquest because they were so heavily tied to the Indians' everyday way of life: "They continue to worship their devils by night, especially at the time of planting and harvesting of maize, such rites having been performed since time immemorial by their ancestors and thus understandably difficult to abandon" (1993, 232). Fuentes y Guzmán noted that this tendency continued in Guatemala more than a century after the conquest:

Everything they did and said so concerned maize that they almost regarded it as a god. The enchantment and rapture with which they look upon their maize fields is such that on their account they forget children, wife, and any other pleasure, as though the maize fields were their final purpose in life and the source of their happiness. (1932–1933, I.12.3; translation by author)

After pointing out the elements of the pulpit, Nicolás said that he based his design on the way that farmers who practice the old traditions lay out their fields:

After preparing the ground, but before planting, four colored candles are placed at the corners of the maize field representing the four directions of the earth—white for the east so that light will shine on the seeds; red to the west so that the maize will not be burned by the sun; green for the north so that the maize seed will be protected; and blue for the south so that the harvest will be abundant. These four candles are the ears of maize in the corners of the lectern. See how I put rays of light around them? In the middle of the maize field, the farmer arranges a circle of 12 or 24 candles along with incense, drinks, chocolate, sugar, and honey. At the center of the circle he then places a special kind of maize ear called yo'x ["twins"] which splits at the end to form extra little cobs. These have been previously blessed by an elder in the Confraternity of San Juan where the ruk'u'x way ["heart of food"] is kept in a wooden chest. Many yo'x cobs hang from the ceiling there because this is where maize is born. These cobs are burned and farmers bury the ashes beneath the ground so that they can come back to life and make more maize.

Carlsen also noted that some Atitecos continue to place offerings for their ancestors in a hole at the center of their fields (Carlsen 1991,

27). Ximénez described similar rituals among the K'iche's soon after the Spanish Conquest (1929–1931 [1722], I.xxxi.88). In his account, the Maya placed fire and incense at the four corners of the field and at the center, which they designated as the "heart."

The hole in the center of the maize field into which the ashes of the *yo'x* maize cobs are buried is called the *r'muxux* ("navel"), the same name applied to the world center hole in the church. It is likely that both are conceptually equivalent portals to the underworld realm of the dead. The alcohol, chocolate, sugar, and honey placed at the center of the field are all derived from fluids taken from living sources. For the ancient Maya, these substances are laden with *itz,* the "magic stuff" which animates and sustains life. Freidel, Schele, and Parker suggest that Yucatec-Maya shamans use *itz* in their ceremonies in a reciprocal way (1993, 51). With it they open a portal to the other world to nourish and sustain the divinities who reside there. In return, the offerings charge the earth with sacred power so that it may produce abundant harvests in their season as well as sustain all life in general. The cultivation of maize serves as a metaphor for the nature of the world which must also be carefully tended and nourished through human agency. Its neat rows of carefully tended maize contrast with the surrounding forest as a place of order and symmetry in the midst of chaos. Davíd Carrasco wrote that for the Maya,

> *Agriculture is not just a profane skill, but . . . it deals with powers and life forces that dwell in the seeds, furrows, rain, and sunshine. Human society and the agricultural process are viewed as set within and dependent upon the dramatic and tense cosmic cycles that insure the vital process of plant fertilization, ripening, harvest, decay, death, and rebirth. The forces in the plants, land, and rains are viewed as sacred forces, which reveal themselves in dramatic and critical moments that are never to be taken for granted. In fact the Maya not only considered the plants and seeds as in need of regeneration, but the entire cosmos depended on various processes of rebirth (1993, 98–99).*

The Atiteco practice of first burning and then burying split cobs of maize, which they call *yo'x* (twins), recalls the history of the Hero Twins in the *Popol Vuh* (Christenson 2000, 83–126). These twins, named Hunahpu and Xbalanque, were conceived miraculously by a maiden named Xkik' in the underworld realm of Xibalba. After climbing up to the world of the living, Xkik' gave birth to twin boys,

who grew up in the household of the aged grandmother goddess Xmucane. Xmucane appears in earlier passages as the patron deity of midwives who helped to bring about the birth of the world through divination (Christenson 2000, 37–39; D. Tedlock 1996, 69–70). She was also the goddess who ground the first maize to make the flesh of mankind (Christenson 2000, 127–129; D. Tedlock 1996, 146).

In time, the lords of death summoned the twins to the underworld. Their distraught grandmother pleaded with them not to go since she feared that they would die there just as her son had years before. To comfort her, the twins planted two ears of maize in the center of the family house which would live or die depending on what befell them in the underworld:

"This is the sign of our word that we will leave behind. Each of us shall surely plant an ear of corn in the center of the house. If it dries up, this is a sign of our death. 'They have died,' you will say when it dries up. If then it sprouts again, 'They are alive,' you will say, our grandmother and mother. This is the sign of our word that is left with you," they said.

Thus Hunahpu planted one, and Xbalanque planted another in the house. They did not plant them in the mountains or in fertile ground. It was merely in dry ground in the middle of the interior of their home. (Christenson 2000, 103)

The planting of the two ears of maize in the center of the grandmother's house as symbolic proxies for the Hero Twins suggests that their descent into the underworld is to be understood as a metaphor for the life cycle of maize. Just as the mature maize plant dies and its seed is buried in the earth, it bears within itself the power to grow again out of the ground to new life.

Nicolás Chávez noted that the first ears of maize buried in newly prepared fields are of the special type called *yo'x* ("twins"), which bear multiple cobs, perhaps a recollection of the descent of the twins into the underworld. These ears are often blessed in the Confraternity of San Juan, whose rafters are hung with numerous examples of such split maize ears (Fig. 5.9). Atitecos believe that eating maize from *yo'x* cobs engenders twins, further connecting these special ears of maize with their human counterparts (Mendelson 1957, 253, 375). The *yo'x* also have anthropomorphic counterparts as the twin sons of the Virgin Mary. An image belonging to the Confraternity of San Juan called Ruyo'x Mari'y ("Mary's Twins") displays two children held in the

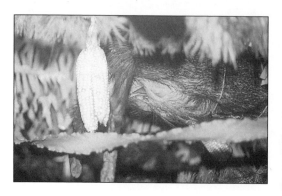

Fig. 5.9. Yo'x *(twins) split-cob ears of maize hanging from the rafters of the Confraternity of San Juan. Such cobs are considered sacred as tokens of abundance.*

Fig. 5.10. *The image of Ruyo'x Mari'y (Mary's Twins) in the church. The two children are symbolically linked with split-cob maize and receive petitions for abundant harvests.*

arms of a rather unhappy looking Virgin (Fig. 5.10). Although the children appear to be female, many Atitecos identify them as twin "maize boys" and pray to the image for abundant harvests.

The Confraternity of San Juan may also be conceptually linked to the house of Xmucane, the grandmother in the *Popol Vuh* story. As noted in Chapter 4, this confraternity houses one of the major devotional images of Yaxper, the patron deity of midwives (Mendelson 1958a, 123; Tarn and Prechtel 1986, 174; Carlsen and Prechtel 1994, 100). The little figure of Yaxper is kept in a glass case on the altar (Fig. 5.11a). She wears typical Tz'utujil dress, including the winding headband which Atitecos identify as a representation of a rainbow serpent. Yaxper is worshiped as the patron of the moon and is the only divinity in Santiago Atitlán commonly referred to as grandmother. The nature and attributes of Yaxper may also link her to the ancient Yucatec Maya goddess of the moon, childbirth, and midwifery named Ixchel (Goddess O). Ixchel's name means Lady Rainbow (Taube 1992, 99; 1994, 658), and in artistic representations she too wears a serpent headdress (Fig. 5.11b), analogous to the rainbow-serpent winding headband of Yaxper. Like Yaxper, she is also an aged grandmother figure in her aspect as a goddess of midwives.

Mendelson's informants described the Atiteco goddess Yaxper as "a very old woman of ancient times, crippled and bent, but still powerful" (1957, 458). Any woman suffering from sterility or parturition

A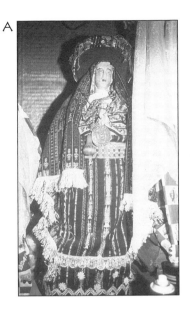

B

Fig. 5.11. Patron goddesses of midwives wearing serpent headdresses. (a) Yaxper, Confraternity Concepción. (b) Ixchel (Goddess O), Dresden Codex 39b. (Redrawn after Villacorta and Villacorta 1930.)

trouble went with an *ajkun* to call upon her because, as the great midwife, she "opened the path for the child" (Mendelson 1957, 458). A secondary cult image of Yaxper is kept in the Confraternity of Concepción ("Conception"), where she assists in birthing ceremonies.

When a woman reaches the seventh or eighth month of pregnancy her chosen midwife often takes her to the porch of the San Juan Confraternity on an evening with a full moon; there she bathes in its light. The midwife also places a basin of water in front of the prospective mother so that she can speak to the moon's reflection and ask for a healthy child. The link with maize cultivation is also evident in that it is customary for Atitecos to plant by the light of the full moon at midnight. According to the *Chilam Balam of Tizimin,* the Maya of ancient Yucatán believed that the moon germinates the seeds of maize, an indication that the Atiteco practice has ancient precedent (Makemson 1951, 41). While carrying out their duties, Tz'utujils believe that midwives are possessed by Yaxper or the moon (Carlsen and Prechtel 1994, 101). In Santiago Atitlán, the role of midwife is extremely important, commanding a level of respect equivalent to community elders. There are few if any young midwives, most being postmenopausal women who are addressed with the honorific title of Grandmother.

A sacred bundle belonging to Yaxper is kept inside the Confraternity house of San Juan in a carved chest made by Diego

A 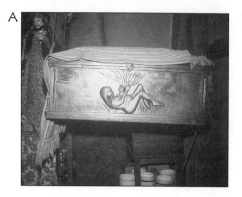 B

Fig. 5.12. María chest in the Confraternity of San Juan, carved by Diego Chávez Petzey.
(a) The carving on the front of the chest depicts a woman giving birth. The chest is dedicated
to the patron deity of midwives. (b) The bundle within represents a placenta and symbolizes
the birth cord linking all humans to their divine origin.

Chávez that bears the image of a woman giving birth (Fig. 5.12a). The chest hangs from the ceiling attached to cords representing the umbilicus which ties the newborn child to its origin in the other world.

The Yaxper bundle is called *ruk'u'x alaniem* ("heart of the placenta") and consists of a small woven cloth with pendant ribbons and tassels which the head of the confraternity said represent umbilical cords and tendrils of plants (Fig. 5.12b). The cloth itself symbolizes the inside of a woman, including the placenta (Mendelson 1957, 374). Three small angel faces are sewn onto the cloth which represent the "corn girls" (Tarn and Prechtel 1986, 175). The cloth is used by midwives and shamans to aid in childbirth as well as in healing ceremonies for sick infants. Following delivery, midwives often bring the placenta to the confraternity to be blessed. It is then wrapped in a cloth and buried, either at the edge of the mother's hearth, or sent to be thrown into the lake (Mendelson 1957, 227, 548 n. 11). Under the ribbons at the base of the cloth are two small, round, very hard cloth bags, which I was told contain dried lumps of maize dough. These are called the *yuxa* ("divine twins"), which Tarn and Prechtel's sources associate with the original placentas, or "seeds" of the human race; all things that have an umbilicus are linked to this womb-root (Tarn and Prechtel 1986, 175–176). The association of placentas with the sacred bundle of the grandmotherly midwife deity Yaxper, which contains the original "seeds" of the human race, likely ties the Confraternity of San Juan with the house of Xmucane, grandmother of the Hero Twins in their aspect as maize deities.

Through trickery, the Hero Twins of the *Popol Vuh* account were able to frustrate the death lords' attempts to kill them in the underworld, but ultimately they realized that they would never be allowed to leave in their mortal state. They therefore planned their own deaths in such a way that they would have power to revive themselves. In front of the underworld lords, who welcomed the prospect of being rid of them, they joined hands and jumped head first into a great stone oven. By prior arrangement, their bones and ashes were then ground to dust and thrown into a river, where they sank to the bottom. The association between the bodies of the Hero Twins and maize is made explicit by the lords of the underworld, who declare, "it would be best if their bones were ground upon the face of a stone, like finely ground corn flour" (Christenson 2000, 116). After five days in the waters of the underworld, the twins reconstituted themselves and emerged as handsome young men who were ultimately able to defeat the lords of death and revive their father.

The immolation of the Hero Twins is a likely source for the Atiteco custom of burning the "twin" maize cobs and burying the ashes in a hole in the center of their fields, thus introducing them into the underworld. At length, the new maize plants grow out of the ground just as the Hero Twins rose from the dead.

Another Atiteco custom that may derive from this myth is the preparation of *maatz'*, a maize gruel drunk only at the most sacred ritual occasions. Unlike the usual type of maize drink which is made from watered-down corn dough, *maatz'* is made from grain that has been toasted and then ground fine before it is mixed with two handfuls of ash and placed in a boiling pot of water. This procedure, the only time that Tz'utujils grind maize kernels into dry flour, or allow maize to come into direct contact with fire, matches the *Popol Vuh* description of the underworld lords grinding the burned bones of the Hero Twins "like finely ground corn flour" (Carlsen 1997, 57–59).

Because traditionalist Atitecos believe that the preparation of *maatz'* is fraught with danger, it is carried out under the direction of the Xo', the wife of the head of the confraternity in which it is to be consumed. A confraternity elder blesses her beforehand so that she will not be burned in the process. (Nicolás Chávez suggested that drinking *maatz'* symbolized victory over death and the fires of the underworld.) The resulting mixture is sometimes addressed as mother's milk or sperm, both associated with rebirth and regeneration (Freidel et al. 1993, 180). Although confraternity members frequently

share food and drink in an atmosphere of informality sometimes bordering on the raucous, they drink *maatz'* with great solemnity. The highest-ranking confraternity elder present distributes it to those assembled in order of their rank. As he does so he addresses each by name and title and calls on the patron saint of the confraternity to bless the recipient so that that person's feet, knees, heart, arms, head, and thoughts will have power and nothing untoward will happen to the individual during the year. The great Tz'utujil culture hero Francisco Sojuel is said to have called *maatz'* the true *ruk'u'x way* ("heart of food") and refused to eat anything else when carrying out important ceremonies (Mendelson 1957, 139).

In the *Popol Vuh* account, the maize stalks left by the Hero Twins in their grandmother's house prior to their departure to Xibalba did indeed wither and die at the same moment that the Twins threw themselves into the underworld oven to be burned:

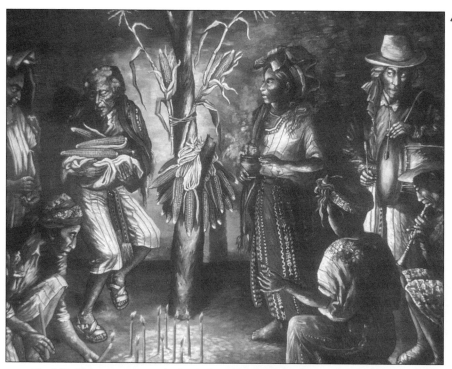

Fig. 5.13. Maize tree ceremony in the Confraternity of San Juan, once performed by the nab'eysil priest to ensure abundant harvests. (a) "The Tree of Life in the Confraternity of San Juan," by Miguel Chávez Petzey. (Courtesy of the artist.) (b) "Worshiping the Maize Tree in the Confraternity of San Juan," by Nicolás Chávez Sojuel. (Collection of the author.)

*Now at the same time, the grandmother was weeping, crying out
before the corn that had been left planted. It had sprouted, but then it
dried up when [the twins] were burned in the furnace. Then the corn
had sprouted once again, and the grandmother had burned copal
incense before it in remembrance of them. For the heart of their grand-
mother rejoiced when the corn sprouted a second time. Thus it was dei-
fied by their grandmother. She named it Center House, Center Harvest,
Revitalized Corn, and Leveled Earth. (Christenson 2000, 125)*

The planting of the maize stalks in the house of the grandmother
goddess also may have a counterpart in modern Atiteco ritual. The
nab'eysil (priest-shaman of the San Juan Confraternity) would erect an
effigy maize plant consisting of a wooden pole hung with leaves and
ripe ears of maize in the center of the confraternity house at harvest
time. An elderly woman featured prominently in this ceremony, tend-
ing the "maize tree" to ensure its fertility. This woman symbolically
represented the patron deity of midwives, Yaxper, conceived as an aged

grandmother with flowing white hair (Tarn and Prechtel 1986, 174). Other worshipers placed offerings of candles, incense, and alcohol before the effigy while the *nab'eysil* prayed on behalf of the plants soon to be harvested, so that they would yield their seed for the benefit of the people and have the strength to grow again at planting time. The ceremony has not been performed for many years and I have not witnessed it myself. Nicolás Chávez suggested that the most recent *nab'eysils* do not observe the ritual because they are unsure of the proper words, and because the carved pole once used as the "maize stalk" has disappeared. He thought that it might have been sold along with other objects from the confraternity by an unscrupulous elder. Several Atitecos described the ceremony to me, however, and considered it to have been one of the more important rituals of the year.

Miguel Chávez Petzey, the brother of Diego and Nicolás and an important artist in his own right, painted a number of versions of this ceremony showing the *nab'eysil* and the elderly representative of Yaxper tending the maize effigy in the confraternity house of San Juan (Fig. 5.13a and b). He said that he remembers seeing the ceremony performed in his youth, an experience that made a great impression on him. The fact that the ritual took place in the same confraternity where the principal image of the moon goddess Yaxper is housed is perhaps significant in view of the Atiteco belief that the first seeds of the planting season should be sown under a full moon, a widespread practice among various Maya groups (Bassie-Sweet 1991, 86).

THE NECKLACE OF TEPEPUL

Both Nicolás and Diego Chávez referred to the beaded spiral design along which the Maya confraternity elders of the altarpiece climb as the "jade necklace of King Tepepul" (Figs. 1.5 I, 5.14). Tepepul, a prominent figure in contemporary Atiteco myths, was a king of the pre-Columbian Tz'utujils and thus the "necklace" design identifies the altarpiece as specific to Tz'utujil ancestors, rather than as the abode of foreign deities. Although no written texts concerning the ancient history of Chiya' are known from indigenous Tz'utujil sources, oral traditions are common. They describe the ancient kings as living in great palaces filled with gold. Gods cooperated with them in planting the earth, so all good things grew in miraculous abundance: maize plants attained tremendous heights, cobs grew twice the size of those

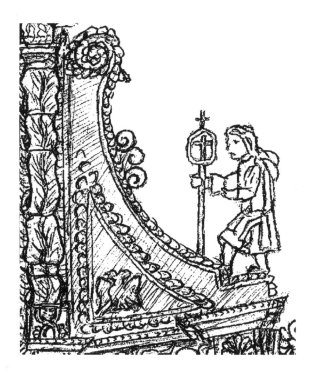

Fig. 5.14. Necklace of Tepepul motif. Many Atiteco myths feature Tepepul, legendary king of the Tz'utujils, as a protector in times of community crisis.

today and were so numerous that a single plant could yield as many grains as an entire small field does now. During times of crisis, such as a drought or an attack by the army, Atitecos say that a bright light like the sun appears at midnight in the ruins of Chiya', which can be seen clearly from town. This is a sign that the ancient kings of the Tz'utujils are present and trying to defend their descendants.

Tz'utujil shamans who sometimes visit a small cave near the ruins of Chiya' leave offerings such as candles, incense, flowers, and liquor as gifts to the spirits of ancient rulers they believe inhabit the interior of the hill (Lothrop 1933, 83). Nicolás said that when powerful shamans go there, they use special words to open the mouth of the cave wider so that they may enter into the hill beyond, much the way they enter Paq'alib'al or the subterranean world under the church.

The most powerful of the ancient kings to inhabit the cave is Tepepul, who sits on a massive stone throne with giant serpents flanking him, each with three heads and long hair. These are called *rutz'i' Tepepul* ("dogs of Tepepul") because they protect the king as well as the hordes of gold and jewels that lie in heaps around him. Sometimes people who suddenly come into a lot of money are rumored to have

visited Tepepul in his underground court. Few envy such persons, for Tepepul's wealth is heavily cursed and those who try to possess it generally meet an untimely and painful end. Old people sometimes leave rocks at the cave's entrance to symbolically seal it so that Tepepul cannot get out and cause trouble, particularly earthquakes and strong winds.

THE CULT OF THE SAINTS IN SANTIAGO ATITLÁN

With the rise of the cult of the saints in Europe, altarpieces of the type decorating the church at Santiago Atitlán grew in importance as a means of displaying sacred images. At the Synod of Trier in 1310, the Roman Catholic Church ordained that every altar should identify in some way the saint to whom it is dedicated (Dunkerton et al. 1991, 26), whether through inscriptions, paintings, or sculpted images. Composite altarpieces developed as a means of presenting patron saints in a visually striking manner and could be placed directly on the altar (a dossal) or, like the altarpiece at Santiago Atitlán, behind it at a short distance (a retablo). The latter arrangement allows the officiating priest to stand behind the altar of the Eucharist, facing the congregation, with the retablo rising behind him as a backdrop. By at least the fifteenth century, such altarpieces were especially popular in Spain and rapidly grew in size and elaboration. The great altarpiece in the cathedral at Seville, built between 1481 and 1564, stands 23m. high and involved the work of more than a dozen sculptors and painters. Because Seville served as the exclusive embarkation point for all trade and missionary activities to the New World, its art and architecture had a great impact on colonial churches (Webster 1992, 11). Composite altarpieces of the retablo type became the most common type of apse decoration in colonial Mexico and Guatemala, just as they were in Seville.

As identified by Atitecos, the saints in the lower tier of the altarpiece (Figs. 1.4 and 1.5 Q–U), are, from left to right, María Andolor (Mary of Pain),[2] San Juan Apóstol (St. John the Apostle, nicknamed San Juan Carajo—"St. John the Prick"), Santiago Mayor (St. James the Great, the

[2] The name of this image likely derives from the Spanish Virgen Dolorosa, known to English-speaking Catholics as the Sorrowful Virgin. Though "sorrowful" is likely more accurate from a Roman Catholic theological standpoint, most Atitecos use the more literal term "pain" when referring to her characteristics. In addition, people with severe pain pray before her image for relief, implying that they have this concept in mind.

town's patron saint), Santiago Menor (St. James the Lesser, who acts as the interpreter and counselor for Santiago Mayor), and María Zaragosa, also known in Santiago Atitlán as María Dragón ("Dragon Mary"). The latter's name is derived from the winged, multiheaded dragon beneath her, a creature that Tz'utujils consider a protective serpent rather than a symbol for the devil.

The identities of the second tier of saints are much less clear (Figs. 1.4 and 1.5 *K–M*). Not even the *cabecera* (principal elder of the confraternity system) or the president of the Church Committee were positive as to who is represented. In speaking with *ajkuns,* who include all of the saints in their prayers, it is apparent that each worshiper is free to choose identities for these lesser divinities according to personal needs. Diego Chávez suggests that they are San Pablo (St. Paul), Simón Mam ("Simon Grandfather" or "Simon the Ancient"), and San Marcos (St. Mark). The saint in the third-tier niche is San Francisco (St. Francis), whose prominent position no doubt reflects the fact that the church was founded by Franciscan missionaries (Figs. 1.4 and 1.5 *E*).

At the pinnacle of the monument, representing the highest point of heaven in Catholic iconography, is the half-length figure of God the Father making the sign of the Trinity with his right hand and holding the orb of the universe in his left (Figs. 1.4 and 1.5 *B*). Originally the altarpiece had light rays radiating outward from this upper tier, which the Chávez brothers replaced with the world tree/maize plant motif.

Each saint plays a specific role in Atiteco society, some related to European Catholic precedents, others completely unrelated. San Francisco is the patron deity of the dead and watches over their souls in the underworld. The two Marys on the altarpiece are considered distinct individuals:[3] María Dragón ("Mary of the Dragon") is a protective deity who commands the winged serpent beneath her and the serpents on the columns of the altarpiece in order to defend the town and keep it from harm; María Andolor ("Mary of Pain") is a young moon deity associated with fertility, sexual licentiousness, and

[3] Atitecos recognize at least twelve separate Marys. Some are considered sisters. Several have husbands. They are nearly always invoked in formal Atiteco prayers, although the order and secondary titles may vary, as can be seen in the various lists recorded by anthropologists in the past (Orellana 1975b, 860; Mendelson 1957, 458; Mendelson 1965, 88; Tarn and Prechtel 1986). Some of these, such as María Natividad (Mary of the Nativity), bear names wholly derived from Spanish sources. Yet, in many ways they function in the Atiteco world in ways that are inconsistent with European Catholic orthodoxy. María Natividad, for example, is the wife of San Gregorio and lives in a palace at the bottom of Lake Atitlán, where she imprisons those who drown.

childbirth (Tarn and Prechtel 1986, 180; Canby 1992, 331) (Fig. 5.15a). At midnight prior to Holy Friday during Easter Week her image, along with statues of San Juan Carajo (Fig. 5.15b), San Nicholás, and Christ the Nazarene carrying a cross, are processed out of the church, preceded by a confraternity elder blowing a shell trumpet.[4] Young men then stage races in which they carry San Juan rapidly back and forth in the darkness between the image of María Andolor and those of the other two saints, which are positioned at opposite ends of a three-block stretch of the market fronting the municipal buildings. Each time San Juan reaches Mary, he is lifted high into the air two or three times. The rumor, generally told in embarrassed whispers, is that San Juan Carajo symbolically impregnates María during these "races" in order to give birth to the new world the following day. This is apparently a very old tradition. Lothrop wrote that on the night of the crucifixion, St. John and the Virgin were said to have engaged in illicit relations. To prevent this, their images were imprisoned in separate cells, along with the drunks. They were liberated in the morning after their guardian elders paid a fine of 200 pesos (1929, 25).

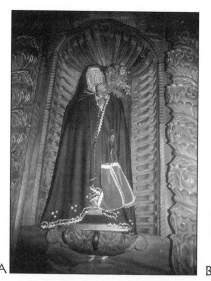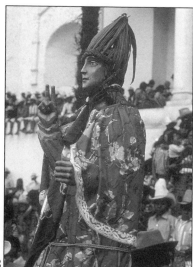

A B

Fig. 5.15. (a) María Andolor in her niche in the altarpiece. Traditionalist Atitecos consider her a young moon goddess who gives birth to the world during Easter Week, having been impregnated at midnight by (b) her lover San Juan Carajo.

[4] The shell trumpet is associated with the underworld, while the midnight observance places the events that transpire in primordial time prior to the first dawn of the sun.

It is a great honor for the young men to run San Juan back and forth, an opportunity to demonstrate their strength and perseverance. It is also somewhat dangerous since the image on its platform is heavy, the street is uneven, and the boys are required to run through the darkness as quickly as they can, time and time again, throughout the night. Apprentice *ajkuns* often volunteer for the "races" to prove their endurance. One *ajkun* told me that in the old days people used to throw bits of broken glass or obsidian in the runners' path to impede them through black magic. If the runners were able to endure despite this test, it was a sign that they had power. Although for several years I witnessed the races from midnight to dawn, and have seen the saint come perilously close to falling over due to the fatigue or drunkenness of his bearers, I have never seen the saint actually fall to the pavement. One year, however, the image was dropped, and required repairs that Nicolás Chávez carried out. He noted that the image had a hollowed-out place within it that contained a bit of old cotton, twelve needles, a spindle whorl, and a round green stone with a lock of hair bound to it. The cotton, needles, and spindle whorl may relate to the creation of the world, which Atitecos associate with the weaving of cloth on a backstrap loom (Tarn and Prechtel 1986; Prechtel and Carlsen 1988). The various manifestations of the Virgin Mary often bear names that are linked to weaving instruments in Atiteco mythology.

In Santiago Atitlán, the image of the Virgin who participates in the San Juan races is linked symbolically with the moon. This associ-ation is prevalent throughout the Maya world, perhaps because in Roman Catholic art she is often depicted standing on a crescent moon (Mendelson 1958a, 125 n. 9; Thompson 1970, 244; Farriss 1984, 306), as is the image of María Concepción in a glass case in the northeast corner of the church at Santiago Atitlán (Fig. 5.16a). It is not surpris-ing, then, that Marian images acquired the persona, however theolog-ically incongruent, of the young moon goddess who is associated with sexual indulgence and repeated illicit affairs with various gods in Maya cosmology, both ancient and modern (Mendelson 1958, 185; Thompson 1970, 164; Miller and Taube 1993, 147) (Fig. 5.16b).

The late J. Eric Thompson noted that the contemporary lowland Maya of Belize and Yucatán also equated the Virgin Mary with the moon goddess "who was very far from being a virgin," but lamented that with time the association was eroding: "It is sad that this wan-ton, vivacious lady, whose doings arouse our interest and excite our

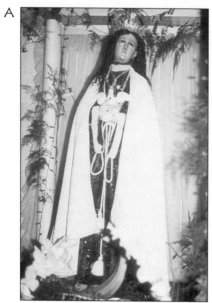

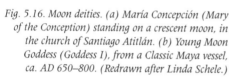

Fig. 5.16. Moon deities. (a) María Concepción (Mary
of the Conception) standing on a crescent moon, in
the church of Santiago Atitlán. (b) Young Moon
Goddess (Goddess I), from a Classic Maya vessel,
ca. AD 650–800. (Redrawn after Linda Schele.)

sympathy, should now be taking her last curtain calls" (Thompson
1970, 249). Thompson would likely have been comforted to know that
she is still alive and well in Santiago Atitlán.

For Atitecos, Santiago Mayor (St. James the Great) is by far
the most important saint on the altarpiece. Since at least the time of
congregation in 1547 he has been the patron saint of the town. In
Catholic tradition, Santiago was one of the original twelve apostles of
Jesus Christ and the first to die a martyr for the Christian faith (Acts
12:2). As the patron saint of Spain, both the Church and the Spanish
Crown heavily endowed his cult centered at Santiago de Compostela.
In Spanish art he is generally depicted on horseback and flourishing
a long sword, a powerful warrior riding out to defend Christianity
against the Moors—a role that gave him his principal title during the

sixteenth century, Santiago Matamoros ("St. James the Moor Killer"). In Santiago Atitlán, there is a painted image of him in Spanish costume on the church belltower, where, consistent with traditional iconography, he rides a horse and brandishes a long sword. A nearly life-size image of Santiago on a horse and with upraised sword is housed in the Confraternity of Santiago, where Atitecos worship him as a war deity as well as the patron of the planet Venus (Tarn and Prechtel 1986, 174). This image (Figs. 5.17a and b) accompanies images of Mary and other saints to guard them as they are carried in procession around town (although he is pointedly absent as a chaperone during the San Juan Carajo races).

Diego Chávez noted that the ancient artists who carved the original altarpiece also recognized Santiago's greatness because they made his niche the largest and placed it at the lowest point in the heart of the monument. In the Atiteco conception of the altarpiece as a mountain, the innermost "heart" at the bottom of the monument is the place of greatest honor. The truncated God the Father at the top, the preeminent position in Western notions of hierarchy, is rarely mentioned or even noticed.

A B

Fig. 5.17. (a) Santiago, patron saint of Santiago Atitlán, carried through the streets in procession during the town's titular festival. (b) Santiago on a horse, the principal image in the Confraternity of Santiago. Both the horse and the sword that the saint wields are symbolic of lightning, a force necessary to make maize seeds germinate in Atiteco theology.

Not only does Santiago provide protection, he is also the principal deity that brings fertility to the earth. Carlsen classifies him as a *bokunab*, a deity with the power to multiply elements of the world (in D. Carrasco 1993, 148). His sword thus multiplies maize by dividing it in two to regenerate the world and make it more abundant. (We have seen that Atitecos use split ears of maize, or *yo'x*, in rituals to enhance the fertility of the earth.) In Tz'utujil cosmology, the sword of Santiago also represents lightning that clefts the earth to allow germinating seeds to grow. The association with lightning may derive partially from the New Testament title for the apostles James and John—Boanerges ("sons of thunder")—although it is more likely that the colonial-era Maya were impressed with metal swords, like Santiago's, that give off sparks when striking certain objects. Santiago's ability to cleft the earth with his sword to allow maize to grow out of the underworld parallels the role of the ancient highland Maya lightning god Hurakan, who quickened the primordial sea with his thunderbolts, allowing the world and all humanity to emerge (Christenson 2000, 40–43). The Tz'utujil Santiago is also analogous to the lowland Maya god Chak who wields an axe-like lightning bolt associated with both war and cracking open the primordial earth to allow maize to germinate and grow (Taube 1992, 17–27; Taube 1993, 66–67; Freidel, Schele, and Parker 1993, 412).

In discussing the image of Santiago in the church, Diego Chávez said that "he was once a foreigner and helped the Spaniards conquer the Maya. But now he is an Atiteco. He speaks our language, and looks out for us, and protects us from the Guatemalan soldiers. He uses his sword to kill our enemies, but he also uses it in the form of lightning to split the maize that we grow in the hills so that we will have more abundant harvests." Modern Atitecos recognize the Spanish origin of their saints' names but nevertheless claim them as belonging now to the people of Santiago Atitlán and no one else. The saints understand and speak only the Tz'utujil language (Qatz'ojb'al, "our language") with the exception of Santiago Menor, who acts as an interpreter for Spanish-speaking worshipers. They help local maize to grow but have little interest in helping farmers elsewhere, even in neighboring Tz'utujil communities. They are not, therefore, considered imposed divinities from Spain. One of Mendelson's informants insisted that Santiago was a pre-Columbian deity despite his Spanish name: "Santiago came here before the Spaniards but I don't know how" (Mendelson 1957, 459).

Nicolás Chávez told me that when the Spaniards came the earth died along with the ancient gods and kings. The finality of this statement must be understood in the context of the Tz'utujil-Maya belief in the cyclic repetition of past events. Nicolás went on to point out that the earth has died many times already. Each time it happens, the world and its gods are reborn to new life, the gods regain their former power, and new gods are added. Thus Nicolás explained that "the saints today have Spanish names because the old earth died in the days of the Spanish conquerors. When the spirit keepers of the world appeared again they were the saints, but they do the same work that the old gods did anciently."

The image of Santiago in the church retains his distinctively foreign appearance as a European saint, yet the Tz'utujils have adopted him as an essential member of the community. He plays a role in their everyday agricultural concerns in uniquely Maya ways that have no counterparts in orthodox Catholicism. Although Maya saints bear European names and attributes, they often represent fusions with native deities who retain their pre-Columbian roles in society (Farriss 1984, 313; Orellana 1984, 106; Hill 1992, 92; Schele and Mathews 1998, 48). Fischer believes that the Maya penchant for seeing unity in what to us would seem diverse deities is characteristic of the hybridity of Maya religion (Fischer 1999, 479–480). In traditional Atiteco belief, deities and mythical figures may appear under a variety of different names and symbolic associations, but they retain an essentially unified nature and purpose that is distinctively Maya. Freidel, Schele, and Parker argue that the Spanish Conquest did not destroy most of indigenous Maya culture and that modern rituals and beliefs attest a fundamentally Maya vision of the cosmos which retains core ideas from their pre-Columbian past:

Some scholars have presumed that the trauma of the Conquest destroyed most of indigenous Maya culture. . . . Nevertheless, we believe that changes in the world of their actual experience caused by the arrival of the Spanish have been accommodated by their capacity to transform their models of the cosmos without destroying the basic structures of the models themselves (1993, 38).

For many Tz'utujils, the Spanish Conquest was not a catastrophic event that ended Maya culture. Rather, it was a kind of temporary death followed by rebirth, little different in kind from other periodic

world renewals that took place prior to the conquest and continue to some degree today during Easter Week. Carlsen suggests that "far from being converted themselves, [the Maya] converted the Catholic saints" (Carlsen 1997, 99). When the first Tz'utujil lords were baptized during early evangelization efforts, they adopted new Christian names while remaining in office and governing their realm much as they had before the arrival of the Spaniards. It is likely that the Tz'utujils regarded the saints in a similar manner, as the baptized and newly christened form of their old gods. They were, after all, tied with nature and thus inherently immune to permanent destruction.

In contrast to the fatalistic acceptance of defeat found in K'iche' and Kaqchikel accounts of the conquest, most legends told by Atitecos about the arrival of the Spaniards emphasize the magic power of the ancient kings and their gods who escaped the destruction that befell other highland Maya kingdoms. This version is from Nicolás Chávez:

> In a great battle near Chukumuk [a small settlement near the lake northeast of town], King Tz'utujil threw down a great stone before the invaders which broke into two thousand pieces, each becoming a crab which pinched the Spaniards and halted their advance. He then blew in their direction, causing a wind which killed many of the invaders and drove them into the lake. King Tepepul then hurled a long staff at them which became a serpent that killed many more. In those days the lake was lower and you could walk on dry land to the old capital city across the bay. But when the Spaniards came the daughter of King Tepepul, a girl named María, stood on the peninsula and wept, making the water rise and drowning the Spaniards who wished to cross. That is why the Virgin María owns the lake and has her home there.

From Nicolás' account and many other similar legends about the conquest, you would hardly know that the Tz'utujils had lost the war. In the previously cited K'iche' account of the conquest from the *Títulos de la Casa Ixquin-Nehaib*, it is the gods of the Spaniards who are treated as the real victors, particularly the Virgin Mary and the Holy Spirit in the form of a footless bird who protected the Spaniards and caused the Maya sorcerers to fall blinded to the ground (Recinos 1957, 85–94). Once the old gods were defeated, the destruction of their K'iche' followers in battle became inevitable. Yet in the Atiteco version of the conquest, the Virgin Mary is already assimilated into

the Tz'utujil pantheon—as the daughter of the deified king of Chiya' and as the patron divinity of Lake Atitlán. In this view, Christian divinities were not imposed on the Tz'utujils by the Spanish Conquest but actually sided with their ancestors to protect them from the destruction that visited neighboring highland Maya kingdoms.

This perspective probably dates back to the very beginning of Spanish rule in the sixteenth century but reflects an ancient Maya view of the relationship between kings and divine beings. Highland Maya kings often adopted the names of gods or the patron divinities of calendric days to assert their own power as supernatural beings. The Tz'utujil king's name prior to the conquest was Joo No'j K'iq'ab'. Joo No'j ("5 Thoughts") is a day on the sacred Maya calendar, as well as the name of the deity of wisdom who presides over it; K'iq'ab' ("Many Hands") suggests the power of the king to act in ways which would be impossible for an ordinary person with only two hands. Combined, the name of the Tz'utujil king proclaims him to be intelligent as well as a powerful man of deeds. The K'iche' king who founded the capital city of Q'umarkaj took the name Gucumatz ("Quetzal Serpent"), a creator deity with an important temple cult in the new city. The *Popol Vuh* describes this king as having the ability to transform himself into both the reptilian and avian aspects of this deity:

On one occasion he would climb up to the sky; on another he would go down the road to Xibalba [the underworld]. On another occasion he would be serpentine, becoming an actual serpent. On yet another occasion he would make himself aquiline, and on another feline; he would become like an actual eagle or a jaguar in his appearance. On another occasion it would be a pool of blood; he would become nothing but a pool of blood. Truly his being was that of a lord of genius (D. Tedlock 1996, 186).

After the Tz'utujil king at the time of the conquest was baptized, he took the Christian name Pedro, likely in honor of Pedro de Alvarado (Carlsen 1997, 84). In doing so, the king also adopted the personal patron deity of the Spanish conqueror, San Pedro. For titular saint of their city, the Tz'utujils chose Santiago, the patron deity of the Spanish army and founding saint of Ciudad del Señor Santiago de los Caballeros ("City of Lord Santiago of the Knights"), Alvarado's first capital. Thus, in selecting the names of Pedro and Santiago, the Tz'utujil king applied

to himself and his capital the protective power of the two most prominent divinities whose patronage had given the Spaniards their astonishing success. In effect, he usurped their supernatural power and placed them at the service of the Tz'utujils.

KALKOJ: THE BICEPHALIC BIRD

I suspect that the double-headed bird motif located medial to the climbing Maya confraternity elders on the Santiago Atitlán altarpiece has a similar syncretic history (Figs. 1.4, 1.5 N, and 5.18). Although the Chávez brothers recarved the panels, they resembled similar designs that existed on the original altarpiece in the same positions. Unfortunately these were destroyed in the 1960 earthquake and could not be salvaged.

The original intent of the motif was likely a reference to the Hapsburg eagle, an important heraldic device used by the Spanish monarchs during the colonial period. In Spain, as well as its colonies in the New World, imperial emblems figured prominently on choir screens and other church decorations as an indication of the political autonomy of the Church, which was not accountable to local authority but only to the Crown (Peterson 1993, 150–151) (Fig. 5.19a). In

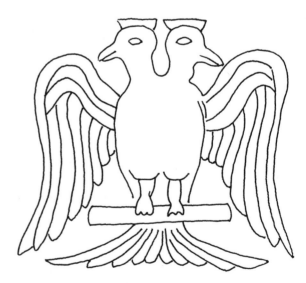

*Fig. 5.18. Bicephalic bird (*kalkoj*) motif from the central altarpiece. In Atiteco myth, the two-headed bird lives in the mountains and defends the community from its enemies.*

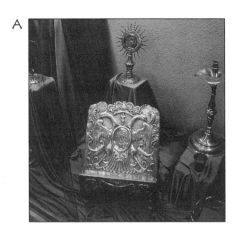

Fig. 5.19. Colonial-era depictions of the bicephalic
bird. (a) Silver lectern with the Hapsburg Eagle,
sixteenth century (Museo Popol Vuh, Guatemala
City). (b) Coat of arms of the K'iche'-Maya C'oyoi
lineage, Título C'oyoi, ca. A.D. 1550–1570.
(From Carmack 1973, 266.) (c) Coat of arms
from the Título Totonicapán, ca. A.D. 1554.
(From Carmack and Mondloch 1983, 40.)

addition, coats of arms were likely displayed as an acknowledgment
of royal financial support. Although the Barahona family refused to
help in the construction of the church at Santiago Atitlán, the Spanish
Crown contributed 100 pesos and donated the church's bronze bell
and a chalice (*Relación de los caciques* 1952 [1571], 437–438). The bell
is still used and bears a casting date of 1547, the same year the town
was congregated.

It seems reasonable that local Tz'utujil elites would have welcomed
the opportunity to display the imperial device as a token of their own
power, in much the same way that the *cacique* don Pedro selected
Santiago as the titular saint of his town as a visual symbol of divine
patronage. Other highland Maya groups also adopted the Hapsburg
eagle for their own emblems. The K'iche' lords at Quetzaltenango used

it as their family crest on a pictorial from the sixteenth-century *Título C'oyoi* (Carmack 1973, 266) (Fig. 5.19b). Another version appears on folio 2 of the *Título Totonicapán,* compiled by surviving members of the old K'iche' ruling dynasty at about the same time (Carmack and Mondloch 1983, 40) (Fig. 5.19c).[5]

All trace of this Spanish royal association is forgotten, however, in contemporary Santiago Atitlán. Diego Chávez said that the bird has two meanings. For some it is the Catholic Holy Spirit which "knows the good from the bad." For most Atitecos, however, the bird is known as *kalkoj* ("puma's child"), a protective divinity who is the animal counterpart of the mountain gods. Its two heads represent the dual nature of these gods—both benevolent and malevolent depending on their mood. Nicolás Chávez related a long tale in which the *kalkoj* along with other vicious animals swept down from the mountains to protect Francisco Sojuel from the servant of the president of Antigua, a gigantic black man who ate human flesh. The bird grasped the black man in its beaks and flew high into the sky before dropping him onto a pile of stones and smashing him to bits. Both Mendelson and Orellana recorded similar legends (Mendelson 1957, 484–486; Orellana 1975b, 861).

The *kalkoj* motif is relatively widespread in the community (Fig. 5.20). Nicolás has a rough drawing of it incised into the cement walkway leading to his workshop which serves as a protective talisman. The painter Juan Sisay had Diego Chávez carve two large versions of the bird on his front doors. Simpler *kalkoj* designs also appear on Atiteco woven textiles, particularly women's *huipils*. Like Santiago and the other Roman Catholic saints, the Hapsburg eagle has been thoroughly assimilated into Tz'utujil society and defends it from foreign incursions. Irma Otzoy, a prominent highland Maya scholar, contends that the foreign origin of this motif does not necessarily preclude divergent interpretations along uniquely Maya lines,

[5] As previously noted, the K'iche' account of the Spanish conquest in the *Títulos de la Casa Ixquin-Nehaib* says that the army of Pedro de Alvarado was protected by a "very white young girl" and "birds without legs." Victoria Bricker interprets this passage as referring to the Virgin Mary and the Holy Spirit (Bricker 1981, 39–40). It is also possible that the bird was the Hapsburg eagle the Spanish king carried on battle banners as a sign of royal patronage. The prominence of the device on sixteenth-century highland Maya documents attests to its importance during this early period.

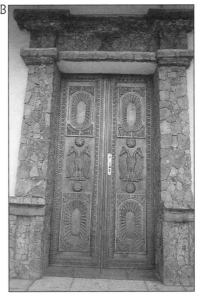

Fig. 5.20. Bicephalic bird motif at Santiago Atitlán. (a) Incised kalkoj on the walkway leading to the home of Nicolás Chávez Sojuel. The artist believes the bird represents a protective entity. (b) Doors of the house of Juan Sisay, carved by Diego Chávez Petzey. (c) Traditional Atiteco huipil displaying several versions of the two-headed bird.

Even if the Maya did borrow the bicephalous bird design from the Spanish rather than from neighboring Mesoamerican peoples, this in no way implies that the symbolism of the motif is indeed Spanish. It is probable that the motif was adopted by the Maya precisely because it fit in with an already existing system of Maya metaphors and that it is continually reinterpreted in a manner consistent with Maya philosophy and experiences. . . . Thus, the specific historical origin of an element does not determine whether or not that element is Maya (1996, 144).

THE FLOWING VESSELS MOTIF

While gathering information for this study, I was struck by the general consistency of opinions that Atitecos held concerning individual symbols on the altarpiece, most of which refer to myths and rituals that are well known in the community. The major exception to this uniformity concerns the paired vessels pouring out liquid below the image of San Francisco on the third tier of the altarpiece (Figs. 1.4, 1.5 G, and 5.21). In independent conversations, three *catequistas*

(orthodox Roman Catholics) all agreed that the liquid in the vessels represents the "living water" of God, a popular reference in sermons delivered during Mass. An *ajkun* asserted that it represented "magic water," sometimes brought from Lake Atitlán to cleanse and purify sacred objects and buildings before use in native ceremonies. A member of the San Juan Confraternity believed that it represented *psiwan ya'* ("canyon water"), a homemade alcoholic brew which members of his confraternity drink on ceremonial occasions and pour out as libations to native deities. Diego Chávez said that the two vessels represent the power of both the Maya religion and Roman Catholicism to cleanse people from impurity. A local Protestant who works as a guide for English-speaking tourists insisted that the pitchers are the two ends of the Milky Way and that they represent the path of the ancient Maya to heaven (an idea he later confessed to have gotten while reading the book *Maya Cosmos* by David Freidel, Linda Schele, and Joy Parker [1993]). Nicolás Chávez, who helped carve the motif, gave a more personal interpretation: "Diego and I wanted to show respect for our father in some way that would not be too obvious. He was born in the month of Aquarius so we decided to put water pitchers near the top."

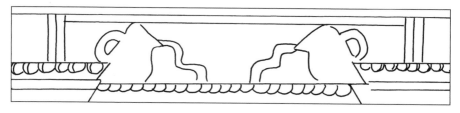

Fig. 5.21. Flowing pitchers motif from the central altarpiece. This motif is interpreted in a number of ways among Atitecos, but the artists' original intent was likely a personal tribute to their father, who was born under the sign of Aquarius.

The Basal Narrative Panels of the Central Altarpiece

The series of five narrative panels the Chávez brothers added at the base of the altarpiece—which were not part of the original decorative scheme—seek to codify the major rituals conducted at Santiago Atitlán as they relate to the human lifecycle from birth, on the left panel, to death, on the right panel (Figs. 1.4, 1.5 V–Z, and 3.5). In contrast to Tz'utujil myths, which are recited informally and vary widely in content and circumstance of telling, rituals are highly systematized as to place of performance, and Atitecos assert that they change little over time.

The narrative panels are an innovative way of engaging the viewer by presenting contemporary members of Atiteco society as they interact with sacred objects and personages familiar from prominent local ceremonies. This interplay serves to break down the barrier between the viewer and the world of the spirit. The artists strengthened the effect by arranging the narrative panels horizontally at a level where they may be seen close at hand, unlike the saints' niches and decorative motifs, which the verticality of the monumental altarpiece increasingly distances from the viewer, making the sacred less approachable. The proliferation of images in these lower panels and their smaller scale invite close inspection, whereas the more isolated figures above, though larger, are somewhat difficult to see.

For Atitecos, supernatural beings express their presence and influence through visible *rijtaal* ("signs"). These may be naturally occurring elements left in the world by ancient gods or ancestors, such as mountains, lakes, a rare and beautiful plant, jade, or a bit of quartz crystal. In other cases they may be man-made objects crafted

by the ancestral *nuwals* as receptacles for sacred power—a fragment of pre-Columbian carved stone or terra cotta, a colonial-era saint, or a church altarpiece. Each of these bears a living *k'u'x* ("heart") and is a visual manifestation of some aspect of divine nature which is essential to existence. The lower panels of the altarpiece are not mere evocations of ritual acts but bear the *k'u'x* of the things portrayed, having power in and of themselves. When a worshiper prays before them, or even reads them visually in sequence, the panels are enlivened by the human interaction and bestow their power on the viewer as if the rituals depicted on them had actually taken place materially.

It is rare not to find several candles burning in front of each of the five lower panels to "feed the heart" of the altarpiece. This was of considerable benefit to me while drawing the panels, which are otherwise often hidden in shadow. When reflected off the surface of the cedar wood, the flickering candlelight also provides a deep reddish glow that animates the figures and creates an unsettling illusion of movement. A number of Atitecos have noted this effect and told me that at midnight the wooden gods and people carved on the altarpiece come to life and dance the steps of world-renewing rituals.

PANEL 1: THE BIRTH OF HUMANITY AND THE SACRED WORD

All but the central panel in the basal narrative sequence are arranged as a triad of images that follow a single ideologic theme. The first panel represents birth, in terms of both human and spiritual beginnings (Figs. 1.4, 1.5 V, 6.1a and b). Diego Chávez explained that Father Rother wanted to convey the idea that the world began with the word of God. Diego therefore designed the panel to show divine will as revealed in various aspects of Atiteco experience.

On the right-hand side of the panel is the first revealed word of the Christian God, symbolized by Moses standing on a mountain with the tablet of the Ten Commandments. To emphasize the foreign nature of this event, Diego used a wall of quadrangular blocks of stone masonry as a background, a building technique he associated with Europeans. Father Rother suggested the theme of this section and pointed out that the "mountain" represents the Church from which the word of God is taught.

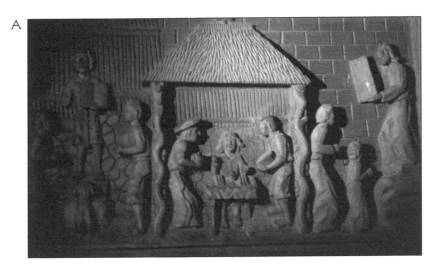

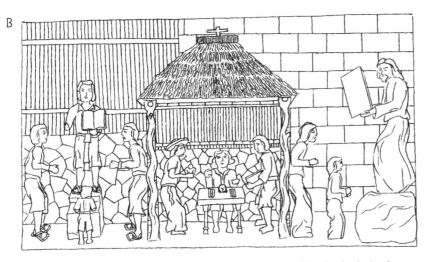

Fig. 6.1. The first panel from the base of the central altarpiece, dedicated to birth rituals: (a) photograph, (b) author's drawing.

On the left side of the panel is the first Christian sermon in Santiago Atitlán, set within a traditional Atiteco room consisting of a half-wall of irregularly cut stones topped by bound maize stalks. The figure in the center is a *pixkal* (from the Spanish *fiscal*, or "lay deacon"), a Tz'utujil elder of the church who assists the priest and calls people to Mass. He stands on an elevated podium teaching from the Bible in a manner analogous to Moses on the mountain. The *pixkal*

wears a traditional Atiteco costume that is still worn today and faces forward, engaging the viewer in a more direct and personal manner than does Moses, who stands in a semiprofile posture and whose dress and beard distinguish him as an outsider.

There has never been an ordained Tz'utujil Roman Catholic priest, therefore the office of *pixkal* is the highest position within the official Catholic hierarchy to which an Atiteco may aspire. European missionaries instituted the office early in the colonial history of Guatemala to aid in the evangelization of the various highland Maya communities. Missionaries selected them from among the indigenous nobility and taught them Christian doctrine (Farriss 1984, 236). In the absence of the priest, the *pixkals* directed the community's religious affairs within the structure of the Roman Catholic Church. They supervised the catechism and taught the youth to read, write, sing, and play musical instruments. They also organized the celebration of festivals and the decoration of the church, controlled who would serve in parochial offices, examined and coached candidates for the sacraments, guarded the priest's vestments and liturgical vessels, led the daily recitation of prayers, and conducted religious services on Sunday and holy days when no priest was available. The office carried tremendous prestige, its holder having more sway than local government officials (Orellana 1984, 204). He was exempt from tribute and personal service and permitted to carry a staff of office topped by a silver cross to represent the church (Gage 1958 [1648], 230–231).

During Mass, the principal *pixkal* at Santiago Atitlán once carried a whip to remind the congregation to maintain a correct, respectful posture (Mendelson 1957, 100). Following the adoption of the parish by the archdiocese of Oklahoma in 1964 and the arrival of a permanent priest, the office of the *pixkal* has become somewhat less prestigious in Santiago Atitlán, although the *pixkal* continues to direct much of the day-to-day nonliturgical business of the church and often serves as translator for the current priest, who does not speak Tz'utujil. Nevertheless, on this panel Diego Chávez chose to portray a *pixkal* rather than the priest as the principal source of religious doctrine, because "this is how our ancestors received the word of Christianity, without the need for foreigners."

The central section of the first panel depicts the revelation of divine will in traditional Atiteco worship through the mediation of an *ajkun* shaman (Fig. 6.1b). The ceremony is the blessing of an infant child held in the arms of the woman on the left. The *ajkun* is seated at

a table in the center, which is set with paraphernalia used in divination—a small carved-stone head, incense, and two sets of three candles. The man on the right, the father of the child, holds a book containing the auguries for each of the 260 days of the Tzolkin, or Maya calendar. For the highland Maya, the day on which an infant is born determines to a certain extent the child's fate in life (Schultze Jena 1954, 75; B. Tedlock 1982, 108–127). Because fate is selected by time itself, highland Maya who use the old calendar are quite obsessive about determining what their fate is and how they can order their lives to make the best of it. Ximénez wrote that highland Maya parents in the early eighteenth century also consulted diviners to determine the fate of their newborns, during which consultations shamanic rites were performed according to the fates of the days (1967b [ca. 1722], 10).

The actual process involved in highland Maya divination is beyond the scope of this study, and somewhat irrelevant in any case. Atitecos freely admit that while the ancient Maya calendar is important, their *ajkuns* are not nearly as good at interpreting it as are the K'iche's or even Tz'utujils living further south toward the coast (Mendelson 1957, 307–309). Diego said that he included the augury book because in former times *ajkuns* were much more powerful and knew how to read the days, the clouds, and the calls of animals. He had heard that some of them kept books filled with secret knowledge and included one in the panel to show that the Tz'utujils also had writings containing revelations from the spirit world that were equally as powerful as the words in the Bible or on the tablet of Moses. Ximénez (1929–1931 [1722], I.1.101–102) and Cortés y Larraz (1958 [1770], 11, 57) wrote that indigenous calendars were common in the seventeenth and eighteenth centuries throughout the highlands. A K'iche' manuscript dated 1722 contains three Maya calendric cycles grouped together along with a list of auguries for each of the days (*Calendario* 1722; Carmack 1973, 165–167). The manuscript likely served as a divinatory almanac of the type seen on the Santiago Atitlán altarpiece.

The other items on the table of the *ajkun* are still used in modern Tz'utujil shamanic ceremonies. The small carved head is a fragment from a pre-Columbian figurine. Small stone and terra cotta sculptures are relatively common in the area in and around Santiago Atitlán, and most traditionalist Atitecos, including Diego and Nicolás, keep a collection of them on their personal altars as relics of the ancestors. Each is considered a powerful *rijtaal*, or sign, of divine communication.

Fig. 6.2. Stone heads from the Confraternity of Francisco Sojuel. Each stone represents a saint or deified ancestor, purportedly carved by the culture hero Francisco Sojuel.

Ajkuns use them along with quartz crystals, jade, or obsidian flakes as *ilb'al* (instruments for seeing) whereby mountain or ancestral spirits may be consulted on behalf of clients. Traditionalist Atitecos worship larger stone heads as well, giving them the names of gods or saints and dressing them in typical Tz'utujil clothing (Fig. 6.2).

Ajkun shamans light candles, like those depicted in the altarpiece panel, as offerings to deities and ancestors so that these may bestow their blessings on the living. Traditionalist Atitecos believe that the flame which consumes wax to sustain the candle's light represents the spirits eating their meal. On the ground in front of the candles, they also pour out liquor in a line for the spirits to drink. Vogt recorded a similar belief among the Tzotzils, who consider candles the "tortillas" of their ancestral gods who live inside the mountains, which the gods consume along with cane alcohol (1976, 1). As an essential part of ceremonial offerings, liquor is commonly dribbled into the mouths of confraternity saints' images (as well as over sacred bundles and tables) to, as one confraternity elder said, "refresh them and give them heart to endure the rigors of their office." No Atiteco would think of petitioning an ancestor or saint without first laying out an offering to accompany the request. It is generally left to confraternity elders or an *ajkun* to determine the size, amount, and type of offering needed to obtain a favorable response.

The other essential offering that accompanies every important prayer or ritual in Tz'utujil society is copal incense, or *pom* (Fig. 6.3). When the Chávez brothers carved the left narrative panel they included a small incense brazier motif at the foot of the table (Fig. 6.1b), but

Fig. 6.3. Incense brazier and bowl of copal in the Confraternity of San Nicolás. Copal smoke is used to cense participants and objects used in rituals.

this has since broken off. Vogt suggests that incense represents "cigarettes" for the pleasure of ancestral spirits (1976, 1), although I never heard this association in Santiago Atitlán. Indeed, when Atiteco saints desire to smoke they receive real cigars and cigarettes. The Mam always has a lit cigar in his mouth, which his attendants tap periodically to remove ashes and replace when it is consumed (Fig. 3.6a).

Among the Tz'utujils, incense appears to be more of a sacrificial offering. The Maya derive copal incense from nodules of tree sap, a token of the sacred "blood" of the world tree which bears within itself the essence of life. In the *Popol Vuh,* the lords of the underworld condemned Xkik' (Lady Blood), the mother of the Hero Twins, for becoming pregnant illicitly. They sent her away to the place of sacrifice where owls were to extract her heart. But the owls took pity on her and asked what they could give to the death lords as a substitute for her heart. She suggested that they gather red tree sap in a bowl:

Thus she went to collect the red secretions of the tree into the bowl. There it congealed and became round. The red tree, therefore, oozed forth the substitute for her heart. The sap of the red tree was thus like blood when it came out. It was the substitute for her blood. (Christenson 2000, 86)

The owls gave the bowl of tree sap to the lords of death, which they roasted over a fire, creating a smoke that was "truly sweet." The authors of the *Popol Vuh* wrote that, because of this trick on the part of

The Basal Narrative Panels of the Central Altarpiece

Xkik', "tree sap" now belongs only to the lords of the underworld (Christenson 2000, 85). Xkik' meantime petitioned the owls to fly her up to the surface of the upperworld, where she escaped through a hole in the ground.

I think it probable that copal incense still represents a substitute for the blood sacrifice pre-Columbian Maya once offered to their ancient gods. In the *Popol Vuh*, the substitution allowed Xkik' to bear the Hero Twins, a symbol for life born out of the underworld realm of death. At the beginning of the eighteenth century Fray Antonio Margil recorded an incident in which a sick man consulted a K'iche' shaman after falling ill in a forest. The shaman informed him that the Lord of the Forest had made him ill, but that there was a remedy: "Do not worry, because I go now to pray to the Lord of the Forest for you, and will take him his food [copal incense] in your name" (Hill 1992, 144). The shaman thus used copal to purchase the health of the man by offering it as a replacement to assuage the appetite of the Lord of the Forest. The *ajkun* on the altarpiece panel acts in a similar fashion, burning a sacrificial offering of incense to purchase the life of the young child.

The table used for the divination in the panel bears symbolic significance as well, and is called the Santa Mesa ("Holy Table"). This type of table may also be seen in a small carving by Diego Chávez Ajtujal (Fig. 6.4). Possession of a divinatory table implies acceptance of the role of shaman and responsibility to act as a mediator with spirit beings (Mendelson 1957, 281; B. Tedlock 1982, 74). The shaman's table is analogous to the church altar, and on it *ajkuns* bless all ritual paraphernalia prior to use and offerings before they are made.

At the beginning of shamanistic prayers, the *ajkun* calls upon a long litany of sacred beings and objects whose power he wishes to invoke on behalf of his client. Prominent in this list are the "Holy Table

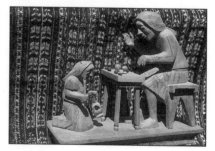

Fig. 6.4. "Ajkun," by Diego Chávez Ajtujal. This piece, one of the last sculptures carved by the patriarch of the Chávez family before arthritis crippled his hands, shows an ajkun *(shaman) at his divinatory table. (Collection of the author.)*

Fig. 6.5. Although divination is now becoming rare in Santiago Atitlán, it is still practiced widely among the K'iche's, a related highland Maya group. This divinatory table belongs to a respected ajq'ij ("daykeeper") in Momostenango.

and Holy Chair" which bear their own souls and influence the outcome of the divination. The four corners of the table's surface represent the four corners of the world, and the placement of the *ilb'al* and other divinatory implements suggests the arrangement of sacred spots on the earth (Mendelson 1957, 283). When the *ajkun* sits at the table he places himself in a transcendent role that bridges the three layers of the cosmos (Fig. 6.5). His legs conceptually extend beneath the surface of the earth/table, his arms manipulate its sacred geography, while his upper body rises into the upperworld. In this way, the *ajkun* is able to "see" all places where the spirit beings live and converse with them. The Tzotzils also believe that shamans have "the power to 'see' into the mountains and talk to the gods face-to-face" (Vogt 1976, 50).

The setting of the ritual as depicted on the altarpiece panel also has symbolic significance. The blessing of the infant takes place in a traditional Ateco house with a rear wall similar to the one pictured on the left side of the same panel. In the center section, however, the view is a more distant one so as to include the supporting twisted posts at the corners and the thatched roof above (Fig. 6.1b). The structure is akin to confraternity houses (Fig. 6.6), where the images of saints and spirit beings are kept, as well as to the private homes of *ajkuns,* both of which represent sacred mountains and whose doorways symbolize a cave entrance into the mountain's interior (Mendelson 1957, 471 n. 4). In the center section of the panel the undulating corner posts are the serpents that guard the way inside, as well as sacred trees that stand at the four corners of the world. The stone masonry of the lower courses of the walls represent the mountain itself and the maize canes and thatch above are the maize fields, trees, and vegetation that blanket the mountain's surface.

The Basal Narrative Panels of the Central Altarpiece 151

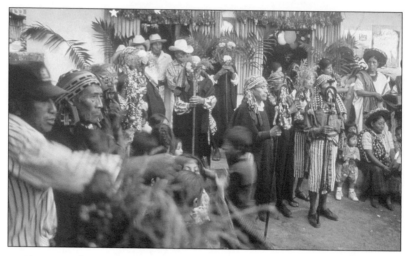

Fig. 6.6. Confraternity elders, holding their staffs of office, and their wives participate in a ceremony in front of the Confraternity of San Francisco/Animas on the Day of the Dead. The reed canes and foliage decorating the doorway and windows of the confraternity house mark it as a sacred cave giving access to the mountain home of deity.

Atop the house is a cross, which Diego insisted is not a Christian motif. It symbolizes the four cardinal directions, marking the peak of the house as the center point of the world. Nicolás said that in past tradition, when an important house was dedicated, an *ajkun* sacrificed a hen at each of the four corners and sprinkled their blood on the posts to feed them. He also tied a special type of plant on each of the corner posts and offered incense, alcohol, and candles to guard against evil. The *ajkun* then sliced a lemon in half and squeezed out the juice at each of the house corners to cleanse the path for divine personages to approach from their mountain homes at the edges of the world. Finally, he would bury an offering of blood, bones, or chocolate at the center of the house to provide the dwelling with its "soul." Today the Tz'utujils substitute copal smoke for sacrificial blood in such ceremonies.

The placement of offerings at the four corners and center of a house is a common Maya practice, the sacrificial animals serving as the spirit co-essence of the house and of those who live and work within it (Vogt 1970, 98–107; 1993, 51–55; Taube 1994, 670; Stone 1995, 36). The ancient Maya also deposited sacrificial offerings in caches placed beneath floors, inside doorways, and under the center point and corners of their houses and temples. John Fox suggests that

such caches link buildings to a greater cosmography by endowing them with life derived from the divine essence inherent in blood (1996, 485–487). A major purpose for sacrificial offerings was to ensure that sacred buildings had a "soul-force":

This soul-force became ever more powerful with usage. The offering plates and buckets opened an ol, *or "portal," that allowed access to the supernatural world. When the Maya materialized their gods and ancestors through these portals, the spiritual beings left residual energy in the buildings and the objects that opened the portals. (Schele and Mathews 1998, 49–50)*

Neither a confraternity house nor the home of an *ajkun* differs from a normal residence in construction or appearance. It is ritual use and decoration that sacralize it and set it apart from the mundane world. Once a building has been dedicated as a confraternity house, the space on which its stands should never again be used for ordinary human habitation, although it may be used to store maize if the spirits that reside there do not object. Nicolás Chávez worried because the land on which his house sits once belonged to an ancestor who had headed a confraternity and he was not sure on which part of the property ceremonies were conducted. Nicolás uses his home as a workshop in part because he considers sculpting to be a ritual act and therefore excuses him from living on sacred space.

When the most important ceremonies are carried out, all the doors and windows are shut so that the interior of the house is cut off physically from the profane environment outside. The most ritually appropriate time for this is at midnight, when the dark underworld comes into closest contact with this plane of existence. The *nab'eysil* of the Confraternity of San Juan said that the thick incense smoke used in their ceremonies represents rain clouds which are born inside sacred mountains.[1] As the *nab'eysil* performs ritual dances or other actions, he appears to float through an ambient atmosphere of subterranean mist or rainclouds that alternately conceals and reveals his movements. When the doors and windows are opened at the conclusion of these ceremonies, the smoke pours out like clouds emerging from the

[1] Thompson records that other contemporary Maya associate the black smoke of copal with rain clouds (Thompson 1970, 167).

sacred-cave home of the ancestors at Paq'alib'al. The serpent posts, too, are likely associated with rain. In the Dance of Patzca at Rabinal, performers representing aged ancestors carry canes carved to represent undulating snakes. The Rabinals believe that these snake canes call the rain clouds (Mace 1970, 80–83).

PANEL 2: THE DANCE OF LIFE
AND DEATH—MARTÍN AND THE MAM

For the Maya, ritual dance is not merely a symbolic act but a means by which humans transform themselves into supernaturals in order to replicate their actions (Schele and Miller 1986, 260; Mendelson 1958a, 124). The second in the series of narrative panels at the base of the altarpiece presents the struggle between life and death as played out in the major confraternity dance cycles of Santiago Atitlán—those honoring Martín and the Mam (Figs. 1.4, 1.5 W, and 6.7a and b). The cults of these two deities encompass rituals which are in stark contrast to those of orthodox Catholic worship and appear to represent contemporary versions of ancient Maya divinities (Mendelson 1957, 159; 1958a, 121). Martín and the Mam represent the life and death aspects of nature respectively. Atitecos believe that the power of the universe manifests itself in an endless cycle of paired opposites which are complementary in their nature and infinite in

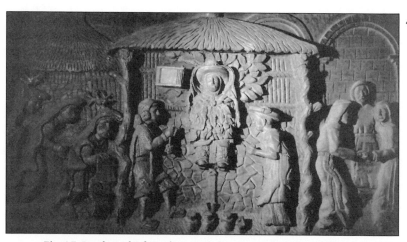

A

Fig. 6.7. Basal panel 2 from the central altarpiece, dedicated to sacrifice and rebirth: (a) photograph, (b) author's drawing.

their variety. The interplay of day and night, light and darkness, male and female, life and death, is a fundamental part of human experience and determines to a great extent how Atitecos define themselves and pattern their lives. It is this very opposition, however, which unites the cosmos and gives it vitality. The interaction is given symbolic expression in the second narrative panel of the Santiago Atitlán altarpiece.

The ancient Maya of the Classic period (ca. A.D. 200–900) represented the dual nature of the universe by combining the glyph for *k'in* ("sun, brightness, day"), and the glyph *akbal* ("darkness, night") into a single collocation (Fig. 6.8a). This pair of glyphs encompasses a broad range of complementary or cyclic powers in the cosmos. It was a kind of iconic shorthand that included all of the essential elements necessary to life and social success. A glyphic substitute for the *k'in/akbal* pairing is *hel* ("change," or "succession") (Fig. 6.8b). This change may be of any kind—day into night, the succession of one king following another, or the transition from life into death (Schele 1990, 142). The Maya viewed these changes not in linear but in cyclic terms, endlessly flowing from one state into another in an eternal round. Opposition need not represent confrontation, however. One side could not exist without the other, any more than day could exist without night. It was a duality of interdependent, interrelated forces, each playing its role in concert with the other.

B

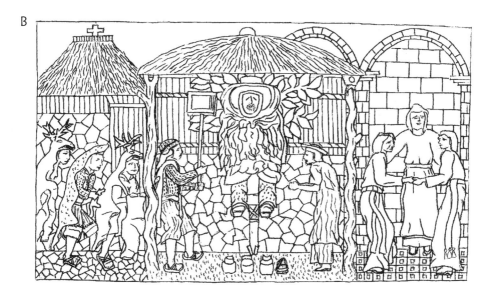

The Basal Narrative Panels of the Central Altarpiece 155

Fig. 6.8. Maya hieroglyphs indicative of "change": (a) k'in/akbal glyphic collocation; (b) hel glyph.

On the right side of the second panel is a dance performed by three Franciscan monks. Diego Chávez designed this scene following a conversation with Father Rother in which Diego asked whether Catholics staged ritual dances like the Maya. The priest replied that Franciscan monks danced on the Day of San Juan (June 24) to honor God and demonstrate their joy. Diego found this important because the Dance of Martín is performed in the Confraternity of San Juan (St. John the Baptist). Although Diego said that he knew nothing about the Franciscan monks and got the impression that dancing on the Day of San Juan was a rather insignificant event, Father Rother's comments nevertheless demonstrated the legitimacy of dance in religious contexts and provided a Roman Catholic parallel to the actions of the Tz'utujils.

The left section of the second panel represents the Dance of the Deer, which reenacts the sacrificial death of the god Martín in the

A
B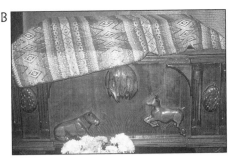

Fig. 6.9. (a) The Martín bundle on the altar of the Confraternity of San Juan. Atitecos consider Martín to be the oldest of their divinities. (b) The Martín bundle is kept in this chest in the Confraternity of San Juan. It was carved by Diego Chávez Petzey. The design in the center is a massive ear of split-cob maize, the most powerful of Martín's symbols and an indication of his ability to create abundance.

form of a deer. In Atiteco theology, Martín is the deity who embodies the positive, life-generating aspects of the world. Although Martín is a powerful deity, he also has his limits. Like other Maya gods, he ages, falters, and dies on an annual basis. No single god, including Martín, has the advantage of omnipotence. In the end everything, including gods in all their manifestations, must periodically give way to darkness and chaos before they can be reborn to new life.

While most cult images of saints and other deities at Santiago Atitlán are carved wooden statues, the god invoked as Martín is a cloth bundle wrapped in green velvet called the *ruk'u'x way, ruk'u'x ya'* ("heart of food, heart of water") (Carlsen 1997, 80). For most of the year, the Martín bundle is kept in a wooden chest in the Confraternity of San Juan (Fig. 6.9). The chest was carved by Diego Chávez and bears the images of a massive *yo'x* (an ear of maize with multiple split cobs), a leaping deer, and other symbols of animal and vegetal fertility. The Tz'utujils consider the bundle of Martín to be the supreme patron of the maize harvest, and he is called on in the blessing of seed corn before it is planted. At various times Martín is also invoked as the patron of the earth, mountains, the three volcanoes surrounding town, ancestral spirits, deer, the two-headed *kalkoj* bird, fruit, fire, the sun, rain, thunder, wind, clouds, and the surface of the lake. The list varies widely and the variety serves to emphasize the extent of his universal power.

Atitecos celebrate the Dance of Martín on November 11, the day dedicated to St. Martin of Tours on the Roman Catholic calendar. This date marks the end of the harvest season, when the Guatemalan highlands enter a long season of dry, cold weather that lasts until the

coming of the rains the following April or May. Although the highlands are not subject to the freezing winters of more northerly latitudes, the lack of rain makes it impossible to grow most crops. The Maya thus see the season as one of sterility and universal death. The Dance of Martín is performed in an effort to help renew the world and give it power to bear new life.

Although the Tz'utujils venerate the name of Martín on that day, his cult bears little resemblance to traditional Catholic observance and he is seldom addressed with the Spanish title San ("Saint") like other local saints. Atitecos consider Martín to be more ancient than any other god, and father to them all (Mendelson 1957, 462; 1958b, 5). They address him as "King Martín," and other saints and divinities, including Jesus Christ, obey him as his servants (Mendelson 1957, 454; Orellana 1984, 106; Canby 1992, 325). Because of the presence of the Martín bundle in Santiago Atitlán, Atitecos consider their community to be the *remexux jab', remexux uliw* ("navel of the rain, navel of the earth") (Mendelson 1958a, 123). An elder who holds a very high position in the leadership of the Confraternity of San Juan describes Martín's power as all-encompassing:

> *Martín is the lord of everything—of the six points [the cardinal directions plus up and down], of the twelve points [the six points above the earth plus the six points in the underworld]. He is the lord of maize and the seedlings. He gives maize. His symbol is the split cob of the yo'x. He has the power to cure all illnesses. He walks the mountains where maize is hidden. The deer is his animal counterpart who carries on its back the power of life. He is the male lord of all things, while Yaxper is the female, the woman who weaves the world on her loom. Here is great power, the power of all things.*

The bundle is handled only by the *nab'eysil*, a special priest-shaman dedicated exclusively to the cult of Martín (Fig. 6.10). In some way that is not altogether clear, the *nab'eysil* acts as a personification of the deity's power over the maize harvest and rain. The *nab'eysil* is a highly respected member of the community, one of only two priest-shamans (the other being the *telinel* of the Mam) who perform rituals that have world-renewing significance, as opposed to those that are of more individual concern, such as healings. Traditionally the office of *nab'eysil* is a lifelong calling, and the person who acts in this capacity must remain ritually pure and celibate throughout the year. Shamans

Fig. 6.10. The nab'eysil priest is dedicated to the cult of Martín and is the only one who may dance the Martín bundle on ceremonial occasions.

invoke deceased *nab'eysils* like Francisco Sojuel and his successors in their prayers, often coupled with the title Martín, an indication that they are identified as the tangible embodiment of that deity (Mendelson 1958a, 124; 1958b, 6; 1965, 91). Nicolás said that Martín is the only god that has no form of his own, instead adopting the guise of his *nab'eysils*: "When he appears to people on the street or in dreams he is a very old *nab'eysil* with snow-white hair, wearing traditional Atiteco clothes and the *su't* head cloth of confraternity members. He lives in the cave of Paq'alib'al with all the other *nab'eysils*."

The following description of the Day of Martín observance is based on my notes from 1989 and 1997. In preparation for the Day of Martín, the confraternity house in which the god's bundle is housed is thoroughly cleaned and swept the previous day. Confraternity members gather the dust and old candle scrapings in a bag to be destroyed later. Then confraternity elders spread pine needles over the floor to form a thick carpet of greenery. At about 10:00 in the morning of November 10, the *nab'eysil* priest removes the Martín bundle from its chest and holds it briefly in front of each of the saints on the confraternity altar to, as he describes it, "give them power." During the year, these saints will turn over any difficult matters they cannot handle alone to Martín as their *dueño* ("master," "keeper"). Having presented Martín to the saints, the *nab'eysil* then lays the bundle on the altar where other confraternity members cense it with copal smoke, spray it with cologne (the preferred brand these days is Brut for Men), and sprinkle it with flower petals. Throughout the day, petitioners come to pray and give

The Basal Narrative Panels of the Central Altarpiece 159

offerings to the Martín bundle because they believe that on this day Martín emerges to walk all over the mountains surrounding town, bestowing blessings on the people.

A few hours after sunset, a group of four young men performs a Deer Dance in honor of the Martín bundle. Two of the dancers wear very old and nearly hairless jaguar skins and the other two wear deer pelts with the head and antlers still attached, adorned with green and red ribbons (Fig. 6.11). In the carved version of the dance on the second altarpiece panel (Fig. 6.7), only the front half of the deer impersonator on the far left may be seen, implying that the scene continues beyond the confines of the sculpted frame. The artists used this device to indicate that there are more participants in the dance without showing them all and making the panel unnecessarily crowded and confusing.

The animal skins used in the dance are normally kept on a table at the southern end of the confraternity house. Prior to the dance, the *nab'eysil* blesses one of the deerskins, addressing it as "King Martín, Lord of the Three Levels, Lord of Rain, Lord of Maize, and Lord of All the Mountains." He also places a line of candles along the edge of the table as he prays, while attendants spray the skins with cologne and wave incense burners to purify the skins with copal incense smoke. While this is going on, another confraternity member sprays those in attendance on their chests with more cologne. In addition, everyone present waves a copal incense brazier under each arm and across their chests in preparation for the ceremony.

Fig. 6.11. Dance of the Deer in the Confraternity of San Juan. At the climax of this dance, the deer dancer is "killed" as a sacrifice so that the world can be reborn.

Once the *nab'eysil* has finished blessing the deer and jaguar skins, the dancers put them on. The deer impersonators place the head of the deer on top of their own and let the remainder of the pelt fall across their backs. A separate deerskin fragment is then hung in front of the chest of the dancer, who holds it in place as he dances. The first jaguar impersonator carries a small stuffed squirrel called the *ral b'ajlam* ("child of jaguar"), which he uses to claw at the back of the principal deer dancer. Participants insist that the squirrel is to be understood as a small jaguar who hunts and kills the deer. The dancers once used a stuffed mountain cat, an example of which also lies on the table with the deerskins, but these are hard to find now and the head of the confraternity does not wish to have the ancient one damaged by overuse. Nicolás says the principal deer dancer is the "substitute" or "changeling" of Martín and that the skin, skull, and antlers represent the body of the god in his animal form. In a prayer of blessing, the *nab'eysil* asks for Martín's pardon and permission to carry out the same transformation himself, and in the same way that the ancestors once did in ancient times.

At the beginning of the Dance of the Deer, all four costumed dancers kneel in a line, the first deer at the head, facing the doorway to the east. The first deer impersonator calls on the mountains and other important features located to the east to bless the dance. He also raises his head to call on "Heart of the Sky" and kisses the ground while praying to "Heart of the Earth." The dancers then repeat the procedure facing to the south, west, and north. Having prayed to the four directions, the performers dance rapidly around the room, hopping from foot to foot and periodically whirling around in place as they mark a generally clockwise course around the interior of the confraternity house. As they dance, the jaguars make loud whistling sounds while roughly pawing at the backs of the deer with the stuffed animal. The deer in turn cry out and try to escape from them. The dance is accompanied by the Xo', who kneels on the ground beating a split-log drum with a wooden stick. The cadence of the drum changes periodically, each rhythm being connected with a different mythic song related to the first creation (although the songs are no longer sung aloud). The jaguar impersonators eventually "kill" the principal deer dancer, whom they carry back to the altar as if he were a sacrificial offering.

The death of the deer occurs just before midnight, the hour when the power of the underworld is at its greatest. Among the K'iche's of

Momostenango, night not only marks a time of day, but may also refer to the mythic past when the living may meet and talk with dead ancestors and their gods (B. Tedlock 1986, 128). In Santiago Atitlán, Atitecos often tell of meeting long-dead relatives or one of the town's deities while walking the streets at midnight and most major confraternity rituals take place at either noon or midnight, the latter being associated with the creation of the world prior to the first dawn of the sun. Mendelson, who first witnessed the ceremony in 1952, records that the Martín bundle is removed from its chest only at noon or midnight because that is when the god emerges from his place in the otherworld (1958a, 124).

Once the deer and jaguar impersonators complete their dance, they return the animal pelts to the table where they are normally kept and the *nab'eysil* begins his portion of the ritual. First, all the doors and windows of the confraternity house are closed and bolted shut because participants believe that if the Martín bundle were opened with the doors or windows left open, its power would rush out and destroy the world in a great wind storm (Mendelson 1965, 57). In 1997, a drunken man tried to leave the confraternity house after the doors were locked. A half-dozen others leapt at him before he could unbolt the door and forcibly restrained him on the ground for the remainder of the ceremony. The man sitting next to me whispered that if the drunk had succeeded in opening the door, the world would have come to an end and "wouldn't that be a shame since I just got married."

Having secured the room, the *nab'eysil* then begins his portion of the ritual. He opens the Martín bundle from which he removes a very old beige-colored shirt with a painted pattern resembling tufts of hair. The *nab'eysil* likened this design to the deer pelts used in the Dance of the Deer, but much older and more powerful. Nicolás said that the garments in the bundle were once worn by Francisco Sojuel when he danced in honor of Martín in the role of the principal deer and that they came from Paq'alib'al, where the gods wove them.

The head of the confraternity removes from the Martín chest an old wood carving of a recumbent animal called *rutz'i' Martín* ("dog of Martín"), a title which suggests that the animal belongs to the deity and is subservient to it, for in Tz'utujil-Maya speech, "dog" can simply mean "servant" (Tarn and Prechtel 1997, 54). It is actually another effigy jaguar (Fig. 6.12). The head of the confraternity explains that this jaguar is both a dangerous animal who kills and a protector who helps the deer dancer. In the subsequent ritual performed by the

Fig. 6.12. The head of the Confraternity of San Juan dancing an effigy jaguar as an instrument of sacrifice.

Fig. 6.13. The nab'eysil priest wearing one of the garments of Martín. These garments are removed from the bundle only once a year, at midnight on November 11.

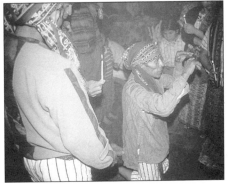

nab'eysil, he plays the same role as the jaguar sacrificers in the Dance of the Deer. The nab'eysil thus represents the sacrificial deer of Martín who offers his life so that the world might be reborn (Mendelson 1958a, 124).

Dressed in the garments of Martín, the nab'eysil kneels to the four directions in the same order and fashion as the deer and jaguar dancers (Fig. 6.13). While kneeling, the nab'eysil invokes the power of Martín with a long series of titles, including Navel of Martín; Heart of Martín; Heart of Maize; Heart of Water; Heart of the Lake; Heart of the Harvest; Heart of the Sky; Heart of the Earth; Heart of the Stars; Heart of the Sun; Heart of the Moon; You, Who Are Creation; You, Child of the Mountains; You, Child of the Plains; Lord of Rain; Lord of Maize; Lord of the Sun; Lord of Clouds; Heart of Paq'alib'al; Heart of the Earth; Heart of the Sky; Heart of the Mountains; and Heart of the Plains. He also thanks the ancient ancestors, listing a long series of names of powerful nab'eysils from the past who along with Martín provide the people with white, red, and black ears of maize. During

The Basal Narrative Panels of the Central Altarpiece 163

this phase of the ritual in 1997, the *nab'eysil* declared that he knew that Martín alone could give these things, and that he will never give up coming to dance for Martín, even though many in his family are now Protestants and deny the power of the ancestors. At this point in his prayer, the *nab'eysil* was interrupted by several claps of thunder from the direction of a nearby volcano located across the bay to the west, followed by a heavy downpour of rain. One of the elders of the confraternity elbowed me hard and exclaimed, "You see? Martín is in the mountains bringing the rains, even though this is the dry season when there isn't supposed to be any rain."

Nicolás Chávez told me the following myth concerning the *nab'eysil's* prayer:

> In the days of the great nab'eysil *Francisco Sojuel, a mob of his enemies tried to take away his power on the Day of Martín. But when they tried to take him by force, he called on the power of Martín to help him. Immediately the first of Martín's garments began to fly and transformed into a deer. It then flew up into the clouds and the lightning started. Francisco Sojuel's enemies became frightened and asked him to make the lightning stop before they were killed, so Francisco made prayers to Martín. This was the same prayer that the* nab'eysil *uses today to call on Martín so that he will give them rain and all the kinds of fruit and food and not kill them with lightning. The drum that he dances to is the thunder. The incense smoke in the room is thick and dark, just like clouds when it is about to rain.*

Following his prayer to the four cardinal directions, the *nab'eysil* dances three slow and stately circuits around the confraternity house in a clockwise direction. In comparison to the rapid movements of the deer and jaguar dancers, the dance of the *nab'eysil* is much more restrained. It consists mostly of small, purposeful steps taken with the knees slightly bent, the arms held downward and away from the body, and the body rhythmically leaning from side to side. The steps follow the cadence of the split-log drum played by the wife of the confraternity leader (Fig. 6.14).

At the end of the third round, the *nab'eysil* stands before a table near the center of the confraternity with his arms outstretched in a crucifixion-like pose. All present approach the *nab'eysil* holding candles and kiss the Martín garment three times in the navel area (Fig. 6.15a). Although the Chávez brothers consider this stage in the ritual to be the

Fig. 6.14. Split-log drum in the Confraternity of San Juan.

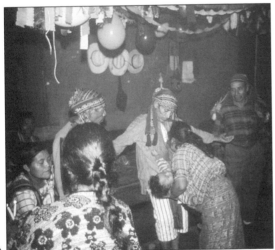

A

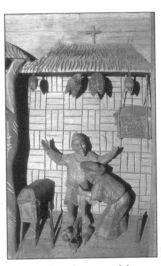

B

Fig. 6.15. (a) After dancing in the garments of Martín, the nab'eysil stands at the center of the confraternity house with his arms outstretched in a crucifixion-like pose. Those present file past one by one, kissing the garment two or three times in the navel area. This is the climactic moment of the ceremony, signifying the rebirth of the world. (b) A panel carved by Nicolás Chávez meant for private devotion depicts the event beneath pendant split-cob maize ears. (Collection of the author.)

most important, they did not include it on the altarpiece because it is too powerful for public view. Nicolás Chávez carved a related panel as a private devotional shrine which shows the *nab'eysil* wearing the garment of Martín approached by a female worshiper who kisses its hem (Fig. 6.15b).

One of the confraternity members explained that the *nab'eysil* had been killed like Jesus Christ and that is why he holds his arms in the form of a cross. Yet Christ is also conflated with Martín as a maize deity. Mendelson records that during a performance of the Martín

dance in 1952, the first jaguar dancer declared that "Jesus Christ and Mary are intertwined with King Martín, the Sacred World, the sky, the earth, and the sons of God" (1957, 215). This is consistent with a comment made to me by a *cofrade* who suggested that the pose of the *nab'eysil* doesn't represent a cross, but a maize plant as it grows out of the earth. This ties the dance with the world tree/maize plant atop the church altarpiece as well as the cross above the Easter Monumento. Both symbolically emerge from the mountain of creation at the center of the cosmos as a symbolic token of renewed life. The outstretched arms of the *nab'eysil* is a position common in ancient Maya depictions of the dance of the maize god as he emerges out of the underworld (Freidel et al. 1993, 276).

After dancing the first garment of Martín, the *nab'eysil* returns to the bundle, where attendants help him to change into a second shirt-like article of clothing. While changing, attendants stroke the back of the *nab'eysil*, comforting him and encouraging him to be strong. During the dancing of the second garment in 1997, the head of the confraternity had to restrain the *nab'eysil* after numerous rounds of the house so that those present could approach him to kiss the cloth. The *nab'eysil* tried to resist, declaring that he felt the power and could dance all night without getting tired. The following day, the *nab'eysil* told me that because Martín had danced through him the world was new again and the rains would come to make the maize grow: "When I dance I feel nothing but the great weight of Martín's garment. I don't see the people around me because I am filled with the power of Martín and the ancestors and I dance in their world."

The confraternity in which the dance takes place also reflects creation imagery. Houses dedicated for ritual use represent the interior of sacred mountains where the saints and other divinities live, and where rain clouds are born. When worshipers enter such houses, they conceptually pass into a symbolic cave where the saints and other divinities reside. The rafters of the Confraternity of San Juan are hung with fruit, sprigs of plants, and stuffed wild animals, representing the bounty of a fertile mountainside. These decorations are set in a grid-like framework composed of small bundles of *pixlaq*, a plant with small round leaves brought from the nearby mountains (Fig. 6.16). With time these leaves shed and fall, which Atitecos liken to the fall of rain or dripping water inside caves.

Set amid the *pixlaq* sprigs, and in a dense line above the altar, are hung numerous ears of split-cob maize (*yo'x*, twins) as a sign that maize

Fig. 6.16. Fruit and stuffed wild animals hang by cords suspended from the ceiling rafters in the Confraternity of San Juan. A peccary may be seen in the center. The decoration is meant to signify a fruitful mountainside. Worshipers who enter the house conceive themselves to be in the heart of a sacred mountain or volcano.

is born here. Small yellow fruits called *tz'um tz'um* with protrusions at the end which look like brightly colored *yo'x* cobs are also scattered about the ceiling. Confraternity members told me that they represent a pure form of *yo'x* maize eaten by the spirit beings in the mountains and that their presence in the confraternity stimulates the maize fields to produce more abundantly. The Martín bundle is considered the *ruk'u'x tajkon* ("heart of the harvest") and "father" of the twin maize ears. The confraternity house is therefore an architectural counterpart to the church altarpiece as the mountain source of maize.

Also hanging from the ceiling are examples of the same fruits that adorn the altarpiece's Monumento during Easter Week—melacotón gourds, corozo, cacao, and pataxte. These not only reinforce the notion that the confraternity house is a source of fertility, but indicate the presence of Francisco Sojuel and other powerful *nuwal* ancestors who continue to use their influence to bring rain and abundance to the earth. The rectilinear pattern of vegetation running north-south and east-west also parallels the Easter Monumento's arrangement of twisted ropes hung with fruit and foliage. Both represent the basic structure of the world, which Atitecos believe was formed at the time of creation by Yaxper, patron goddess of the moon and midwives (Prechtel and Carlsen 1988), who wove the fabric of the cosmos on her backstrap loom, the warp and woof establishing the network of intersecting lines that give structure and support to all things. As mentioned above, her most important image in Santiago Atitlán resides in a glass case at the center of the altar in the San Juan Confraternity.

The Basal Narrative Panels of the Central Altarpiece

Hanging from this framework of vegetation are a number of stuffed wild animals, including five peccaries, six *pizotes* (a large, squirrel-like rodent), a raccoon, and a mountain cat. Some of these appear to be very old, while others are relatively recent. I could not discern any pattern to the number or placement of these animals. Confraternity elders said the pattern changes when hunters bring new animals as offerings to San Juan. They represent all wild creatures that inhabit the mountains around town. Brightly colored plastic streamers parallel the crisscross lines of the plants, fruits, and animals, making them more visually striking.

In contrast with the gridlike pattern of these decorations, eight garlands of imitation pine radiate downward and outward from the center of the ceiling to the corners and walls of the interior. The termini of these garlands represent the cardinal and intercardinal directions, an indication that the power generated in the confraternity extends to the edges of the world.

The geometric configuration of the confraternity's ceiling decoration does not reveal itself unless one stands at the center of the room and looks directly upward (Fig. 6.17). From any other location, the hanging plants and stuffed animals overlap and obscure their very precise and systematic arrangement. From this central vantage point, the rafters give the impression of being the heart of a mountain or volcano with its verdant slopes encompassing the viewer on all sides. The floor beneath this center point is devoid of furnishings of any kind so that visitors are free to experience the illusion without obstacle.

Fig. 6.17. The ceiling rafters as seen from the center of the confraternity house. From this perspective, the orderly geometric arrangement of the decorations can be appreciated.

Art and Society in a Highland Maya Community

The center of the confraternity house is also the focus of the Dance of the Deer and the dance of the *nab'eysil* with the Martín bundle. In both cases, the dance is begun by kneeling outward to acknowledge the mountain lords that dominate the four cardinal directions, beginning with the east, and moving clockwise to repeat the action to the south, west, and finally north. The purpose of the ensuing dance is to center the power of the four directions in the confraternity in order that it may be renewed by the rebirth of Martín. As the *nab'eysil* circles the confraternity with the bundle, or wears the garments of Martín, he follows a clockwise circuit that keeps his dominant right side directed at the center of the room. For the Tz'utujils, the right side (*ijkiq'a*, "adorned hand") represents life and strength, while the left (*xkon* or *ch'u'jq'a*, "crazy hand") signifies death, weakness, and disorder. Once at least three rounds of the confraternity have been completed, the *nab'eysil* stations himself near the center of the room, where everyone present pays homage to the newly resurrected god in the form of the *nab'eysil* with arms outstretched in token of the world tree/maize plant.

The dances in honor of Martín may be an echo of pre-Columbian Maya ritual practices. Creation ceremonies were an important part of ancient highland Maya worship, and the K'iche'-Maya authors of the *Popol Vuh* stipulated that it requires a long "performance" as well as a written account to complete the first dawn of the sky and earth (D. Tedlock 1996, 63, 219). At appropriate times, ancient Maya priests or kings ritually sacrificed animals and wore their skins in imitation of their patron gods. The patron deity of the K'iche's was Tohil, a god who directed the migration of their first ancestors, and his principal sign was the bloody skin of a deer, slain in his name (Recinos 1957, 37; Carmack 1981, 51). The sacred deerskin, wrapped in a bundle and kept hidden in a wooden chest, was called Our Lord of the Stags and venerated as the primary symbol of highland Maya power prior to the Spanish Conquest. In the *Popol Vuh* account, Tohil instructed the first fathers of the highland Maya to "Set the pelts of the deer aside, save them. . . . They will become deerskin bundles, and they will also serve as our surrogates before the tribes. When you are asked: 'Where is Tohil?' then you will show them the deerskin bundle" (D. Tedlock 1996, 163).

Mendelson believes that Martín represents a contemporary version of an ancient Maya divinity, possibly Tohil (1958a, 121, 124). Tohil, the supreme god of all the highland Maya lineages (including the Tz'utujils) prior to the Spanish Conquest, was associated with

life-giving rain, fertility, and sacrifice (Ximénez 1929–1931 [1722], I.xxix.81; P. Carrasco 1967, 256; Carmack 1981, 62, 376; Carmack and Mondloch 1989, 175; D. Tedlock 1996, 152–166). Although each of the highland Maya tribes had their own patron gods, they all recognized Tohil and attended festivals in his honor (D. Tedlock 1996, 159–161, 166, 170, 191, 193). Thus the *Popol Vuh* asserts that Tohil is an expression of other pan-Mesoamerican deities including the central Mexican gods "Yolcuat and Quetzalcoat" (D. Tedlock 1996, 162). K'iche' shamans invoke Martín as "Holy King of the World, Holy Savior of the World, Holy Creator of the World, Holy Martín of the World" on the peak of Ah Tohil, the mountain devoted to the ancient god where one of his principal cult image once stood (D. Tedlock 1993, 138–139).

According to the *Título Totonicapán,* all the major pre-Columbian highland Maya lineages, including the Tz'utujils, gathered at the K'iche' capital at Chiq'umarkaj carrying their patron gods. There the ruling lords put on animal skins and danced with various deity images (Carmack and Mondloch 1983, 17, 196, 252; see also Carmack 1981, 88). The principal image of Tohil presided over the event dressed with military symbols connected with ritual sacrifice. This Great Dance of Tohil took place in the month of Tz'ikin Q'ij, just prior to the principal maize harvest in November, the same time period as the Dance of Martín. The ancient Festival of Tohil also marked the beginning of the solar calendar, when the world and the legitimacy of the king was renewed.

The *Título Pedro Velasco* records that prior to the Spanish Conquest, the highland Maya of Guatemala conducted such dances in special "guest houses" in which their rulers danced in honor of their gods: "Each of the lineages had a house to hear the word and to administer judgment. There the lords danced the Junajpu C'oy and the Wukub Cak'ix, the Awata Tun, and the Jolom Tun. Each lineage had divisions, each with a house" (Carmack and Mondloch 1989, 178). Fray Gerónimo de Mendieta (d. 1604) wrote that "one of the principal things which existed in this land were the songs and dances, to solemnize the festivals of their demons which they honored as gods, as well as to rejoice and find solace. The house of each principal lord thus had a chapel for singers and a place for dances. The great dances were held in the plazas or in the house patios of the great lords, for all had large plazas" (Mendieta 1993, 140). These special houses are likely analogous to the confraternities' houses of today.

Following the Spanish Conquest, the highland Maya of Guatemala continued to perform deer-hunting dances based on ancient precedent (Mace 1970, 55–65). Gage described such a dance performed in the seventeenth century in which wild beasts were sacrificed in honor of one of the saints. The dancers involved were all important lords who clothed themselves in painted animal skins and headpieces, particularly those of pumas and jaguars. He also noted that at times humans were the object of the hunt, pursued by dancers who lept at them and struck their bodies as they shrieked like wild animals. He noted that the Maya particularly favored such dances in connection with a ritual reenactment of the beheading of St. John the Baptist (1958 [1648], 245–246). These were not merely symbolic passion plays in the eyes of the Maya, but manifestations of the mythic events themselves. Gage wrote that participants in sacred dances "are superstitious about what they have done, and they seem almost to believe that they have actually done what they only performed for the dance" (p. 247). If this involved the symbolic "death" of one of the costumed dancers, those responsible came to him to confess and to be absolved of blood guilt.

Most likely a similar tradition underlies elements of the Martín dance at Santiago Atitlán, which takes place in the confraternity house dedicated to St. John the Baptist. Atitecos consider St. John to be the principal patron of wild animals, and the rafters of the house are hung with numerous stuffed animals brought in by hunters as offerings. The principal image of St. John on the altar of the confraternity bears a book in his left hand topped by a small recumbent animal painted with spots to represent a "little jaguar."

Sacred bundles of the type Tz'utujils worship under the name of Martín were also well known by the indigenous people of Mesoamerica prior to the Spanish Conquest. Las Casas wrote that the Maya in an unidentified highland Guatemalan village kept a wooden ark in the sanctuary of their temple which contained an image of their god wrapped in from 700 to 800 layers of fine cotton cloth. When Spaniards destroyed the ark and its sacred bundle, the people wept greatly and believed that this sacrilege would cause the earth to open and swallow them all (Las Casas 1967 [1550], III.clxxx.218–222). Torquemada cited the use of Indian bundles "made of the mantles of the dead gods," a concept which Mendelson compares with the garments in the Martín bundle worn by the *nab'eysil* in token of the god's sacrifice (Mendelson 1958a, 124). Carlsen also associates the bundle

cults at Santiago Atitlán with those of the pre-Columbian Maya and suggests that they represent a survival of ancient fertility cults (Carlsen 1997, 80).

The question arises, How did the festival of Tohil become associated with that of St. Martin of Tours at Santiago Atitlán? The supremacy of the Dance of Martín as a world-renewing ritual cannot be explained by Roman Catholic tradition alone. St. Martin of Tours had no such mythic associations. Its significance must therefore be due either to some importance attached to the tradition of the saint by early Maya converts to Christianity, or to coincidence that the day of the saint's festival happened to fall on a day of importance in the ancient Maya calendar. Both of these possibilities are likely true in the case of the Martín cult at Santiago Atitlán.

Bunzel wrote that Saint Martin was arbitrarily selected as the patron of the earth's fertility by the first Christian missionaries, thereby replacing the name of an earlier Maya god (1952, 57). I think it unlikely that this association was arbitrary. The Maya were quite selective about which saints they chose to adopt as their patrons based on their attributes and the timing of their festivals. The early Spaniards tried to foster San Isidro as the patron of agriculture, but they met with resounding failure because the Maya did not find the history of that saint relevant to their own traditions (Thompson 1970, 164). The Great Dance of Tohil was celebrated in mid-November, timed, like the Dance of Martín, to coincide with the principal maize harvest (Carmack and Mondloch 1983, 196, 252). It was therefore logical for the people of Santiago Atitlán to continue to venerate the old god at the appropriate time of year by transferring his festival to the day of a Roman Catholic saint.

Following the Spanish Conquest, missionaries forcibly replaced the images of native gods with those of Christian saints. These adopted, in the eyes of the Maya, the powers and status of the older indigenous deities. Gage, who visited Guatemala in the 1630s, wrote that the saints' images were worshiped like ancient "idols":

They yield unto the popish religion [Roman Catholicism], especially to the worshiping of saints' images, because they look upon them as much like unto their forefathers' idols; and secondly, because they see some of them painted with beasts . . . and think verily that those beasts were their familiar spirits. . . . The churches are full of them. . . . Upon such saints' days, the owner of the saint maketh a great feast in the town (1958 [1648], 234–235).

Gage noted that the Maya danced in the skins of wild beasts, in which they "merrily" sacrificed the saints themselves, such as St. Peter or John the Baptist (pp. 245–247). Over time the cult of the animals came to take precedence over that of the saints. This may explain the curious identification of the god Tohil and his deerskin bundle with St. Martin. St. Martin is often depicted in European Catholic art riding a horse and dividing his cloak to clothe a naked beggar (Fig. 6.18a). An image of the saint riding his horse may be seen in the private Confraternity of Martín as well as in the church at Cerro de Oro, a rural dependent village of Santiago Atitlán (Fig. 6.18b). The early Maya consistently confused horses with deer (Hill 1992, 151). When the Spaniards arrived, they mistook the horses they rode as giant deer and therefore named them *kej* ("deer"). Even today both animals bear the same name in most Maya languages.

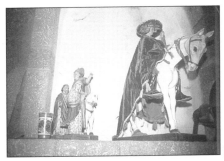

B

Fig. 6.18. St. Martin of Tours: (a) "St. Martin and the Beggar," El Greco, 1597/99 (National Gallery of Art, Washington, D.C.); (b) San Martín from the church at Cerro de Oro, a dependent community near Santiago Atitlán.

A

Ximénez noted that highland Maya dances performed on Roman Catholic holy days originated in stories of the saints translated for the Indians by the first priests but that over time the natives altered them to conform "to pretty memories of their gentile condition" (1967b [ca. 1722], 8). It is perhaps significant that the first resident priests at Santiago Atitlán were a pair of Franciscan monks named Juan Alonso and Diego Martín, who arrived in the newly congregated town in 1566 after evangelizing much of the surrounding region (Orellana 1984, 119). At Chichicastenango, a K'iche' community not far from the Tz'utujil region, the vegetal aspect of the earth is worshiped under the name of Diego Martín, the counterpart of the Atiteco Martín deity (Bunzel 1952, 57). It is reasonable to assume that the first missionaries would have recited the histories of the saints whose names they adopted and encouraged their cults. In contemporary prayer litanies recited by Tz'utujil shamans, "Juan Martín and Diego Martin" are coupled as the two most important manifestations of the god (Mendelson 1957, 457, 500). If the worship of Martín originated in the sermons of Juan Alonso and Diego Martín, the unusual pairing of the names Juan and Diego as a specific referent to the deity Martín in Atiteco prayers becomes understandable.

The characteristics of St. Martin of Tours also made this association logical in the eyes of early Maya converts. In addition to his charity, he was famous for miraculous healings, which included raising the dead, both traits shared by the Santiago Atitlán Martín as a god of resurrection who is frequently consulted to heal illnesses.

The European St. Martin was also a great exorcist (Brown 1981, 107–112; Farmer 1987, 287). As a monk, and later as a bishop at Tours, St. Martin pioneered the conversion of rural areas in Gaul during the fourth century, destroying heathen temples and cutting down sacred trees used in non-Christian rituals. Sulpicius Severus wrote that "when alive, the authority of Saint Martin had elicited, in the agonized cries of the possessed who flocked to him, a roll call of the names of the ancient gods: this amounted to a definitive recognition by the demons, who bore the names of the gods, of the superior *potentia* of Martin and his God" (Sulpicius Severus, *Dialogi* 3.6, cited in Brown 1981, 109–110).

Note that in Sulpicius Severus' account the old gods were not considered nonentities, but were supernaturals who recognized the authority of St. Martin to command them. In the sixteenth century,

exorcism rituals to banish the old native gods were a common part of the early evangelization effort in the New World. I believe it likely that St. Martin of Tours, as the exorcist *par excellence*, would have been invoked by the first missionary friars among the Tz'utujils to force the old gods to subject themselves to the new divine hierarchy. From a Maya perspective, St. Martin the exorcist who commands the "demons" to obey his will could be logically reinterpreted as the Atiteco Martín, king of all the other divinities, who commands them as he would servants at a royal court.

While the practice of traditional Maya religion ceased to be a state function after the Spanish Conquest, many public ceremonies, such as ritual dance performances, survived in outlying regions less affected by Roman Catholic missionary efforts. In some cases, elements of native ritual dances were even encouraged as a means of attracting potential converts. To further their program of converting the Maya to Christianity, the earliest missionaries in the New World often adopted the outward forms of pre-Columbian ceremonialism, sacred dances and dramatic performances among them, in an effort to supplant the old gods. But such strategies of appropriation opened interstices in colonial policy which the Maya were able to exploit. As a result, practices, traditions, and beliefs which previously had been fostered institutionally in pre-Columbian Maya states sometimes persisted in popular forms such as dances or orally transmitted myths.

Sometime between 1520 and 1530, Fray Pedro de Gante wrote a number of songs which were intended to accompany a dance reenacting the Nativity of Christ. He hoped that this performance would eventually replace indigenous dance rituals and thus speed the process of conversion:

And because I saw that all of their songs were dedicated to their gods, I composed a very solemn song concerning the law of God and of Faith, . . . and also I gave them liberty to paint on their robes in which they danced, for thus they were accustomed to do; thus in keeping with the dances and the songs that they once sang, they now clothed themselves with joy (García Icazbalceta 1889–1892, II:231–232).

Rather than destroy the practice of native religion, this policy actually fostered its continued survival. Fray Bernardino de Sahagún (d. 1590) complained that because many priests were ignorant of the

languages of recently converted Indians in the New World, they were easily deceived by them. Through ritual dances and festivals, they continued to honor their ancient gods while hiding the practice beneath a thin veil of Christian faith by occasionally shouting out the name of God or some saint. He suggested that such dances were like a cave or forest where Satan had taken his last refuge (Sahagún 1956, I:255). Despite numerous attempts by Spanish authorities to suppress dance rituals based on ancient indigenous tradition, the Maya in highland Guatemala continued to observe them. Thus Fray Francisco Ximénez observed in the eighteenth century that although dances on Christian holy days originated in stories of the saints translated for the Indians by the first priests, over time the Maya had altered them to worship their own gods:

> The early Fathers gave [the Maya] certain histories of the Saints in their language, in order that they might sing them to the sound of the drum in place of those that they used to sing in the time of their gentility. Nevertheless, in my experience, they sing these in public only when the priests are there to hear them, but they then, in secret, sing songs that conform to pretty memories of their gentile condition. (1857 [ca. 1722], 148–149; translation by author)

In the Guatemalan highlands, Fuentes y Guzmán (d. 1699) wrote that although the Maya acknowledged the Christian saints during confraternity dances, they continued to honor their pre-Columbian gods:

> They enact dances around the one who plays the tepunuguastle [split-log drum] which is played with the blows of some little wooden sticks covered at the ends with rubber. . . . Thus they dance, singing songs to the Saints. But they also, in their prohibited dances, sing the histories and deeds of their ancestors, and of their false and lying gods. (1932, I:212–213; translation by author)

The Atiteco deity Mam, familiar from Chapters 3 and 4, occupies the central position on the second basal panel of the altarpiece (Fig. 6.7). There he is depicted at the height of his power during Easter Week, when he presides over the death of Jesus Christ (Fig. 4.14). To understand how the Mam came to play this role on the altarpiece requires further elaboration on the larger role this ancient Maya divinity plays in traditionalist Atiteco society.

A

B

Fig. 6.19. Acheiropoietic masks. (a) Petroglyph of the Mam from the cemetery south of Santiago Atitlán. Local tradition claims that this mask was carved magically without tools by either Francisco Sojuel or his successor as nab'eysil, Marco Rohuch. (b) Deities carving sacred masks from the Madrid Codex 97ab. (Villacorta and Villacorta 1930.)

The Mam stands in opposition to Martín and his power over new life and fertility. While Martín's character appears to be generally beneficent and never curses anyone with misfortune who does not deserve it, the Mam is the patron of shamans who practice the black arts and delights in bringing down the high and mighty out of sheer capriciousness.

The image of the Mam worshiped in the Confraternity of Santa Cruz consists of a flat piece of wood with two legs and a head attached to the main trunk (Fig. 3.6b). A carved wooden mask tied around the head serves as its face, an ever-present cigar inserted in the mouth. His costume is a disordered mixture of traditional Tz'utujil pants and non-Maya boots, scarves, suit coat, and not one, but two Stetson hats. The Mam's eclectic taste in fashion reflects his chaotic nature as a deity that violates the order of nature as well as the societal norms of Santiago Atitlán. In cosmological terms, the Mam represents the dele-terious power of the underworld realm of death and decay (Mendelson 1958a, 125; Thompson 1960, 134; B. Tedlock 1982, 100–101).

A stone at the edge of the Santiago Atitlán cemetery bears an incised mask of the Mam (Fig. 6.20a). Nicolás claims it was carved by Francisco Sojuel and María Castelyan at the time they carved the mask and body of the Mam. He is in the cemetery because "he is the lord of the dead and watches over their souls in the underworld." Like the altarpiece, then, the Mam represents a creation of the gods, rather than a human invention. The ancient Maya also believed that their sacred images were crafted by divinities: a series of panels in the Madrid Codex depict gods in the act of molding deity heads from clay, or sculpting them with axe-like tools (Fig. 6.19b).

The Mam is associated with earthquakes, floods, destructive winds, disease, madness, and the weakness of old age. He presides over the sterility of the dry season and the bitter cold of the winter months (Tarn and Prechtel 1986, 178–179). As maize ripens, he caus-es the plants to weaken and turn brown and decay. Although elderly and sterile himself, he is characterized by hypersexuality, seducing women about town disguised as a handsome young man (Tarn and Prechtel 1990, 75). His wife, Yamch'or ("Virgin-Whore"), is a prosti-tute whose sexual escapades match his own. Yet their extreme sexual appetites do not produce healthy children. Stillborn babies or infants with severe congenital malformations are sometimes thought to be

the result of the Mam's dalliances.[2] Other Atitecos insist that a woman could never become pregnant by him because his touch would either kill her outright or cause her to die soon afterward of insanity.

In rituals, the Mam represents the power inherent in death and sacrifice to transform and renew. The jaguars that symbolically "kill" the principal deer dancer in the Confraternity of San Juan do so under his authority. He also oversees the death of Jesus Christ at Easter. As a "god-slayer," he is sometimes addressed as Pedro de Alvarado (who defeated the old gods at the time of the Spanish Conquest), Simon Peter (known in Santiago Atitlán principally as the saint who denied Christ), or Judas Iscariot (Lothrop 1929, 20; Mendelson 1958b, 1–5; 1959, 59).

Despite his malevolent nature, the Mam is not shunned by Atiteco society. Seldom have I been in the Confraternity of Santa Cruz when there have not been at least one or two petitioners waiting their turn to approach him in prayer. Tz'utujils believe that for Martín or Jesus Christ to be renewed, they must undergo sacrificial death. The Mam can hardly be blamed for fulfilling a necessary role that ultimately benefits everyone. As Fernando Cervantes writes, "European notions of good and evil, personified in the concepts of god and devil, implied a degree of benevolence and malevolence that was totally alien to Mesoamerican deities" (Cervantes 1994, 42). Both death and life must dance together on the world's stage or neither could exist for very long. If a person wishes to be cured of a severe illness, witchcraft, or madness, it is eminently reasonable to approach the deity who causes such things and thus has power to heal them. Nevertheless, the Mam is invoked with far more caution than with other saints, and his power has a negative tone. Rather than ask for a good harvest, as they would when praying to Martín or Santiago, Atitecos plead with the Mam that their crops will not be destroyed by some blight or other disaster.

The creation of the Mam is one of the most popular mythic tales in Santiago Atitlán. Yet there are as many minor variations on the theme as there are persons who tell it. Some Tz'utujils consider him to be a survivor from their pre-Columbian past, more ancient than Christ himself, having been created "in the beginning of the world" (Mendelson 1957, 338; B. Tedlock 1986, 130). Others say he was made

[2] One might wonder how the Mam, being sterile, could produce offspring of any kind. Atitecos do not seem to be disturbed by such contradictions.

by Francisco Sojuel or some other great *nuwal*. Nearly all of the versions of the myth assert that the ancients carved the Mam to guard their community and protect its moral standards and institutions. Once formed, however, the Mam rebelled against these strictures and reveled in breaking the rules he was charged with enforcing. He thus came to personify the instability inherent in nature which inevitably destroys what it seeks to build. This version of the Mam's origin comes from Nicolás Chávez:

> The great nuwals *Francisco Sojuel, Marco Rohuch, and others were once merchants and periodically left town to go to Antigua. One of their companions named Juan No'j had a wife. One day when he returned from business in Antigua a neighbor told him that his wife was seeing another man while he was away. Other merchants and farmers had the same problem. So Francisco Sojuel went into the mountains accompanied by the ancestors who created the world to find a tree that would be willing to watch over the town while they were away. They first asked the Cedar (*Tioxche'*), but it refused saying that it could only work a few miracles. Next they asked Mahogany (*Q'anxul*), but it was too hard and stiff to walk. Next they asked Breadnut Tree (*Iximche'*), but it was too heavy to work. Finally they consulted the Coral Tree (*Tz'utujil* Tz'ajte'; Spanish Palo de Pito) who agreed to work for the ancestors. So they cut down the tree which laughed as it fell. They then carved the body of the Mam from the tree. But they did not have to hold the tools as they worked. Three women accompanied them named María Castelyan, María Salome, and María Tak'ir.*[3] The women played the split-log drum and danced in front of the tree. María Castelyan would give the wood a drink of liquor and sing, and Francisco Sojuel would strike it with a machete. The machete would then carve the wood by itself.*
>
> *Once the Mam was finished, Francisco Sojuel told him to find out if it was true that the wife of Juan No'j was unfaithful. Now Juan No'j had a maize field near Chukumuk and he had a boy that worked for him there tending the crops. At noon, the wife of Juan No'j used to go to the maize field to deliver lunch for the boy and there they made love. So the Mam disguised himself as the wife of Juan No'j and went*

[3] These same three Marías appear in other myths as creator goddesses who help to form the world and decorate it with trees and animals.

to the field to deliver lunch. But instead of meat, he took cow droppings instead. When the boy saw the Mam coming he thought that it was the wife of Juan No'j and called, "My love, come with my food." While he ate, the Mam cried out and said, "Ha, I caught you and you will now be punished." Soon after, the boy became insane and died.

But the Mam soon got tired of keeping a watch over the people of the town and began to wander far away over all the mountains and all the countries without permission. He was supposed to protect the town from theft and adultery but he started to cause problems, doing whatever he wanted to do. He started to look for beautiful young girls and seduce them. But he could also appear as a beautiful woman himself and drive men crazy who followed "her." So Francisco Sojuel cut away his head, arms, and legs to stop him from wandering everywhere and to make him more obedient. He then tied the pieces back together again with cords. That is why he is called Maximon, which means "He Who is Bound," but his real name is Mam [Grandfather]. He can appear in many forms, but when you see him in town at night he is always at a crossroads smoking a cigar. He has a high-pitched voice and pronounces Tz'utujil like a foreigner. When you shake his hand it feels cold like wood and he only has four fingers because he does not have a thumb. He also has the smell of a skunk so when you smell this, you know he is near and offerings should be made to him or he may harm you or drive you mad.

When he was first created, Francisco Sojuel kept the Mam in his house. But after he went away to live in Paq'alib'al, the people decided that they did not like what the Mam did and left him on the south side of the church where he killed Jesus Christ at Easter. But the Mam did not like being near the church because he was not a Christian. One night he appeared to an ajkun where the town road branches off to go up to the cemetery. He said that if the people didn't treat him with more respect he would find a pretty girl as a wife and really cause trouble. So they took him to the Confraternity of Santa Cruz where he lives during the year and watches over the dead body of Jesus Christ.

There is a shrine to the Mam in the mountains northeast of town where tradition claims Francisco Sojuel cut down the Mam's tree. It consists of three shallow openings in the ground lined with stones and surrounded by offerings. Atitecos believe that these holes lead into the underworld realm of the Mam, guarded by the same jaguars that kill Martín's deer. I visited this shrine with Nicolás. The tree from which

the Mam was carved is purported to have grown from one of the excavated holes, which Nicolás referred to as "caves," although nothing of the stump remains. A number of Atitecos had told me that there is a large stone nearby which is deeply cleft, revealing a passageway into the earth. They said that with a flashlight you can see a stone mask of the Mam deep at the base of the cleft. Nicolás had also heard this tradition, so we searched for it in vain for nearly an hour. We found no evidence of such a stone, but this didn't overly concern Nicolás. He assured me that such powerful things can only be seen when they wish to be seen.

The central section of the altarpiece's second panel depicts the Mam during Easter Week hanging from a tree in his sanctuary near the church (Fig. 4.14a). For a five-day period from the early morning hours of Holy Tuesday to the resurrection of Christ and the rebirth of the world on Saturday morning, the Mam occupies the preeminent position in the religious as well as civil life of the community.

At midnight on the evening of Holy Monday, the *telinel*, the priest-shaman charged with caring for the Mam, washes the image's clothes on three special stones set in the waters of Lake Atitlán. This act likely recalls the three stones set in the primordial waters of the underworld at the time of creation.

The following evening, the *telinel* assembles the pieces of wood that compose the Mam's body and binds them together with cords, replicating Francisco Sojuel's actions. Nicolás refers to the Mam's wooden framework as his "bones" and describes their assemblage as a kind of resurrection from death. The Mam is put together around midnight in the confraternity house of Santa Cruz, with the doors and windows bolted shut. The procedure is done in total darkness because according to tradition the original image of the Mam was formed at night by the ancestors. Once the framework is assembled, the *telinel* then dresses the Mam in layers of clothing, some native and some foreign. The entire process takes about a half an hour, and is carried out mostly in silence, with an occasional joking comment passed between the *telinel* and other members of the confraternity. I was told that this is an important test of the *telinel*'s skill because it requires a special "second sight" to be able to assemble and dress the Mam in the darkness. Only if he bears the spirit of Francisco Sojuel and the other creators can he accomplish the task properly.

Once the Mam is ready, the mats are lowered, the lights turned on, and the Mam is revealed complete with a cigar sticking out of his

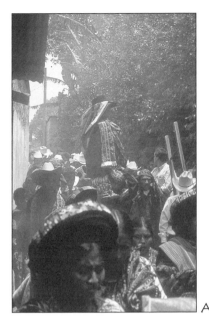

Fig. 6.20. (a) Procession of the Mam to the mayor's office, where he symbolically takes over political control of the community. (b) The Mam lying on a mat in the mayor's office surrounded by the principal women of the confraternity system and baskets of ripe fruit.

carved mouth. The head of the confraternity greets him formally with a long address, referring to the Mam as a beautiful and enchanted boy/man, well dressed and powerful. Those present then approach the image one by one to pray, leave offerings, and admire the *telinel*'s work. Many also look closely for any errors that may have been made, although I've never heard of that happening in recent times.

At around noon the following day (Holy Wednesday), the *telinel* carries the Mam in triumph, surrounded by mobs of Atitecos, from the confraternity to the mayor's office in the municipality building, where the image symbolically accepts rulership over the community (Fig. 6.20). For the next few days the town's government is dissolved and no important business can be conducted.

In the church, a heavy veil is draped over the principal images of Jesus Christ on the altarpiece to the left of the main altarpiece as an indication that God has also been deposed. For two to three hours, the Mam lies in state in the mayor's office flanked by a line of young men that represent his "soldiers or policemen." Before him a circle of women kneel, alongside piles of ripe fruit that will later be hung on the Monumento in front of the church altarpiece. The Mam symbolically copulates with the women and fruit while everyone in attendance drinks liberally and prays for special favors (Tarn and Prechtel 1986, 183 n. 6; Carlsen 1997, 154).

In mid-afternoon, the *telinel* carries the Mam up to the church plaza, where he is hung on a tree in a domed posa chapel (Figs. 4.14a and 6.21) located at the northeast corner of the plaza. Nicolás says that the Mam's sanctuary during Easter Week was once a traditional-style Atiteco house, as shown on the second panel of the altarpiece (Fig. 4.14b), but he was later transferred to the colonial-period structure because it was more permanent. In the altarpiece carving, the thatched roof of the structure is rounded and topped by an inverted earthenware pot. This vessel represents the surface of the earth and identifies the sanctuary below as the underworld. Traditionalist Atitecos interpret the dome of the posa chapel as a monumental version of this pot, and it therefore carries the same symbolic significance as a subterranean place. The location of the chapel below the steps of the church in the plaza also ties it with the waters of the underworld, which Atitecos believe lie just beneath the flagstones. A large hole in the foundation wall of the church complex directly opposite the Mam's chapel serves as a drainage culvert that spouts water whenever it rains, reinforcing this concept (Fig. 4.5).

The man to the left of the Mam on the altarpiece panel (Fig. 4.14b) carries a noisemaker called a *matraca,* which is spun around on its pole handle to announce the presence of the deity. Diego Chávez

Fig. 6.21. The domed sanctuary of the Mam on the church plaza. For traditionalist Atitecos the dome symbolizes the interior of the earth.

said that when the Mam was created a blue jay greeted him loudly with a call that sounds like the *matraca*. On the right is a woman wearing a long ceremonial *huipil* representing María Castelyan, who participated in the creation of the image in the time of Francisco Sojuel and later became the Mam's wife. Incense, candles, and other offerings are arranged at the foot of the Mam's tree. From Wednesday to Friday during Easter Week, the Mam is constantly attended by his followers and receives offerings. While the Mam resides in his sanctuary, Christ is conceptually dead in the underworld, symbolized by covering his principal images on the left altarpiece with a large white cloth. Nicolás said that when the Mam is in his shrine, Christ is in the place of the skulls beneath the floor of the church, near the world navel hole.

At dawn on Friday morning, Atitecos gather to assist Christ's rebirth. Thousands bring gigantic candles decorated with colorful aluminum foil to the church. They enter the west door on their knees, moving slowly in a double line toward the world center hole. There they dip their candles into the hole and then light them to represent new life emerging from death. A great cross is then laid on the floor of the nave and the life-sized image of Christ with moveable arms is taken from the left altarpiece and nailed to it. At about noon, the heavy cross is lowered into the "navel of the world" hole (Fig. 4.4). In western tradition, the crucifixion would represent the death of Christ, but for traditionalist Atitecos it is instead his triumphal rebirth out of the hole as a world tree. All of the bad things that occurred in town during the previous year are forced down into the hole beneath the cross at this time and a new age is inaugurated by the raising of Christ's cross above it. The resurrection of Christ is associated with the rebirth of the world and agricultural renewal. One of the major ritual maize plantings takes place afterward (Mendelson 1957, 374; Tarn and Prechtel 1990, 74).

Once the image of Christ is taken down from the cross three hours later, it is placed in a glass-walled coffin decorated with strings of colored lights that, when turned on, play Christmas tunes—"Silent Night," "Rudolph the Red Nosed Reindeer," and "Santa Claus Is Coming to Town." While this may seem incongruous to outsiders, the cheerful music is a further expression of renewed life. After heavily spraying the coffin inside and out with cologne, a large group of young men carries it down the church steps into the plaza to confront the Mam directly. This is a slow and stately procession that may take well over an hour to reach the bottom of the steps. Once in the plaza, the

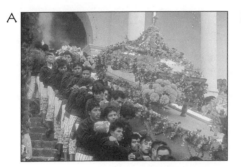

Fig. 6.22. (a) Procession of the coffin of Christ down the steps of the church where (b) he confronts the Mam in the atrium.

Christ in his coffin and the Mam on the shoulder of the *telinel* confront one another, occasionally rushing forward in mock combat followed by a surge of onlookers who scream and get carried along with the crush of bodies filling the plaza (Fig. 6.22).

At length, Christ "defeats" the Mam, who beats a hasty retreat back to the Confraternity of Santa Cruz. In past years, the *telinel* dismantled the image to "render it harmless" (Mendelson 1959, 58, 60). Although his mask was packed away right side up, the head itself was turned backward so as to "leave him without power of speech" (Mendelson 1965, 123). Today the Mam is no longer dismantled, though Christ is recognized as the victor and forces the Mam to remain in his own confraternity house. For the remainder of the evening and on until dawn, Christ's coffin is carried in an agonizingly slow procession in a counterclockwise circuit around the town's central district, symbolically recharging the world with new life. The pathway is covered with brightly colored "carpets" made from dyed sawdust laid down the day before in elaborate designs. People stay up all night waiting for the procession to pass them. The rebirth of the world is given universal validation when the coffin arrives at the entrance to the church just as the following morning dawns.

It is likely that the Mam represents a contemporary version of ancient Maya underworld deities, such as the lords of death described in the *Popol Vuh* who defeated and sacrificed Hun Hunahpu and the Hero Twins prior to their rebirth to new life. The Classic Maya believed that the underworld was dominated by similar underworld deities, one of whom is known among scholars as God L (Coe 1978, 16; Taube 1992, 79). Like the Mam, God L was an aged deity famous for his

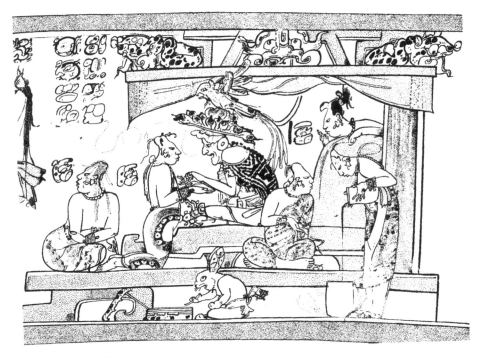

Fig. 6.23. God L in his underworld palace as depicted on the Princeton Vase, ca. AD 650–800. (From a drawing by Diane G. Peck and Diane McC. Holsenbeck in Coe 1973, 92.)

lascivious nature. On a number of finely painted ceramic vessels, he and other aged underworld lords appear surrounded by beautiful young women or fondling the breasts of the moon goddess, indicative of excess and corruption (Stone 1995, 143) (Fig. 6.23).

Both deities are closely associated with the sacrifice of gods and cosmic devastation (God L may be seen on the final page of the Dresden Codex presiding over the destruction of the world by flood) and cigars are a part of their standard iconography (Fig. 6.24a and b). Also, both God L and the Mam are patrons of underworld jaguars (Thompson 1970, 292; Taube 1992, 88) and long-distance travel (Taube 1992, 81). In the Postclassic texts of Yucatán, God L appears as Ek Chuah, the god of merchants (Taube 1992, 90–92; Miller and Taube 1993, 112; Schele and Mathews 1998, 19). One of the Mam's titles is Lord of Merchants (Carlsen 1997, 131) and he is said to wander all over the world, including the United States and Europe in his travels.

Yet the Mam is not an evil being, as are Western god-enemies like Judas Iscariot. He is essential to the proper regeneration of the earth

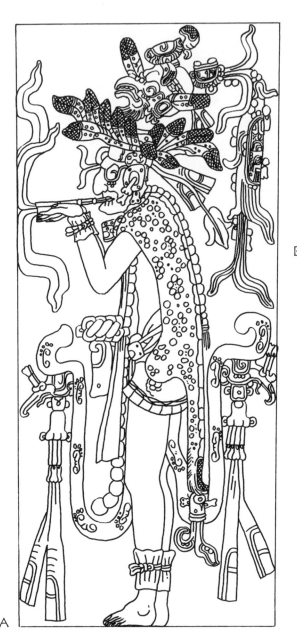

Fig. 6.24. Smoking deities. (a) God L smoking, east outer jamb of the Temple of the Cross, Palenque. (Redrawn after Merle Greene Robertson, 1976.) (b) The Mam with his cigar.

because he provides the means whereby gods like Martín and Jesus Christ may pass through sacrificial death to be reborn to new life. During the night when Christ's coffin is carried in procession through the streets, the Mam is supposed to travel ahead of him in spirit to ensure that everything is in order. This facilitative role in the rebirth of the world is also true of God L in ancient Maya theology. Although he participated in the destruction of the world by flood, a likely reference to the chaos of the primordial waters of the underworld, he also assisted in the rebirth of the world by setting one of the three stones of creation, at the direction of the maize god (Schele and Mathews 1998, 211). The fact that the Mam's clothes are washed at the beginning of Easter Week on three stones set in the waters of Lake Atitlán at midnight hints at a connection with ancient Maya creation mythology. The Mam and God L represent not merely death, but death as a means for gods to transcend mortality to be reborn to a higher state of existence and power.

In Santiago Atitlán, the passage of Martín and Jesus Christ through the underworld realm of the Mam is played out in elaborate dance rituals and public pageants. The same sort of ceremonies took place in the pre-Columbian Maya world. Las Casas and Ximénez wrote that prior to the Spanish Conquest, the highland Maya celebrated a great festival in which their kings reenacted the symbolic death and descent of their gods into the underworld, symbolized by a sunken ballcourt, where they confronted the lords of death (Las Casas 1967 [1550], II.clxxvii.149; Ximénez 1929–1931 [1722], I:81–101). Because of this ritual passage into the realm of the dead, the days of the festival were considered "closed" days, when there were no legitimate rulers and sickness and death afflicted humanity (Carmack 1981, 149; A. Miller 1986, 35). While the kings were symbolically in the underworld, carved images representing underworld gods wrapped in richly decorated mantles were brought forward and honored as temporary kings, taking the place of the legitimate leaders of the community. As such, the Maya gave them offerings and carried them through the streets to the accompaniment of music. Being usurpers of political authority, the images represented the reversal of the customary order of society and therefore functioned much as the Mam does in Santiago Atitlán during Easter Week. Ultimately the kings returned out of the ballcourt with great ceremony, having defeated the lords of death. The images of the underworld lords were then taken away or destroyed,

while the victorious kings were confirmed in their reign. They then gave "a sign" to the people to assure them that the "great god was in his proper place" (Ximénez 1929–1931 [1722], I:85).

Similar festivals continued to be practiced in the Maya area after the Spanish Conquest. Father Pío Pérez wrote that the Maya of Yucatán celebrated a period of five days at the end of the calendar year as the feast of the god Mam, the same name used at Santiago Atitlán. The days of the Mam's reign carried danger of sudden deaths, plagues, and other misfortunes:

> On the first day they carried him about, and feasted him with great magnificence; on the second they diminished the solemnity; on the third they brought him down from the altar and placed him in the middle of the temple; on the fourth they put him at the threshold or door; and on the fifth, or last day, the ceremony of taking leave (or dismissal) took place, that the new year might commence on the following day. (Stephens 1963 [1843],I:281)

López de Cogolludo, who lived in Yucatán during the seventeenth century, also described the Mam as a deity who presided over the Uayeb, or New Year's rites. The five days of the Uayeb were called Vlobol Kin, which means "time of lies, a bad time" (1957 [1688] IV.5.185). "They had a wooden idol which they placed on a bench over a mat, and offered him things to eat and other gifts in a festival called Uayeyab. And at the end of the festival, they undressed him and threw the pieces of wood to the ground without giving him any more reverence. And this idol they called *Mam*" (IV.8.197). Thompson equated the Mam of the Uayeb rites with Santiago Atitlán's Mam image: "Clearly the Yucatec and Atitlán Mams are the same personage" (1970, 298–299).

Much of the ceremonialism characteristic of the ancient Maya New Year's festival was incorporated into Holy Week celebrations, a syncretism documented by a number of scholars (Bunzel 1952, 412; Mendelson 1957, 472–480; Thompson 1960, 133; 1970, 298–299; Cook 1986, 151; Fox 1996, 18; Carlsen 1997, 152). Like Martín, Jesus Christ as the supreme God of the conquering Spaniards was soon equated with the ancient gods. The early K'iche's identified Christ with both Tohil and the maize god Hun Hunahpu (Ximénez 1929–1931 [1722], I:108). This process of religious syncretism almost triggered a religious upheaval in Guatemala:

It happened in this kingdom shortly after being conquered that, upon hearing the [life] of Christ which the friars taught them, there arose a Mexican Indian, a pseudo-prophet. He taught them that Huhapu [Hunahpu, the elder of the Hero Twins] was God and that Hununapu [Hun Hunahpu, father of the Hero Twins] was the son of God; . . . For this cause, there was such a commotion among the Indians that the work was nearly lost, for they came to imagine that our Holy Gospel, told them nothing new (Ximénez 1929–1931 [1722], I:57; translation by author).

The Maya undoubtedly equated Jesus Christ with Hun Hunahpu because both were sacrificed by their enemies and hung in a cruciform "tree" before rising from death. This association did not end with the defeat of the Mexican pseudo-prophet. Because of its ancient connection with rain and the resurrection of their god, the cross was adopted as the symbol of the pre-Columbian world tree (Redfield and Villa Rojas 1934, 110). Early Spanish conquerors and missionaries habitually set up crosses in places of indigenous worship to symbolize the victory of Christianity over heathenism. The Maya apparently attributed the virtues of the defeated gods to the cross itself and gave offerings to it as the world tree/maize plant. This may explain why modern Maya, including the Tz'utujils, often paint major crosses green or decorate them with foliage (Fig. 6.25).

Fig. 6.25. The church plaza cross adorned with palm fronds and flowers for Holy Week. Such foliated crosses are common in the Maya world, where they represent world trees.

PANEL 3: THE LAST SUPPER
AND DIVINE COMMUNION

The third basal panel on the Santiago Atitlán altarpiece depicts the Last Supper as celebrated by Atitecos on Holy Thursday during Easter Week (Figs. 1.4, 1.5 *X*, and 6.26a and b). In Roman Catholic tradition, the Last Supper represents the institution of the Eucharist symbolizing the sacrifice of God: "And as they were eating, Jesus took bread, and blessed it, and brake it, and gave it to the disciples, and said, Take eat; this is my body. And he took the cup, and gave thanks, and gave it to them, saying, Drink ye all of it; For this is my blood of the new testament, which is shed for many for the remission of sins" (Matthew 26:26–28). Tz'utujils also recognize the Last Supper as the sacrificial offering of divine flesh and blood, the pivotal act which brings life into the world. The panel therefore occupies the central position in the narrative sequence. The sacrifice symbolically bridges the left panels, which deal with birth and the struggle for life, and the

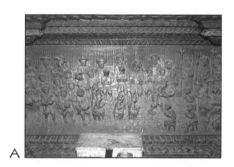

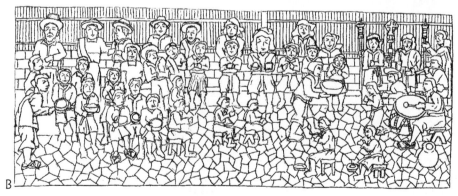

Fig. 6.26. Basal panel 3 from the central altarpiece, representing the "Last Supper," commemorated on the afternoon of Holy Thursday: (a) photograph, (b) author's drawing.

panels that follow, which stress the death and rebirth of the world. The prominence of the central panel is also emphasized by its greater width (140.75 cm. as opposed to 105.75 cm. in the other panels of the series), and the artists' choice of presenting it as a single unified event rather than three.

In this Atiteco version of the Eucharist, the offering is not bread and wine but a round tortilla and a gourd cup containing *maatz'*, the toasted maize beverage served on ceremonial occasions. These represent a sacrament in remembrance of the sacrifice of the maize, which gives life to the Maya people. The shared meal of the Last Supper thus represents a communion in which maize imparts its divine substance to the Tz'utujil community. In the spatial arrangement of the altarpiece as the mountain of creation, the third panel occupies the center, or "heart" and is flanked by the two pairs of maize gods, representing the cardinal directions, that decorate the niches of the saints at either end of the tier just above the panel (Figs. 1.4 and 1.5 *X* and *P*). The panel is therefore analogous to the central hole dug in maize fields where sacrificial offerings are placed to make the sown maize seeds germinate and grow out of the underworld. At the peak of the altarpiece, the reborn maize plant emerges to bestow new life.

Seated at the center of the third panel (Fig. 6.26b) is the *cabecera* (Spanish "principal") of Santiago Atitlán, the highest position attainable within the Maya confraternity system. In addition to presiding over the ten confraternities in Santiago Atitlán, the *cabecera* acts as the liaison between traditionalist Atitecos and the various official committees of the Church. He also holds the keys to the church treasuries and has the final say over the public use of church property. In the

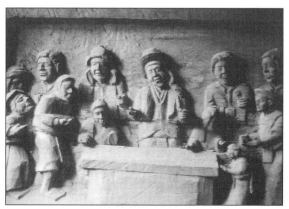

Fig. 6.27. "The Cabecera *Administering Justice," by Diego Chávez Petzey. The* cabecera *is the head of the confraternity system, once the most important position in the community prior to the secularization of civil government in Guatemala. The artist keeps it in his workshop as a reminder of the importance of spiritual guidance in all aspects of community life. (Courtesy of the artist.)*

recent past, the *cabecera* was the highest judicial authority in town and had a great deal of political power. With the secularization of Guatemala's indigenous communities after World War II, however, the *cabecera's* nonreligious role in Atiteco society has diminished dramatically. Diego Chávez carved a panel to decorate his workshop which depicts a *cabecera* in former times administering justice (Fig. 6.27). He is particularly proud of this piece and says that he would never sell it:

> *It reminds me of the old days when people respected the Maya confraternity officials and we had no need for jails. Now all people know is killing and thievery. In this panel I show a woman accused of not respecting her family. At that time if she were found guilty, the* cabecera *would send her to sweep all of the dust around the church. In this way she would remember to sweep the uncleanness from her own life even as she swept the church for the benefit of the town.*

On the altarpiece panel, the *cabecera* represents personified maize/ Jesus Christ holding a tortilla and cup of *maatz'*. He is seated next to seven of the ten heads of individual confraternities. In the upper right corner (Fig. 6.26b) stand the heads of the three most important confraternities—San Juan (which possesses the Martín bundle and the cult image of Yaxper), Santa Cruz (the home of the Mam), and Santiago (the patron saint of the city). Below them are two musicians playing the flute and drum, the standard accompaniment for traditional rituals.

The small figures seated on individual chairs on the floor as well as the low bench on the left-hand side represent the twelve "apostles." These are male children, from six to ten years of age, chosen by the *pixkal* who goes from house to house looking for boys with the best behavior and the most handsome appearance. They wear white tunics with purple sashes crisscrossed at the chest. Although not shown on the altarpiece panel, each also wears a tall crown decorated with multicolored paper flowers (Fig. 6.28).

The larger figures standing on the left with bowls and serving spoons are *alguaciles* (Spanish for "constable"), the same young men that functioned as the Mam's honor guard in the municipality building the day before. They are charged with bringing the food for the assembly. The parents of the twelve "apostles" are standing in the background on the left side. The fathers wear straw hats and collared shirts while the mothers wear the traditional wrap-around headbands and shawls draped over the right shoulder.

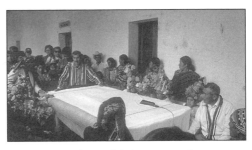

Fig. 6.29. "Apostles" and their parents at the Last Supper on Holy Thursday.

Fig. 6.28. One of the "twelve apostles," young children chosen for their appearance and good behavior to participate in the Last Supper.

The Last Supper is reenacted in the east corridor of the *convento* patio at approximately 2:00 in the afternoon on Holy Thursday (Fig. 6.29). I base the following description of the ceremony on my observations recorded in 1998. The twelve boys representing the apostles gathered in front of the church altar before marching in procession around the plaza to the north entrance of the *convento* complex. There they sat at a large table with the confraternity elders and musicians gathered at the southern end nearest the church. (Diego said that he didn't include a table in the third panel because in his youth they did not use one.) The children remained silent and rather solemn, holding their hands together as if in prayer. Although the *cabecera* was present at the head of the table he did not officiate, deferring instead to the current priest, Father Tomás, to act as the representative of Christ.

Prior to each of the twelve courses of food served, the priest intoned a brief prayer in Spanish designating it as a "remembrance" of the Last Supper of the Lord. The *pixkal* first brought a large vessel of *maatz'*. He was followed by twelve *alguacils* carrying the first course, consisting of tortillas and chicken, for each of the "apostles." Nicolás Chávez suggested that the *alguacils* represent the "warriors of the Mam" who symbolically sacrifice the maize and chickens as ritual offerings.

The Basal Narrative Panels of the Central Altarpiece 195

It is possible that the apostles are young boys because they represent the tender maize sprouts that replace the sacrificed maize, much as the Hero Twins replaced their dead father, Hun Hunahpu in ancient tradition. By eating the tortillas and drinking *maatz'* the apostles present themselves as of the same flesh, in "sacred communion" with father maize. This concept is related also to Catholic theology in which a person who partakes of the Eucharist adopts the name and character of the sacrificed Christ to become a "son or daughter" of God.

The boom of the drum and a brief song on the flute signaled to the children that they could eat. After taking a quick sip of the *maatz'* gruel and a bite of the tortillas and chicken, they refolded their hands while their mothers gathered the remains and placed them in baskets. These were later distributed around town as relics which are believed to have the power to cure illnesses. Eleven more courses followed, served in much the same way, each with more tortillas and *maatz'*. These featured the most commonly eaten Tz'utujil dishes—two kinds of fish, black beans, squash, garbanzos, beef, crab, *piloy* (a large type of bean), stew, white beans, and a watery soup with some type of leafy vegetable in it.

At the end of the last course, the children formed a procession in two lines led by the sacristans and *pixkal*. Behind them marched the principal female members of the confraternities in ceremonial dress. They were followed by the male heads of the confraternities wearing black ceremonial tunics and holding their staffs of office (Fig. 6.30). The Catholic priest brought up the rear shaded by a portable canopy. The procession passed through the north entryway of the *convento,* then turned left to follow a counterclockwise route around the complex to the great stairway leading up to the west entrance of the church. There the priest conducted Mass around 3:30 P.M.

Fig. 6.30. Principal women and confraternity heads in procession from the Last Supper ceremony. Although ostensibly a Roman Catholic celebration, traditionalists view this event as a rebirth of fertility and abundance in the community, centered on the renewal of maize.

Fig. 6.31. "Heart of the navel" pillow near the "navel of the world" hole in the church.

Nicolás suggested that the partaking of maize during the Last Supper was a Maya version of the Catholic Host distributed at Mass. This is consistent with the iconography of the sun vessels on either side of the third tier of the altarpiece (Figs. 1.4, 1.5 *C,* and 5.3). These motifs represent a tortilla on the left, and the Host on the right emerging from the underworld like a radiant sun.

The ritual of the Last Supper represents the sacrifice of deity under the auspices of the Mam's legions, represented by the *alguacils.* In this light, it is significant that just prior to the reenactment of the Last Supper around noon, members of the Confraternity of Santa Cruz (where the Mam is housed) uncover the hole in the church's nave which serves as the principal portal to the underworld. From this hole the malignant spirits of the underworld, called *xorocotel,* are released to afflict and torment humanity. To mark the spot as the central access point to the realm of the Mam, a small pillow called the *ruk'u'x muxux* ("heart of the navel") is laid over the hole (Fig. 6.31). It is normally housed in the Confraternity of Santa Cruz, where it is used to cushion the Mam's head when he is resting. The pillow is purple in color, trimmed with gold, and marked with a large white cross which Nicolás says represents the four major realms of the world which meet at this point. The vertical arm represents the *ruk'u'x kaj* ("heart of the sky") and *ruk'u'x ruxie' mar* ("heart of beneath the sea"), which intersects with the horizontal arm representing the *ruk'u'x ya'* ("heart of the lake") and *ruk'u'x juyu'* ("heart of the mountain").

PANEL 4: DESCENT INTO THE UNDERWORLD

The fourth panel represents rituals conducted after the Last Supper on Holy Thursday to empower deity to rise again out of the underworld (Figs. 1.4, 1.5 *Y,* 6.32a and b). The artists again return to

the convention of dividing the scene into three distinct sections. On the right are Franciscan monks gathered to fast and pray, which Father Rother suggested is customary on the night before the crucifixion in honor of Christ's prayer in the Garden of Gethsemane.

In the center is a temporary altar, set up immediately after the celebration of the Last Supper over the "navel" hole in the church nave leading to the underworld (Fig. 6.32b). The small figures kneeling before it are two of the "apostle" children, who are charged with keeping a vigil over the spot until 10:00 A.M. the following day. Between them is a bowl containing copal incense. (The children once held incense braziers in their hands but these have broken off.) The sides of the altar are adorned with a stylized vine representing new life. Atop the table are two vases for flowers, two small candlestick holders, and between the candlesticks the pillowlike bundle adorned with an embroidered cross called the *ruk'u'x muxux* ("heart of the navel"), which marks the altar as the center of the world.

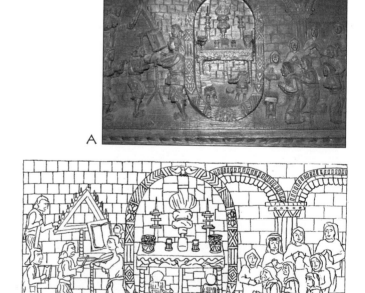

Fig. 6.32. Basal panel 4 of the central altarpiece, dedicated to rituals conducted on the evening of Holy Thursday: (a) photograph, (b) author's drawing.

Behind the altar are two large silver candle holders and a wrapped cross, items usually kept in the baptistry. The cross is the most sacred object of its kind in Santiago Atitlán, being very old and representing the "true sign" left by the ancient *nuwals* at the beginning of the world. Nicolás said that the cross of Jesus Christ, the first maize tree, and the cross on the *ruk'u'x muxux* pillow are all manifestations of this relic and derive their power from it. Except on the most sacred occasions, it is generally kept covered with a white cloth to prevent its power from devastating the world. When used in ceremonies in the church, it is placed on a rickety old sawhorse adorned with three cypress boughs that represent the volcanoes surrounding Santiago Atitlán (Fig. 6.33). The four legs of the sawhorse symbolize the cardinal directions. In the scene depicted on the altarpiece panel, the cross represents the world tree growing out of the underworld hole. The cross is still covered because it has not yet been reborn to new life.

The central section of the panel (Fig. 6.32b) is framed by a great oval band decorated with various designs and representing the long strip of cloth that Atiteco women wind about their heads, called a *xq'ab'* (Fig. 6.34). Diego Chávez said that the headdress was first worn by Yaxper, the goddess of childbirth and midwives, who participated in the creation of the world. It symbolizes a snake, as well as the rainbow which is produced by the breath of a great serpent and protects the world from harm. Diego included this reference to Yaxper on the

Fig. 6.33. The wrapped cross, associated with the souls of the dead.

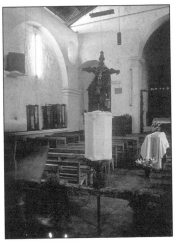

Fig. 6.34. Atiteco women coiling their headdresses in preparation for a ceremony. The headdress represents a rainbow serpent, as well as an umbilical cord tying them to the sky.

The Basal Narrative Panels of the Central Altarpiece 199

altarpiece panel because "only women have the power to create new life, and they must be present at the rebirth of the world." When Nicolás Chávez identified the framing device on the panel as a woman's headdress, he added that the rainbow serpent headband represents the umbilical cord which ties holy women to the sky. It is present here because the altar commemorates the birth of the world out of the "navel" hole in the floor beneath.

The designs on the headband are arranged to reflect the symbolic levels of the altar. At the base is the sun as a maize tortilla at the lowest level of the underworld. On either side are woven mat designs suggesting the mat used to cover the "navel" hole in the nave before the Easter cross is planted in it. The four chevron designs represent the four cardinal directions. Above these are concentric diamonds that symbolize the hole leading to the underworld beneath the altar. Next are three parallel vertical bands representing the serpent columns that support the world above and also the maize canes used in Atiteco house walls. The pair of crossed bands above the vertical bands mark the altar as the center point of creation and, according to Diego Chávez, recall the way that some Atiteco *ajkuns* divine the future, by crossing two bones and looking beyond the center point into the other world. The flower motifs next in the sequence represent rebirth and fertility, and the two patterns above them, the rainbow serpent that arches across the sky. The bird at the top, the "dove of the Holy Spirit," lives in heaven, while the sun/tortilla of the Maya, at the bottom, draws its power from inside the sacred mountain.

The left section of the panel is a ritual conducted inside the church in the hours before midnight on Holy Thursday (Fig. 6.32b). At about 8:00 P.M., the *cabecera* opened the baptistry and oversaw the removal of a triangular-shaped candelabrum, which he set up in the center of the nave toward the west end of the church. The elders of all of the confraternities and their wives sat in hierarchical positions along two long benches extending eastward from the candelabrum.

While a choir of four elderly sacristans sang in Latin from an old missal,[4] the head of the Confraternity of Santa Cruz placed thirteen

[4] The choir of sacristans performs on a number of important ceremonial occasions, particularly on the night of the Day of the Dead and at ritual transfers of power when the leadership of the confraternities changes on the day of their patron saints. The centuries-old violins shown on the altarpiece panel were stolen more than ten years ago when one of the sacristans charged with returning them to the church baptistry passed out in the streets from too much drink.

candles on the candelabrum, six on either side and one at the top (Fig. 6.35). The candles were of a special type called *esterinas*, made of white-colored wax with an expanded base that steps inward approximately a third the way up the taper. This type is more commonly used by *ajkuns* in shamanistic ceremonies rather than for rituals associated with orthodox Catholic worship. The confraternity elder lit the candles in pairs beginning at the bottom of the candelabrum and working his way up, periodically removing wax drippings as they accumulated along the sides of the candles. After allowing the candles to burn approximately a third of their length, other members of the Santa Cruz confraternity began removing them one by one and replacing them with fresh ones. Explanations for the candle ceremony vary widely. One participant told me that each burning candle represents the life of a human from birth to death; the candles are removed periodically because "they become old and weary." Another said that the twelve candles represent the apostles, while the candle at the top represents Jesus Christ and was allowed to burn without being replaced because he is eternal. One of the confraternity heads told me that the twelve candles represent the twelve days that Francisco Sojuel and his associates planned the creation of the Mam and that the candles are lit at night because it was in darkness that the Mam was carved out of a tree, before the sunrise.

The uncovered "navel" hole of the underworld lies a short distance away at the east end of the nave and there appears to be a connection between the malignant spirits that emerge from it and the snuffing out of the candles. Considering that the Mam acts as the transitional figure between life and death, it is perhaps significant that only members of the Confraternity of Santa Cruz, the home of the Mam, lit and extinguished the candles.

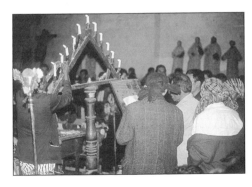

Fig. 6.35. Lighting of the candelabrum in the church on the evening of Holy Thursday. The sacristans may be seen in the foreground singing from an old missal.

The Basal Narrative Panels of the Central Altarpiece 201

Soon after midnight, the head of the Santa Cruz Confraternity began putting out all of the candles and removing them in pairs starting at the bottom. At the moment when he extinguished the final candle, the one at the top representing Christ, an elder blew a long wailing note on a shell trumpet. At this signal, everyone present filed out of the church in procession, carrying the images of María Andolor, San Juan Carajo, Cristo Nazareno, and San Nicolás, which were to participate in the "races" that I described above. The doors of the church were then closed and all lights extinguished. The darkness and descent of the images down the steps into the plaza represent the descent of the saints into the underworld, where life and fertility is eventually renewed by the miraculous impregnation of María as the moon goddess. Light is restored symbolically to the community on Saturday night, when the Catholic priest strikes new fire in the center of the church plaza near the town cross.

PANEL 5: DEATH AND REBIRTH

The fifth of the basal panels compares the death of deity with that of individual human beings as analogous events, both of which carry the hope of ultimate resurrection to new life (Figs. 1.4, 1.5 Z, and 6.36a and b). In European Catholic theology, Jesus Christ rose physically from death after three days in a sepulcher. The right-hand section of the panel alludes to this death in the form of a *pietà,* where the body of Christ is held in the arms of a grieving Virgin. Father Rother suggested the design and supplied a picture for the Chávez brothers to work from. For the Tz'utujils the death and rebirth of deity, whether it be Christ during Easter Week or Martín as the patron of maize during the harvest season in November, is not a unique historical event set in the distant past but an annually recurring phenomenon. The dances and passion plays performed at Santiago Atitlán are perceived by Atitecos not as commemorative displays to instruct the faithful, but as the recurrence of cosmic crises at appropriate seasons of the year, carrying real power to regenerate life on a universal scale.

The death of individual human beings is also a crisis, being the victory of unseen underworld deities and malignant spirits over the power of life. There appears to be a distinction, however, between the death and afterlife of ordinary persons, as exemplified by the infant burial in the left-hand section of the panel and that seen in

the central section (Fig. 6.36b) involving the death of a powerful *nab'eysil*, who in life acts as a vessel to receive the spirit of sacred beings during ritual dances and other ceremonies. Each time persons such as the *nab'eysil* successfully complete a ceremony, a portion of the divine presence of deity remains with them, just as ancient objects retain a bit of the soul of ancestors who once manipulated them. The death of a *nab'eysil* threatens to extinguish a measure of sacred power which is necessary to sustain the community and perpetuate life. Atitecos therefore undertake more elaborate ceremonies on behalf of *nab'eysils* to forestall this horror and ensure that the deceased individual ultimately triumphs over death to continue work on the town's behalf.

A

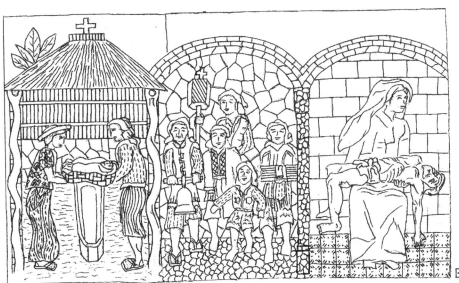

B

Fig. 6.36. Basal panel 5 from the central altarpiece, dedicated to ceremonies connected with the dead: (a) photograph, (b) author's drawing.

In the left section of the altarpiece panel the grandparents of an infant who died at birth are wrapping the body in a woven palm mat before placing it in a wooden coffin for burial. Grandparents carry out this task because in Tz'utujil society children represent the *k'exel* ("replacement," "substitute") for their ancestors. The death of a child represents a "spirit loss" which would otherwise ensure that the life force of the older generations continues. Robert Carlsen writes that much of Tz'utujil society is based on the principle of change as manifested in the transition from birth to death and back again (Carlsen and Prechtel 1991, 26; Carlsen 1997, 50–55). Generational changes represent the transferal of life from the grandparents to their grandchildren. Thus when a baby is born, Atitecos say the child "sprouted" or "returned," implying that the spirit of a dead ancestor, like a newly sprouted plant from the dead husk of a maize kernel, has returned to occupy a new body.

In the Tz'utujil language the word for grandfather, *mam,* is also the word for grandchild, suggesting an equivalent relationship, and parents commonly name their children after their grandparents to reinforce this idea of substitution. This is true in the Chávez family. The patriarch Diego Chávez Ajtujal has four sons, each of whom named their firstborn son Diego after their grandfather. Houston and Stuart also note that among the Classic Maya royal names tend to skip one or more generations, perhaps an allusion to this principle of generational substitution (1996, 295). On a panel from Palenque now housed in the Dumbarton Oaks collection in Washington, D.C., K'an Hok' Chitam dances out of the underworld in the guise of the god Chak Xib Chak. He is named in the accompanying text as the *k'exol* ("replacement") of an ancestor with the same name who died ninety-two years earlier (Schele and Miller 1986, 274).

The mat in which the infant's body is wrapped is characteristic of Atiteco burial practices (Mendelson 1957, 543). Diego Chávez said that it represents unity that continues beyond death. The interlaced reeds represent the way that each Tz'utujil individual is tied together with the other members of his family, both living and dead, as well as with the community as a whole. Confraternities also hang woven reed mats as backdrops for their principal altars bearing patron saints and other sacred objects. The head of the Confraternity of San Juan told me that the mat represents the way that the ancestors of the Tz'utujil people, the saints, and those who come to pray are all woven

together. In the sculpted panel of the Martín Dance that Nicolás Chávez carved, he included a mat design in the background, which he explained represents the bond between those present at the ritual and the ancestral spirits (Fig. 6.15b).

The Classic Maya also built special structures marked with mat designs, called *popol na* ("mat houses"), where sacred ancestors were revered and dance pageants were staged (Freidel et al. 1993, 152–153; Schele and Mathews 1998, 269–270). In the Motul Dictionary, *popol na* is glossed as a "community house," suggesting that the woven pattern of the mat also represented the unity of the polity's residents. William Fash identifies Structure 10L-22 at Copán as a *popol na* (Fash 1991, 130–131). It is decorated with sculpted mat designs alternating with eight human figures, likely representing the founders of important local lineages from the surrounding region.

As in many cultures whose livelihood is based on agriculture, the Maya believe that human birth, death, and rebirth are inextricably linked to the life cycle of sacred plants such as maize or the world tree. In the *Popol Vuh,* the great ancestor deity Hun Hunahpu descended into the underworld, where he was sacrificed and transformed into a fruitful tree that grew near the ballcourt. The skull of Hun Hunahpu in the guise of one of the fruits hanging in the tree miraculously impregnated Xkik' (Lady Blood) with a drop of spittle in order to provide a living replacement for his body on earth:

This head of mine no longer functions, for it is merely a skull that cannot work. The head of the great lord has good flesh upon his face. But when he dies, the people become frightened because of his bones. In like manner, his son is like his saliva, his spittle. He is his essence. If his son becomes a lord or a sage or a master of speech, then nothing will be lost. He will go on and once more become complete. The face of the lord will not be extinguished nor will it be ruined. The man, the sage, the master of speech will remain in the form of his daughters and his sons. (Christenson 2000, 84)

The leaves that appear above and to the left of the thatch-roof house in the left section of the panel represent a living tree that offers hope of rebirth from death. This is likely related conceptually to the tree of Hun Hunahpu. The highland Maya term for cemetery is *jom,* the same word used in ancient texts to refer to the underworld ballcourt

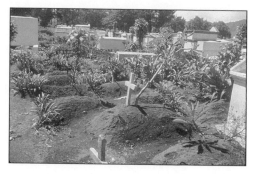

Fig. 6.37. The cemetery of Santiago Atitlán. Each grave is planted with a tree, representing the rebirth of that individual to new life. In the mythic history of Francisco Sojuel, his enemies tried to kill him by cutting him into pieces and burying them, only to find that a tree had grown up in the place of his body.

where Hun Hunahpu's tree stands. In the *Popol Vuh*, the Hero Twins assure their father that he will be remembered and that people will come to honor him:

> *"They who are born in the light, they who are begotten in the light, shall go out to you first. They shall surely worship you first. Your name shall not be forgotten. Thus be it so," they said to their father when they comforted his heart. (Christenson 2000, 126)*

Hunahpu is the last of the named days in the highland Maya sacred calendar and is still set aside for ceremonies in honor of deceased ancestors and remembering the dead in the cemetery (Schultze Jena 1954, 71; B. Tedlock 1982, 124; D. Tedlock 1996, 286).

Once placed in the grave, Atitecos raise a small mound of earth over the body and plant a tree on top which represents the soul of the dead reborn to new life. In the Santiago Atitlán cemetery, located southeast of town on a hill overlooking the bay, there are long rows of graves bearing trees, giving the place the appearance of a great orchard or grove (Fig. 6.37). Ximénez described a similar practice in highland Guatemala at the beginning of the eighteenth century and noted that persons were frequently buried in the maize fields, an indication that the dead were reborn as maize (1929–1931 [1722], I:100).

Nicolás Chávez noted that most people plant either palm or zapote trees over the graves of their loved ones. Palm trees are important because, in Tz'utujil myth, on one occasion when Christ was pursued by the Jews he turned himself into a palm tree and therefore escaped death. The zapote tree (*Manilkara zapota*) bears a sweet, light brown fruit with chocolate-colored flesh. While explaining the symbolism of the leaves on the fifth panel, Nicolás related the following story about Francisco Sojuel:

When Francisco Sojuel was being persecuted by his enemies they tried to kill him by cutting him into little pieces and sprinkling them with lemon juice and salt. But when they came back the next day they found that his coffin was empty and from it grew a giant zapote tree filled with fruit. People plant zapote trees over the graves of their family in memory of Francisco Sojuel because he did not die.

Fig. 6.38. Depiction of a deceased ancestor as a fruit-bearing tree, from the side of Hanab Pakal's sarcophagus, Temple of Inscriptions, Palenque, ca. AD 683. (Redrawn after Merle Greene Robertson 1976.)

The Basal Narrative Panels of the Central Altarpiece 207

The association between ancestors and fruit trees is also characteristic of ancient Maya thought. The sides of the sarcophagus of Hanab Pakal at Palenque depict ten of the king's ancestors emerging out of a cleft in the groundline marked with *kaban* ("earth") signs (Fig. 6.38). Behind each ancestor is a fruit-bearing tree, indicating that they are rising from their graves in a fashion parallel to the sprouting of world trees (Schele and Freidel 1990, 221; McAnany 1995, 43) (Fig. 6.38).

The center section of the fifth altarpiece panel depicts a group of confraternity elders (Fig. 6.36b). Although the scene ostensibly represents part of a formal procession on the Day of the Dead (November 1), the same individuals and sacred objects play an essential role in funerary rites conducted on behalf of important religious leaders. Atitecos distinguish between the death of ordinary members of the community, whose afterlife is a rather vague existence in the underworld beneath the cemetery, and that of powerful individuals like the *nab'eysils* who reside in Paq'alib'al with Francisco Sojuel and the other sacred ancestors.

The tall figure in the background holding the cross is the head of the Confraternity of San Gregorio, which houses a small image of the death god San Pascual, who guards the souls of malevolent persons in a jail beneath the surface of the lake and prevents them from tormenting the living (Fig. 6.39). The cross in the central section of the panel 5 is the same one that is wrapped in a cloth on panel 4

Fig. 6.39. San Pascual, a patron of the dead in the Confraternity of San Gregorio/Concepción. In Atiteco myth, San Pascual lives at the bottom of Lake Atitlán, where he watches over the souls of malevolent dead persons, preventing them from harming the living.

(Fig. 6.32b). It is one of the preeminent crosses in the community, as noted above, and is closely associated with the ancestral spirits of Santiago Atitlán. Nicolás says that whenever it is uncovered, the souls of the great *nab'eysils* and confraternity members who lived in the past gather around it.

The figure holding the bell in Fig. 6.36b is the *rukab'* ("second"— the second-highest position in each confraternity) of the Confraternity of San Francisco. In Atiteco theology, San Francisco is the patron of the souls of all the righteous dead, and rituals conducted in this confraternity stress the veneration of sacred ancestors. Bells are closely tied with the dead as well. A bell is rung as accompaniment for death dances, just as the split-log drum sounds the cadence for the Martín Dance; on the Day of the Dead, people say that bells can be heard ringing below the ground in the cemetery, in the ancient ruins at Chiya', and at Paq'alib'al. The space beneath the church's campanile is the congregation point for the souls of the dead who gather whenever the bell is rung for Mass or other special occasions. On November 1 the church bell is rung continuously by rotating teams of young men and children from noon until the following afternoon to call on the dead to participate in the Day of the Dead festival.

The tall man at the back of the panel's procession is the head of the Confraternity of San Juan. He ensures that Martín is invoked to bless the souls of the dead in the underworld and protect the living from harm. The figure on the right is his *rukab'*, carrying a bundle of twelve candles to be lit in honor of the dead.

The smaller figure in the foreground is also the only Tz'utujil figure on the altarpiece that represents a specific individual. He is Diego Kihu, the *nab'eysil* who died shortly before the restoration of the altarpiece. Because of his reputation as a powerful *nab'eysil*, the Chávez brothers wished to honor him by carving his portrait. At the time of his death he was a very old man. His peculiar manner of walking hunched over with arms outstretched is easily recognized on the panel by most Atitecos, who are fond of telling stories about him. Many say that he was the last *nab'eysil* who could call down rain by flying into the clouds, and that deer and jaguars obeyed his instructions and followed him whenever he went into the mountains.

The annual procession depicted in the central section of the fifth panel takes place in mid-afternoon on November 1 (Fig. 6.40). After the church bells have been rung for several hours and the sacristans have sung the responses for the dead, these five individuals process

from the church to the Confraternity of San Juan to offer the candles in front of the Martín chest on behalf of the dead. From there the group moves on to the Confraternity of San Francisco, where further prayers and offerings are conducted in the presence of the cult image of San Francisco. The procession concludes at the entrance to the cemetery, where the elders perform ritual prayers at the tomb of Marco Rohuch, the *nab'eysil* who succeeded Francisco Sojuel, in honor of the souls of the dead who gather there from their graves nearby.

Both Diego and Nicolás suggested that, although the center of the panel commemorates the Day of the Dead ritual, it also represents the funeral procession of Diego Kihu. When I expressed curiosity about how Kihu could walk in his own funerary cortege, each gave a similar response, saying that powerful *nab'eysils* like Francisco Sojuel and Diego Kihu never really die. Myths surrounding the figure of the *nab'eysil* Francisco Sojuel are replete with references to the ways that his enemies tried to kill him. But all insist that they could never succeed in finishing him off. Sojuel simply went away to Paq'alib'al, where he continues to hear prayers and periodically returns to Santiago Atitlán to help in times of crisis. The following is a description of the "death" of Diego Kihu as related by Nicolás Chávez:

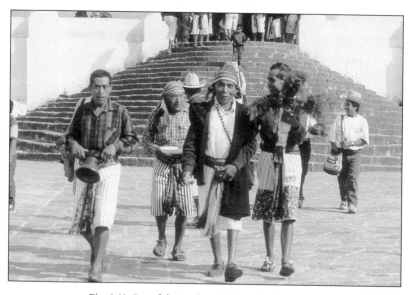

Fig. 6.40. Day of the Dead procession. This is the same procession depicted on the center section of the fifth panel. The bell carried by the elder on the left is used to call the souls of the dead to participate in the rituals of the day.

Art and Society in a Highland Maya Community

Diego Kihu was filled with the spirit of Martín and could work many miracles. He had the face of a saint's image. He had power over water and rain. He could make it rain whenever he wished, and yet when he walked in the rain he never got wet. When I was young he cured me of an injury when the Mam kicked me in the back after I said something disrespectful to him at the Santa Cruz confraternity. He [Diego Kihu] was very old when he died, about 128. But he didn't die of illness, he just decided to leave because he wanted to be with the other nab'eysils in Paq'alib'al. He told people that he would go at 6:00 PM on a Wednesday and said goodbye to everyone and gave them his blessing. Everyone placed candles around his bed and he left right at 6, as he had said. That evening he visited many people in dreams and told them not to worry about him because he was in Paq'alib'al. When he was buried a great wind and earthquake passed through the cemetery to prove that he was not dead.

When a *nab'eysil* dies, the head of the Confraternity of San Juan places the sacred deerskin worn in the Dance of the Deer in honor of Martín on the altar, covered with a black-colored tunic. This practice appears to indicate that the death of the *nab'eysil* represents in some way the death of Martín as well. Confraternity members also placed the divining stones of the *nab'eysil* and other ritual implements in the coffin so that he could use them on behalf of the community after death.

Tz'utujil prayers invoke deceased *nab'eysils* in the same breath with deities, their names frequently followed by the title Martín. It is not altogether clear what the precise relationship between deity and the *nab'eysil* is, although the latter appears to be a corporeal manifestation of Martín's power (Mendelson 1957, 475; 1958a, 124; 1967, 409). Once touched by this divinity through ritual, the *nab'eysil* never loses its presence even in death. He thus acts as a liminal figure in Tz'utujil society, bridging the material and spiritual worlds to ensure the continuation of life. The burial of a *nab'eysil* is exceptional to ordinary custom because he was never fully tied to the mortal world to begin with and can therefore never die. The funerary procession of Diego Kihu on the fifth altarpiece panel is situated between the burial rites of mortal humanity and God because *nab'eysils* act as transitional figures, not wholly a part of either plane of existence.

CHAPTER SEVEN
Conclusion

As reconstructed by the Chávez brothers, the central altarpiece in the church of Santiago Atitlán represents a translation of contemporary Tz'utujil theology into material form. This theology is based on a worldview in which all things, both animate and inanimate, require periodic renewal through ritual performance to reenact the origin of the cosmos. Atiteco rituals are eminently social events which reflect collective realities. Therefore the artists chose to carve the altarpiece with references to motifs and ceremonial performances which are familiar to the religious experience of their community. Although set in the context of a Roman Catholic church, the altarpiece conveys a theology that is consistent with uniquely Maya concepts, some of which predate the Spanish Conquest.

The altarpiece does not ignore any aspect of its community's remembered history. From my discussions with the Chávez brothers, it is apparent that the Roman Catholic elements in its iconographic program are not a mask to hide a separable ancient and pristine Maya worldview. Although the message it visually expresses is predominantly Maya, it is not a fossil of the pre-Columbian past with a superficial gilding of Catholicism to hide its "true" nature. The artists included European Christian elements in the narrative panels at the suggestion of Father Rother and used them as the starting point to expound visually analogous Tz'utujil concepts. The Catholic components are therefore integral to the overall message of the monument.

Mendelson noted that the Tz'utujils celebrate the death and rebirth of their old gods in the history of the Christian God (1965, 138). This is

not because the Maya perceive indigenous gods as equivalent in all respects with Christ and the saints, but because each set of deities carries out similar roles in society. It is these similarities which Tz'utujils emphasize, rather than the differences. Atitecos seldom consider whether the components of a myth or ritual are Christian or Maya. It is simply the religion which has existed since the beginning of time as ordained by all the gods and saints, including Martín, Christ, and the Mam, and it must be continued according to the patterns set by the Tz'utujil ancestors. Atitecos label orthodox Catholics and priests who seek to weed out "pagan" elements as "Protestants" (in no way a compliment) who have no authority to interfere with the practice of their faith. The two religious systems are not separable, and any attempts to distinguish between the two would ultimately lead to an artificial construct that is foreign to Atiteco experience and understanding.

The Chávez brothers did not abandon their identity as Maya, however, in order to carry out artistic projects for the Catholic Church. It is the capacity of the Maya to change while maintaining their identity which characterizes much of the history of Santiago Atitlán. The artists developed the visual expression for their worldview as the Tz'utujils always have in the development of their myths and ritual performances, by adapting to a changing world and interpreting those changes in Maya terms.

The Tz'utujils are a modern people. They are not a lost civilization somehow rediscovered from the ancient past. Like any living society, they are well aware of the world beyond the borders of their community and readily adopt aspects of Western culture, art, and language which fit the needs of their people. The colonial Spanish past as well as the political turbulence of the present are integral to the structure and meaning of the Santiago Atitlán altarpiece because they are at least as much a part of the Tz'utujil world as their preconquest heritage. Too often scholars have divided themselves into two opposing camps—those who see Maya society as an artifact of either the pre-Columbian or of the colonial Christian eras (Farriss 1984, 7). Both of these positions assume that the Maya are incapable of assimilating new ideas without abandoning their own identity. Guatemalan historian Severo Martínez Peláez suggests that any significant acculturation among the highland Maya implies a rejection of their cultural integrity:

It is well understood that an Indian dressed in jeans and wearing boots is no longer Indian. And even less so if he speaks other modern languages besides Spanish. And less still if the cofradía *[confraternity] has been changed for the labor union, and the sweat bath for antibiotics (1970, 611).*

The recent work of John Watanabe challenges this assertion and suggests instead that even radical shifts in religion and society do not necessarily jeopardize highland Maya identity. This is because the Maya tend to alter external influences to fit already established indigenous cultural patterns, modifying rather than transforming them (1992, 1520). The Maya do not passively adopt foreign intrusions imposed on them but select those aspects of Western culture that complement their own unique worldview. Thus Carlsen notes that "despite Spanish efforts, Mayan culture has been far more resilient and self-directed than many scholars have believed," and while conceding certain transformations due to European influence it has remained "distinctively and identifiably Mayan" (1997, 48–49).

Raxche', a Kaqchikel-Maya writer and linguist, asserts that despite the adoption of select Western customs and ideas highland Maya culture remains fundamentally indigenous:

Maya culture has been shaped by the favorable and unfavorable circumstances under which we Maya have lived throughout our history, yet it remains the same culture developed over thousands of years by our ancestors in the territory that is today Guatemala. The form of our culture has changed, but not its essence (Raxche' 1996, 76).

Diego Chávez insists that although he accepts the power of the local community saints, including the various manifestations of Christ and the Virgin Mary, his conception of them as divine beings is more influenced by traditional Atiteco worship than by what the foreign Catholic priests say about them. It is this appeal to the cultural heritage of the Chávez brothers' own community that enlivens their work and asserts its relevance as a reflection of a uniquely Maya view of the world.

Acuña, René
1975 "Problemas del *Popol Vuh.*" *Mester. Revista de Literatura: Creación-Teoría-Interpretación,* April 5, pp. 123–132.
1983 "El *Popol Vuh,* Vico y la *Theologia Indorum.*" In *Nuevas perspectivas sobre el Popol Vuh,* edited by Robert M. Carmack and Francisco Morales Santos, pp. 1–16. Guatemala City: Piedra Santa.

Alvarado, Pedro de
1946 [1524] *Relación hecha por Pedro de Alvarado a Hernando Cortés.* Biblioteca de Autores Españoles, vol. 22, pp. 457–459. Madrid: Atlas.

Avendaño y Loyola, Fray Andrés de
1987 [1688] *Relation of Two Trips to Petén.* Translated by Charles P. Bowditch and Guillermo Rivera, edited by Frank E. Comparto. Culver City, Calif.: Labyrinthos.

Bassie-Sweet, Karen
1991 *From the Mouth of the Dark Cave: Commemorative Sculpture of the Late Classic Maya.* Norman: University of Oklahoma Press.

Baudez, Claude-François
1994 *Maya Sculpture of Copán.* Norman: University of Oklahoma Press.

Betancor, Alonso Paez, and Fray Pedro de Arboleda
1964 [1585] "Relación de Santiago Atitlán, año de 1585." *Anales de la Sociedad de Geografía e Historia de Guatemala* 37:87–106.

Brady, James E.

1991 "Caves and Cosmovision at Utatlan." *California Anthropologist* 18:1–10.

Brady, James E., and George Veni

1992 "Man-Made and Pseudo-Karst Caves: The Implications of Subsurface Features Within Maya Centers." *Geoarchaeology* 7:149–162.

Bricker, Victoria Reifler

1981 *The Indian Christ, the Indian King: The Historical Substrate of Maya Myth and Ritual.* Austin: University of Texas Press.

Brown, Peter

1981 *The Cult of the Saints: Its Rise and Function in Latin Christianity.* Chicago: The University of Chicago Press.

Bunzel, Ruth Leah

1992 (1932) *Zuni Ceremonialism.* Albuquerque: University of New Mexico Press.

1952 *Chichicastenango, a Guatemalan Village.* Publications of the American Ethnological Society 22. Locust Valley, N.Y.: J. J. Augustin.

Calendario de los indios de Guatemala

1722 Manuscript copy in the William E. Gates Collection, University Museum Library, University of Pennsylvania.

Canby, Peter

1992 *The Heart of the Sky: Travels among the Maya.* New York: Harper Collins.

Carlsen, Robert S.

1996 "Social Organization and Disorganization in Santiago Atitlán, Guatemala." *Ethnology,* no. 2, pt. 1:141–160.

1997 *The War for the Heart and Soul of a Highland Maya Town.* Austin: University of Texas Press.

Carlsen, Robert S., and Martín Prechtel

1991 "The Flowering of the Dead: An Interpretation of Highland Maya Culture." *Man* 26:23–42.

1994 "Walking on Two Legs: Shamanism in Santiago Atitlán, Guatemala." In *Ancient Traditions: Culture and Shamanism in Central Asia and the Americas,* edited by Gary Seaman and Jane Day, pp. 77–111. Niwot: University Press of Colorado.

Carmack, Robert M.

1973 *Quichean Civilization.* Berkeley: University of California Press.

1981 *The Quiché Mayas of Utatlan: The Evolution of a Highland Guatemala Kingdom.* Norman: University of Oklahoma Press.

Carmack, Robert M., and James L. Mondloch

1983 *Título de Totonicapán.* Mexico City: Universidad Nacional Autónoma de México.

1989 *Título de Yax, y otros documentos quichés de Totonicapán, Guatemala.* Mexico City: Centro de Estudios Mayas, Universidad Nacional Autónoma de México.

Carrasco, Davíd

1993 *Religions of Mesoamerica.* New York: Harper and Row.

Carrasco, Pedro

1967 "Don Juan Cortés, Cacique de Santa Cruz Quiché." *Estudios de Cultura Maya* 6:251–266. Mexico City: Universidad Nacional Autónoma de México.

Cervantes, Fernando

1994 *The Devil in the New World: The Impact of Diabolism in New Spain.* New Haven, Conn.: Yale University Press.

Chance, John K., and William B. Taylor

1985 "Cofradías and Cargos: An Historical Perspective on the Mesoamerican Civil-Religious Hierarchy." *American Ethnologist* 12:1–26.

Chonay, Dionisio José, and Delia Goetz

1953 *Title of the Lords of Totonicapán.* Norman: University of Oklahoma Press.

Christenson, Allen J.

2000 *Popol Vuh: The Mythic Sections.* Provo, Utah: Brigham Young University Studies.

Coe, Michael D.

1973 *The Maya Scribe and His World.* New York: The Grolier Club.

1977 "Olmec and Maya: A Study in Relationships." In *The Origins of Maya Civilization,* edited by Richard E. W. Adams, pp. 183–196. Albuquerque: University of New Mexico Press.

1978 *Lords of the Underworld: Masterpieces of Classic Maya Ceramics.* Princeton, N.J.: Princeton University Press.

1989 "The Hero Twins: Myth and Image." In *The Maya Vase Book: A Corpus of Rollout Photographs of Maya Vases,* vol. 1, edited by Justin Kerr, pp. 161–182. New York: Kerr Associates.

Cook, Garrett

1986 "Quichean Folk Theology and Southern Maya Supernaturalism." In *Symbol and Meaning Beyond the Closed Community: Essays in Mesoamerican Ideas,* edited by Gary H. Gossen, pp. 139–153. Albany, N.Y.: Institute for Mesoamerican Studies, University at Albany, SUNY.

Cortés y Larraz, Pedro

1958 [1770] *Descripción Geográfico-Moral de la Diócesis de Goathemala.* 2 vols. Guatemala City: Biblioteca de la Sociedad de Geografía e Historia de Guatemala.

Coto, Fray Thomás de

1983 [ca. 1650] *Thesaurus Verborum: Vocabulario de la Lengua Cakchiquel u [El] Guatemalteca, Nuevamente hecho y Recopilado con Summo Estudio, Travajo y Erudición.* Mexico City: Universidad Autónoma de México.

Covarrubias, Miguel

1957 *Indian Art of Mexico and Central America.* New York: Alfred A. Knopf.

Davies, Nigel

1977 *The Toltecs.* Norman: University of Oklahoma Press.

Deal, Michael

1987 "Ritual Space and Architecture in the Highland Maya Household." In *Mirror and Metaphor,* edited by Daniel W. Ingersoll Jr. and Gordon Bronitsky. Lanham, Md.: University Press of America.

Douglas, Bill

1969 "Illness and Curing in Santiago Atitlán." Ph.D. diss., Stanford University.

Dunkerton, Jill, Susan Foister, Dillian Gordon, and Nicholas Penny

1991 *Giotto to Dürer: Early Renaissance Painting in the National Gallery.* New Haven, Conn.: Yale University Press.

Durán, Diego [d.1588]

1951 *Historia de las Indias de Nueva-España y islas de Tierra Firme.* Edited by José Fernando Ramírez. 2 vols. in 1. Mexico City: Editora Nacional.

Durkheim, Emile

1995 (ca. 1912) *The Elementary Forms of Religious Life.* Translated by Karen E. Fields. New York: The Free Press.

Edmonson, Munro S.

1965 *Quiché-English Dictionary.* Middle American Research Institute Publication 30. New Orleans: Tulane University.

1982 *The Ancient Future of the Itza: The Book of Chilam Balam of Tizimin.* Austin: University of Texas Press.

Eliade, Mircea

1959 *The Sacred and the Profane: The Nature of Religion.* Translated by Willard R. Trask. New York: Harcourt, Brace & World.

Estrada Monroy, Agustín

1979 *El Mundo K'ekchi' de la Vera Paz.* Guatemala City: Editorial del Ejército.

1993 *Vida esotérica Maya-K'ekchi'.* Guatemala City: Agustín Estrada Monroy.

Farmer, David Hugh

1987 *The Oxford Dictionary of Saints.* 2d ed. Oxford: Oxford University Press.

Farriss, Nancy M.

1984 *Maya Society under Colonial Rule: The Collective Enterprise of Survival.* Princeton, N.J.: Princeton University Press.

Fash, William

1991 *Scribes, Warriors and Kings.* London: Thames and Hudson.

Ferguson, George

1954 *Signs and Symbols in Christian Art.* London: Oxford University Press.

Fergusson, Erna

1936 *Guatemala.* New York: Alfred A. Knopf.

Fernández Valbuena, José A.

1996 *Mirroring the Sky: A Postclassic K'iche-Maya Cosmology.* Lancaster, Calif.: Labyrinthos.

Fischer, Edward F., and R. McKenna Brown

1996 *Maya Cultural Activism in Guatemala.* Austin: University of Texas Press.

Fischer, Edward F.

1999 "Cultural Logic and Maya Identity." *Current Anthropology* 40:473–499.

Flynn, Maureen

1989 *Sacred Charity: Confraternities and Social Welfare in Spain, 1400–1700.* Ithaca, N.Y.: Cornell University Press.

Foster, George M.

1953 "Cofradía and Compadrazgo in Spain and Spanish America." *Southwestern Journal of Anthropology* 9:1–28.

Fox, John G.

1978 *Quiché Conquest: Centralism and Regionalism in Highland Guatemalan State Development.* Albuquerque: University of New Mexico Press.

1996 "Playing with Power." *Current Anthropology* 37:483–509.

Fox, Richard G.

1985 *Lions of the Punjab: Culture in the Making.* Berkeley: University of California Press.

Freidel, David A.

1992 "Children of the First Father's Skull: Terminal Classic Warfare in the Northern Maya Lowlands and the Transformation of Kingship and Elite Hierarchies." In *Mesoamerican Elites: An Archaeological Assessment,* edited by Diane Z. Chase and Arlen F. Chase, pp. 99–117. Norman: University of Oklahoma Press.

Freidel, David, Linda Schele, and Joy Parker

1993 *Maya Cosmos: Three Thousand Years of the Shaman's Path.* New York: Morrow.

Friedman, Jonathan

1994 *Cultural Identity and Global Process.* London: Sage.

Fuentes y Guzmán, Francisco de [d. 1699]

1932–1933 *Recordación Florida.* 3 vols. Biblioteca "Goathemala." Geografía de la Sociedad de Historia, vols. 7–8. Guatemala City: Tipografía Nacional.

1969–1972 *Obras Históricas de don Francisco Antonio de Fuentes y Guzmán.* Edited by Carmelo Sáenz de Santa María. 3 vols. Madrid: Ediciones Atlas.

Gage, Thomas

1958 [1648]. *Travels in the New World.* Edited by J. Eric S. Thompson. Norman: University of Oklahoma Press.

García Icazbalceta, Joaquín, ed.

1889–1892. *Nueva colección de documentos para la historia de México.* 5 vols. Mexico City: Andrade y Morales.

García Pelaez, Francisco de Paula
1943–1944 [1851] *Memorias para la historia del antiguo reino de Guatemala*. 2nd ed. 3 vols. Biblioteca "Payo de Rivera." Guatemala City: Tipografia Nacional.

Gossen, Gary H.
1999 *Telling Maya Tales*. New York and London: Routledge.

Harley, J. B.
1990 *Maps and the Columbian Encounter*. Milwaukee: The Golda Meir Library, University of Wisconsin.

Helms, Mary W.
1993 *Craft and the Kingly Ideal: Art, Trade, and Power*. Austin: University of Texas Press.

Hermitte, María Esther
1964 "Supernatural Power and Social Control in a Modern Mayan Village." Ph.D. diss., University of Chicago.

Heyden, Doris
1975 "An Interpretation of the Cave Underneath the Pyramid of the Sun in Teotihuacan, Mexico." *American Antiquity* 40:131–147.

1981 "Caves, Gods, and Myths: World-View and Planning in Teotihuacan." In *Mesoamerican Sites and World Views*, edited by Elizabeth Benson, pp. 1–35. Washington: Dumbarton Oaks Research Library and Collections.

Hill, Robert M.
1992 *Colonial Cakchiquels: Highland Maya Adaptation to Spanish Rule, 1600–1700*. Fort Worth: Harcourt Brace Jovanovich.

Himelblau, Jack J.
1989 *Quiché Worlds in Creation: The Popol Vuh as a Narrative Work of Art*. Culver City, Calif.: Labyrinthos.

Houston, Stephen, and David Stuart
1996 "Of Gods, Glyphs and Kings: Divinity and Rulership among the Classic Maya." *Antiquity* 70:289–312.

Isagoge Histórica Apologética de las Indias Occidentales
1935 [ca. 1700] Biblioteca "Goathemala," vol. 8. Guatemala City: Tipografía Nacional.

Jones, Oakah L.
1994 *Guatemala in the Spanish Colonial Period*. Norman: University of Oklahoma Press.

Kerr, Justin

1989–1997 *The Maya Vase Book: A Corpus of Rollout Photographs of Maya Vases.* 5 vols. New York: Kerr Associates.

Kirchoff, Paul, Lina Odena Güemes, and Luís Reyes García, eds.

1976　*Historia Tolteca-Chichimeca.* Mexico City: Instituto Nacional de Antropología e Historia.

Klein, Cecelia F.

1990　"Editor's Statement: Depictions of the Dispossessed." *Art Journal* 49:106–109.

Kubler, George

1948　*Mexican Architecture of the Sixteenth Century.* 2 vols. New Haven: Yale University Press.

1961　"On the Colonial Extinction of the Motifs of Precolumbian Art." In *Essays in Pre-Columbian Art and Archaeology,* edited by Samuel K. Lothrop, pp. 14–34. Cambridge, Mass.: Harvard University Press.

La Farge, Oliver

1947　*Santa Eulalia: The Religion of a Cuchumatan Indian Town.* Chicago: University of Chicago Press.

La Farge, Oliver, and D. Byers

1931　*The Year Bearer's People.* Middle American Research Institute Publication 3. New Orleans: Tulane University.

Landa, Fray Diego de

1941 [1566] *Landa's relación de las cosas de Yucatán.* Translated by Alfred M. Tozzer. Cambridge, Mass.: Peabody Museum of Archaeology and Ethnology, Harvard University.

Las Casas, Fray Bartolomé de

1958 [ca. 1550] 3d ed. *Apologética historia de las Indias.* 2 vols. Biblioteca de Autores Españoles, nos. 105–106. Madrid: Atlas.

1967 [ca. 1550] *Apologética historia sumaria de las Indias,* 2 vols. Mexico City: Universidad Nacional Autónoma de México.

1971　*Bartolomé de Las Casas: A Selection of His Writings.* Edited by George Sanderlin. New York: Alfred A. Knopf.

Lee, Thomas A., Jr.

1985　*Los Códices Mayas.* Tuxtla Gutierrez: Universidad Autónoma de Chiapas.

Levenson, Jay A.

1991　*Circa 1492: Art in the Age of Exploration.* New Haven: Yale University Press.

López de Cogolludo, Fray Diego
1957 [1688] *Historia de Yucatán*. Mexico: Editorial Academia Literaria.

Lothrop, Samuel K.
1928 "Santiago Atitlán, Guatemala." *Indian Notes*, 5:370–395.
1929 "Further Notes on Indian Ceremonies in Guatemala." *Indian Notes* 6:1–25.
1933 *Atitlán: An Archaeological Study of the Ancient Remains on the Borders of Lake Atitlán, Guatemala*. Publication no. 44. Washington, D.C.: Carnegie Institution of Washington.

Lutz, Christopher H.
1994 *Santiago de Guatemala, 1541–1773: City, Caste, and the Colonial Experience*. Norman: University of Oklahoma Press.

Lutz, Christopher H., and W. George Lovell
1990 "Core and Periphery in Colonial Guatemala." In *Guatemalan Indians and the State, 1540–1988*, edited by Carol A. Smith, pp. 35–51. Austin: University of Texas Press.

Mace, Carroll Edward
1970 *Two Spanish-Quiché Dance Dramas of Rabinal*. New Orleans: Tulane University.

MacNutt, Francis Augustus
1909 *Bartholomew de Las Casas: His Life, His Apostolate, and His Writings*. New York: G. P. Putnam.

Makemson, Maud W.
1951 *The Book of the Jaguar Priest: A Translation of the Book of Chilam Balam Tizimin with Commentary*. New York: Schuman.

Martínez Peláez, Severo
1970 *La patria del criollo: Ensayo de interpretación de la realidad colonial guatemalteca*. Guatemala City: Editorial Universitario.

McAnany, Patricia A.
1995 *Living with the Ancestors: Kinship and Kingship in Ancient Maya Society*. Austin: University of Texas Press.

McBryde, Felix W.
1947 *Cultural and Historical Geography of Southwest Guatemala*. Smithsonian Institution Institute of Social Anthropology Publication no. 4. Washington, D.C.: Smithsonian Institution.

McDougall, Elsie
1955 "Easter Ceremonies at Santiago Atitlán in 1930." In *Notes on Middle American Archaeology and Ethnology* no. 123, pp. 63–74. Washington, D.C.: Carnegie Institution of Washington.

Mendelson, E. Michael

1956 "Religion and World-View in Santiago Atitlán." Ph.D. diss., University of Chicago.

1957 *Religion and World-View in a Guatemalan Village*. Microfilm Collection of Manuscripts on Middle American Cultural Anthropology, no. 52. Chicago: University of Chicago Library.

1958a "A Guatemalan Sacred Bundle." *Man* 58:121–126.

1958b "The King, the Traitor, and the Cross: An Interpretation of a Highland Maya Religious Conflict." *Diogenes* 21: 1–10.

1959 "Maximon: An Iconographical Introduction." *Man* 59: 57–60.

1965 *Las escándolas de Maximon*. Seminario de Integración Social Guatemalteca Publication 19. Guatemala City: Tipografía Nacional.

1967 "Ritual and Mythology." In *Handbook of Middle American Indians*, edited by Richard Wauchope, vol. 7, *Linguistics*, edited by Norman A. McQuown, pp. 392–415. Austin: University of Texas Press.

Mendieta, Fray Gerónimo de [d. 1604]

1993 *Historia Eclesiástica Indiana*. Mexico City: Editorial Porrúa.

Miles, Susan W.

1965 "Summary of Preconquest Ethnology of the Guatemala-Chiapas Highlands and Pacific Slopes." In *Handbook of Middle American Indians*, edited by Richard Wauchope, vol. 2, part 1, *Archaeology of Southern Mesoamerica*, edited by Gordon R. Willey, pp. 276–287. Austin: University of Texas Press.

Miller, Arthur G.

1986 *Maya Rulers of Time*. Philadelphia: The University Museum.

Miller, Mary, and Karl Taube

1993 *The Gods and Symbols of Ancient Mexico and the Maya*. London: Thames and Hudson.

Monaghan, John

1995 *The Covenants with Earth and Rain*. Norman: University of Oklahoma Press.

Morales Santos, Francisco

1981 *El Baile de la Conquista*. Guatemala City: Piedra Santa.

Morris, Walter F., Jr.

1987 *Living Maya*. New York: Harry N. Abrams.

Murga Armas, Jorge
1997 *Santiago Atitlán: Organización comunitaria y seguridad de los habitantes*. Guatemala City: Instituto Latinoamericano de Naciones Unidas para la Prevención del Delito y Tratamiento del Delincuente; San Jose, Calif.: ILANUD/COM/SON EUROPEA.

Oakes, Maud
1951 *The Two Crosses of Todos Santos*. Princeton, N.J.: Princeton University Press.

O'Brien, Linda
1975 "Songs of the Face of the Earth: Ancestor Songs of the Tzutuhil Maya of Santiago Atitlán, Guatemala." Ph.D. diss., University of California at Los Angeles.

Ordoñez Chipín, Martín
1973 "La figura de Judás Iscariote en el Medio Guatemalteco." *Guatemala Indígena*, 3 (1):143–172.

Orellana, Sandra L.
1975a "La introducción del sistema de cofradía en la región del lago de Atitlán en los altos de Guatemala." *América Indígena*, 35:845–856.

1975b "Folk Literature of the Tzutujil Maya." *Anthropos* 70:839–876.

1984 *The Tzutujil Mayas: Continuity and Change, 1250–1630*. Norman: University of Oklahoma Press.

Otzoy, Irma
1996 "Maya Clothing and Identity." In *Maya Cultural Activism in Guatemala*, edited by Edward F. Fischer and R. McKenna Brown, pp. 141–155. Austin: University of Texas Press.

Peterson, Jeanette Favrot
1993 *The Paradise Garden Murals of Malinalco*. Austin: University of Texas Press.

Prechtel, Martín, and Robert S. Carlsen
1988 "Weaving and Cosmos amongst the Tzutujil Maya." *Res* 15:122–132.

Quenon, Michel, and Genevieve Le Fort
1997 "Rebirth and Resurrection in Maize God Iconography." In *The Maya Vase Book: A Corpus of Rollout Photographs of Maya Vases*, vol. 5, edited by Justin Kerr, pp. 884–899. New York: Kerr Associates.

Raxche' (Demetrio Rodríguez Guaján)

1996 "Maya Culture and the Politics of Development." In *Maya Cultural Activism in Guatemala,* edited by Edward F. Fischer and R. McKenna Brown, pp. 74–88. Austin: University of Texas Press.

Recinos, Adrián

1950 *Popol Vuh: The Sacred Book of the Ancient Quiché Maya.* Translated by Delia Goetz and Sylvanus G. Morley. Norman: University of Oklahoma Press.

1953 *The Annals of the Cakchiquels.* Norman: University of Oklahoma Press.

1957 *Crónicas indígenas de Guatemala.* Guatemala City: Editorial Universitaria.

Redfield, Robert, and Alfonso Villa Rojas

1934 *Chan Kom: A Maya Village.* Chicago: The University of Chicago Press.

Reese, Thomas F.

1985 *Studies in Ancient American and European Art: The Collected Essays of George Kubler.* New Haven: Yale University Press.

Reilly, F. Kent, III

1994 "Visions to Another World: Art, Shamanism, and Political Power in Middle Formative Mesoamerica." Ph.D. diss., The University of Texas at Austin.

Relación de los caciques y principales del Pueblo de Atitlán

1952 [1571] *Anales de la Sociedad de Geografía e Historia de Guatemala* 28:68–83.

Remesal, Fray Antonio de

1964 [1617] *Historia general de las Indias Occidentales y particular de la governación de Chiapa y Guatemala.* Madrid: Biblioteca de Autores Españoles.

Robertson, Merle Greene

1985 *The Sculpture of Palenque.* Vol. 2: *The Early Buildings and the Wall Paintings.* Princeton, N.J.: Princeton University Press.

1991 *The Sculpture of Palenque.* Vol. 4: *The Cross, the North Group, the Olvidado, and Other Pieces.* Princeton, N.J.: Princeton University Press.

Robicsek, Francis, and Donald M. Hales

1981 *The Maya Book of the Dead: The Ceramic Codex.* Norman: University of Oklahoma Press.

Roys, Ralph L.
1967 (1933) *The Book of Chilam Balam of Chumayel*. Norman: University of Oklahoma Press.

Sahagún, Fray Bernardino de [d. 1590]
1956 *Historia general de las cosas de Nueva España*. 4 vols. Mexico City: Editorial Porrúa.

Schele, Linda
1990 *Proceedings of the Workshop on Maya Hieroglyphic Writing, March 10–11, 1990*. Austin: The University of Texas at Austin.

Schele, Linda, and Mary Ellen Miller
1986 *The Blood of Kings: Dynasty and Ritual in Maya Art*. Fort Worth: Kimbell Art Museum.

Schele, Linda, and David Freidel
1990 *A Forest of Kings*. New York: William Morrow.

Schele, Linda, and Peter Mathews
1998 *The Code of Kings: The Language of Seven Sacred Maya Temples and Tombs*. New York: Scribner.

Schultze Jena, Leonhard
1954 *La vida y las creencias de los indígenas quiches de Guatemala*. Biblioteca de cultura popular, vol. 49. Translated by Antonio Goubaud Carrera and Herbert D. Sapper. Guatemala City: Ministerio de Educación Pública.

Smith, Carol A., ed.
1990 *Guatemalan Indians and the State: 1540 to 1988*. Austin: University of Texas Press.

Smith, Thomas Vernor
1956 *From Thales to Plato*. Chicago: University of Chicago Press.

Stephens, John Lloyd
1963 [1843] *Incidents of Travel in Yucatan*. 2 vols. New York: Dover Publications.
1969 [1841] *Incidents of Travel in Central America, Chiapas, and Yucatan*. 2 vols. New York: Dover Publications.

Stone, Andrea J.
1995 *Images from the Underworld: Naj Tunich and the Tradition of Maya Cave Painting*. Austin: University of Texas Press.

Stuart, David
1988. "Blood Symbolism in Maya Iconography." In *Maya Iconography*, edited by Elizabeth P. Benson and Gillett G. Griffin, pp. 175–221. Princeton, N.J.: Princeton University Press.

Tarn, Nathaniel, and Martín Prechtel

1986 "Constant Inconstancy: The Feminine Principle in Atiteco Mythology." In *Symbol and Meaning Beyond the Closed Community: Essays in Mesoamerican Ideas,* edited by Gary H. Gossen, pp. 173–184. Albany, N.Y.: Institute for Mesoamerican Studies, University at Albany, SUNY.

1990 "Comiéndose la fruta: Metáforos sexuales e iniciaciones en Santiago Atitlán. *Mesoamérica,* 19:73–82.

1997 *Scandals in the House of Birds: Shamans and Priests on Lake Atitlán.* New York: Marsilio Publishers.

Taube, Karl

1986 "The Teotihuacan Cave of Origin." *Res* 12:51–82.

1992 *The Major Gods of Ancient Yucatan.* Studies in Pre-Columbian Art and Archaeology, no. 32. Washington, D.C.: Dumbarton Oaks Research Library and Collection.

1993 *Aztec and Maya Myths.* Austin: University of Texas Press.

1994 "The Birth Vase: Natal Imagery in Ancient Maya Myth and Ritual." In Vol. 4 of *The Maya Vase Book: A Corpus of Rollout Photographs of Maya Vases,* edited by Justin Kerr, pp. 650–685. New York: Kerr Associates.

Tax, Sol

1941 "World-View and Social Relations in Guatemala." *American Anthropologist,* 43:27–42.

Tedlock, Barbara

1982 *Time and the Highland Maya.* Albuquerque: University of New Mexico Press.

1986 "On a Mountain Road in the Dark: Encounters with the Quiché Maya Culture Hero." In *Symbol and Meaning Beyond the Closed Community: Essays in Mesoamerican Ideas,* edited by Gary H. Gossen, pp. 125–138. Albany, N.Y.: Institute for Mesoamerican Studies, University at Albany, SUNY.

Tedlock, Dennis

1985 *Popol Vuh.* New York: Touchstone.

1986 "Creation in the Popol Vuh: A Hermeneutical Approach." In *Symbol and Meaning Beyond the Closed Community: Essays in Mesoamerican Ideas,* edited by Gary H. Gossen, pp. 77–82. Albany, N.Y.: Institute for Mesoamerican Studies, University at Albany, SUNY.

1993 *Breath on the Mirror: Mythic Voices and Visions of the Living Maya.* New York: Harper.

1996 *Popol Vuh*. Rev. ed. New York: Touchstone.

Termer, Franz
1957 *Etnología y Etnografía de Guatemala*. Publicación 5, Seminario de Integración Social Guatemalteca. Guatemala City: Ministerio de Educación Pública.

Tezozomoc, Fernando Alvarado
1975 [1609] *Crónica Mexicayotl*. Translated by Adrián León. Primera series prehispanica, 3. Mexico City: Universidad Nacional Autónoma de México, Instituto de Investigaciones.

Thompson, J. Eric S.
1960 *Maya Hieroglyphic Writing*. Norman: University of Oklahoma Press.
1970 *Maya History and Religion*. Norman: University of Oklahoma Press.

Torquemada, Fray Juan de
1969 [1615] *Monarquía indiana*. 3 vols. Biblioteca Porrúa, 41–43. Mexico City: Editorial Porrúa.

Vansina, Jan
1985 *Oral Tradition as History*. Madison: The University of Wisconsin Press.

Vásquez, Fray Francisco
1937 [1714] *Crónica de la Provincia del Santísimo Nombre de Jesús de Guatemala*, 4 vols. Guatemala City: La Sociedad de Geografía e Historia.

Villacorta, J. Antonio C., and Carlos A. Villacorta
1930 *Códices Mayas: Reproducidos y Desarrollados*. 3 vols. Sociedad de Geografía e Historia de Guatemala. Guatemala City: Tipografía Nacional.

Vogt, Evon Z.
1969 *Zinacantan: A Maya Community in the Highlands of Chiapas*. Cambridge, Mass.: Harvard University Press.
1970 *The Zinacantecos of Mexico: A Modern Maya Way of Life*. New York: Holt, Rinehart, and Winston.
1976 *Tortillas for the Gods: A Symbolic Analysis of Zinacanteco Rituals*. Norman: University of Oklahoma Press.
1981 "Some Aspects of the Sacred Geography of Highland Chiapas." In *Mesoamerican Sites and World-Views*, edited by Elizabeth P. Benson, pp. 119–138. Washington, D.C.: Dumbarton Oaks.

Wagner, Eugene Logan

1997 "Open Space as a Tool of Conversion: The Syncretism of Sacred Courts and Plazas in Post Conquest Mexico." Ph.D. diss., The University of Texas at Austin.

Warren, Kay B.

1989 *The Symbolism of Subordination: Indian Identity in a Guatemalan Town.* 2d ed. Austin: University of Texas Press.

Watanabe, John M.

1992 *Maya Saints and Souls in a Changing World.* Austin: University of Texas Press.

Webster, Susan V.

1992 "The Processional Sculpture of Penitential Confraternities in Early Modern Seville." Ph.D. diss., University of Texas at Austin.

Wilson, Richard

1993 "Anchored Communities: Identity and History of the Maya Q'eqchi'." *Man* 28:121–138.

Wolf, Eric R.

1959 *Sons of the Shaking Earth.* Chicago: The University of Chicago Press.

Ximénez, Fray Francisco

1701 *Arte de las tres lenguas kaqchiquel, quiche y tz'utuhil.* Manuscript in the Ayer Collection at the Newberry Library, Chicago, Illinois.

1857 [ca. 1722] *Las historias del origen de los Indios de esta provincia de Guatemala,* edited by Carl Scherzer. Vienna: Imperial Academia de las Ciencias.

1929–1931 [1722] *Historia de la provincia de San Vicente de Chiapa y Guatemala.* 3 vols. Biblioteca "Goathemala." Sociedad de Geografía e Historia de Guatemala. Guatemala City: Tipografía Nacional.

1967a [1722] *Historia Natural del Reino de Guatemala.* Guatemala City: Editorial "José de Piñeda Ibarra."

1967b [ca. 1722] *Escolios a las historias de origen de los indios.* Guatemala City: Sociedad de Geografía e Historia de Guatemala.

1985 [ca. 1701] *Primera parte del tesoro de las lenguas cakchiquel, quiche y zutuhil, en que las dichas lenguas se traducen a la nuestra española.* Special Publication no. 30. Guatemala City: Academia de Geografía e Historia.

128–133, 202; María Dragón (Mary of the Dragon), 7–9, 129; San Francisco (Saint Francis of Assisi), 7–9, 129; San Juan "Carajo" (Saint John "the Prick"), 7–9, 128–131, 133, 202; San Marcos (Saint Mark), 7–9, 129; San Pablo (Saint Paul), 7–9, 129; Santiago Mayor (Saint James the Great), 7–9, 83, 94, 100, 111, 128, 132–139; Santiago Menor (Saint James the Lesser), 7–9, 129, 134; Simón Mam (Simon the Ancient), 7–9, 129
 source of maize, 103–107
altarpiece, left, 54–56, 57, 73, 92, 183, 185
altarpiece, right, 56–58
Alvarado, Pedro de, 17, 35–44, 62, 137, 140n.5, 179
ancestors
 actions replicated through ritual, 23–24, 166, 176; ancient things contain their spirit, 3–4, 6, 126, 143, 203; bring fertility, 111, 163, 207; consulted at midnight, 162; creators of the Mam, 180, 182; creators of the world, 95, 97; divination of, 50, 147; dwell beneath floor of church, 76, 79, 82; dwell in sacred caves, 14, 80, 85, 88, 91, 93, 98, 100, 116, 154; founders of tradition, 11, 15–16, 22, 69, 78, 161; Martín their patron deity, 157; offerings given to, 148, 153, 206; punish descendents, 16, 60, 69; renewed through the birth of children, 204
angels, 85
Annals of the Kaqchikels, 31, 36, 38, 75
Antigua, 25, 98, 140, 180
apostles, twelve, 193–196, 198, 201
Aquarius, 142
Arboleda, Fray Pedro de, 19, 49
Atiteco, 12. See also Tz'utujil-Maya
atrio (Spanish, "church plaza"), 19, 46, 185
axis mundi, 105

ballcourt, 189, 205
bananas, 85–87, 98
baptism, 43–45, 136
Barahona el Viejo, Sancho de, 43, 49, 139

beans, black, 87, 116, 196
B'elejeb' Tz'i', 37
bells, 87, 139, 209–210
Bernabé, don, 41
Betancor, Alonzo Paez, 19; and Arboleda, 39
Betanzos, Fray Pedro de, 46
Bible, 63, 116, 145, 147
birds, 85–87, 95
blood, 64, 100, 104, 109–113, 137, 149–150, 152–153, 171, 192
bloodletting, 112–113
blue jay, 185
bokunab, 134
books, highland Maya, 1, 3–4, 6, 17–19, 147
breadnut tree, 180
Bricker, Victoria, 23, 36–37, 140n.5
bromeliad flowers, 94
bundles, sacred, 19, 24–25, 31, 121–122, 148, 157, 169, 171, 173
Bunzel, Ruth Leah, 172

cabecera (Spanish, "principal, head of the confraternity system"), 129, 193–195, 200
cacao, 32–33, 40, 48, 85–87, 98, 117–118, 152, 167
cacique, 41–42, 44
calendar, highland Maya, 3, 23, 92, 137, 147, 170, 206
Cancer, Fray Luís, 19
candles
 always burning outside Paq'alib'al, 87; lit on evening of Holy Thursday, 198–202; offerings in caves, 83, 127; offerings in confraternity rituals, 126, 160, 164, 165; offerings in house dedications, 152; offerings in maize fields, 117; offerings to altarpiece, 144; offerings to ancestors on the Day of the Dead, 209–211; offerings to Mam, 185; use in divination, 147–148; wax drippings scraped in cleansing ceremonies, 92, 159
cardinal directions
 confraternity houses oriented to, 168–169; creation oriented to, 101–102, 113–114, 116–117, 151, 193,

Torquemada, Fray Juan de, 171
tortillas, 107–108, 110, 148, 193–197, 200
traditionalists, 4, 62, 64, 77–78, 108, 148,
 176, 193
Trinity, 56
Tulan-Suiwa, 31–32, 34
Tunadiu (Tlaxcalan, "Sun"), 36, 38. *See
 also* Alvarado, Pedro de
Tzeltal-Maya, 80
Tz'iquin Q'ij, 170
Tzotzil-Maya, 12, 77, 108, 116, 148, 151
tz'um tz'um, 167
tz'utuj (Tz'utujil, "flower of maize"), 107
Tz'utujil, King, 136
Tz'utujil-Maya, 4, 11, 12, 14, 17; colonial
 era architecture, 71–72; colonial era
 art, 28–29, 65; colonial era history, 39,
 41–48; concept of time, 23–25, 67–70,
 87, 104, 135–136, 147, 155; mythic
 origins, 80; pre-Columbian architec-
 ture, 26, 31, 71–72, 84; pre-Columbian
 art, 25–27; pre-Columbian ceramics,
 31; pre-Columbian culture, 17; pre-
 Columbian history, 30–35; ritual per-
 formances, 143, 158, 212; theology
 and myth, 11–12, 16, 18–19, 21–25,
 104, 135, 212–214. *See also* Atiteco

Uayeb, 190
umbilical cords, 95, 100, 109, 122, 200
underworld
 associated with caves, 83–84, 91;
 associated with Lake Atitlan, 113;
 associated with midnight, 153, 161,
 202; associated with serpents as
 portals, 88–89; associated with shells,
 83; center of maize fields as portal
 into, 118–119, 123, 134; crossroads
 as portals into, 113; descent of Christ
 into, 92, 94, 185, 189; descent of Hero
 Twins into, 118–119, 123, 150;
 dwelling place of ancestors, 116,
 208–209; emergence of maize god
 from, 100, 105, 193, 205; location
 beneath church floor, 73, 77–79, 82,
 197–200; Mam patron deity of, 178,
 181, 184, 186–189, 197; quatrefoil
 as symbol of, 97
Utatlan. *See* Q'umarkaj

Vansina, Jan, 23
Vásquez, Fray Francisco, 20
Venus, 133
Vico, Fray Domingo de, 111
Virgin Mary, 36, 56, 84, 118, 129n.3, 131,
 136–137, 140n.5, 166, 202, 214
Vogt, Evon Z., 13, 77, 108, 116, 148–149
volcanoes, 47, 72–74, 76, 85, 97, 157, 164,
 168, 199
Volcano Santiago, 76

Watanabe, John M., 214
weaving, 95, 97, 167
Wilson, Richard, 11
winds, 84, 128, 136, 157, 162, 178, 211
witz mountain, 105
world tree, 100, 104–107, 111, 169, 191,
 199, 205, 208. *See also* altarpiece,
 central, motifs, world tree
Wuqub' Pek, Wuqub' Siwan (K'iche',
 "Seven Caves, Seven Ravines"), 80

Xelajuj, Valley of, 36
Xibalba, 77, 84, 118, 124, 137
Xiloj Peruch, Andrés, 25, 114
Ximénez, Fray Francisco, 18–20, 43, 118,
 147, 174, 176, 189–191, 206
xkajkoj su't, 64, 159
Xkik', 118, 149–150, 205
Xmucane, 119–122
Xo', 123, 161
xorocotel, 197
xq'ab', 199. *See also* rainbow serpent

Yamch'or (Tz'utujil, "Virgin-Whore"), 178
Yaxchilan, Lintel 25, 88–89
Yax Hal Witz Nal (Classic Maya, "first
 true mountain place"), 107
Yaxper, 95–97, 100, 120–122, 125–126,
 158, 167, 199
yo'x (Tz'utujil, "split-cob maize, twins"),
 117–120, 134, 157–158, 165–167
yuxa (Tz'utujil, "divine twins"), 122

zapotes, 84, 206–207
Zinacantan, 13, 77, 88, 116